IMAGES
of America

STEAMBOATS TO MARTHA'S VINEYARD AND NANTUCKET

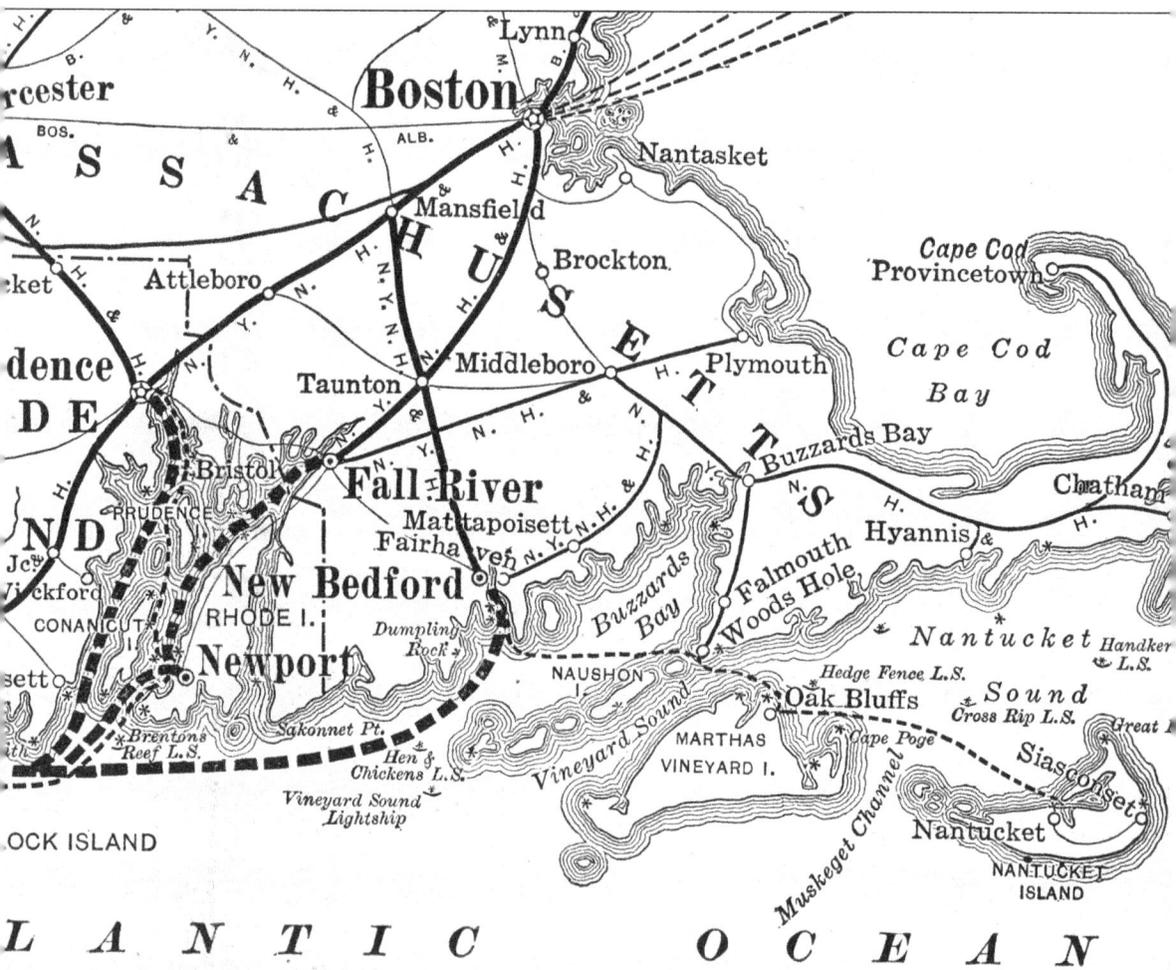

This map is from a 1913 New England Steamship Company brochure and includes the area of steamboat operations covered in this book. The islands of Martha's Vineyard and Nantucket are at lower right, along with the route of the island steamers at the time. The heavy dotted lines going off to the left indicate the night lines to New York. (Author's collection.)

ON THE COVER: In a scene from the 1930s, the steamer *Nantucket* is moored to the south side of the wharf at Oak Bluffs on Martha's Vineyard. The *Nantucket* was built in 1925 as the *Nobska* and was renamed in 1928. In 1957, she received her original name back, and as *Nobska*, she ran until the end of the 1973 season. (Photograph by William K. Covell; author's collection.)

IMAGES
of America

STEAMBOATS TO MARTHA'S VINEYARD AND NANTUCKET

William H. Ewen Jr.
Foreword by Tom Dunlop

ARCADIA
PUBLISHING

Published by Arcadia Publishing
Charleston, South Carolina

Library of Congress Control Number: 2014944514

For all general information, please contact Arcadia Publishing:
Telephone 843-853-2070
Fax 843-853-0044
E-mail sales@arcadiapublishing.com
For customer service and orders:
Toll-Free 1-888-313-2665

Visit us on the Internet at www.arcadiapublishing.com

This book is dedicated to my late parents, Cathleen and William Ewen, and to my sister, Barbara, in honor of all the boat rides we four took together.

CONTENTS

FOREWORD

I was fortunate to be standing on the wharf when the steamer *Naushon* rounded Nobska Point and drove her muscular way into the onrushing tides of Woods Hole, Massachusetts, on May 27, 1988. It was the final scheduled trip the *Naushon* ever made. I saw her—with a "Don't Give Up the Ship" pennant crackling from her mast top—turn and back into a slip at the Woods Hole, Martha's Vineyard, and Nantucket Steamship Authority terminal. The appeal didn't work; this encore voyage of the *Naushon* would mark not just the last time a true steamship carried passengers and cars across the waters of Vineyard and Nantucket Sounds, but actually from anywhere to anywhere along the whole Eastern Seaboard of the United States.

The departure of the *Naushon* for a moribund (and finally derelict) life as a riverside casino boat in the Deep South ended 170 years of steamship history on the waters that surround Cape Cod, Martha's Vineyard, and Nantucket. No more the quiet tick of a reciprocating engine from the steam plant down below, the snug and inviting staterooms that ran along a promenade deck, or the sense that a real ship was carrying real travelers on a real voyage from the broad conventionalities of mainland life to seaward islands where everything looked encouragingly distinctive and felt gratifyingly specific.

Twenty-eight years have passed since that day when the steamer *Naushon* yielded her place to the efficient, but essentially indistinguishable, fleet of diesel ferries that serve the Vineyard and Nantucket today. Forty years have passed since a book told the story of the island steamships. But with *Steamboats to Martha's Vineyard and Nantucket*, William H. Ewen Jr. answers the call anew. Longtime summer resident of Oak Bluffs on the Vineyard, artist, steamship historian, writer, and lecturer, Ewen delivers the book of prose and photographs, many never before seen, that returns us to the decks of the island steamers at a time when everything about them—from engine room to mast tops—looked and felt as warmly and memorably individual as the islands they then served.

—Tom Dunlop, author of *The Chappy Ferry Book*

ACKNOWLEDGMENTS

This book was a labor of love, but without the help of many, the labor would have been much more difficult. If I have forgotten anyone, I sincerely apologize. It was not intentional.

First, I want to acknowledge several who have recorded the history of the island steamers and whose works were invaluable parts of my research. They are *The Story of the Island Steamers* by Harry B. Turner, published in 1910; *A Study of the Nantucket-Vineyard Ferry Lines, 1800–1948*, a 1966 master's thesis at the University of Rhode Island by Edward Law Thomas; and *The Island Steamers* by Paul C. Morris and Joseph F. Morin, published in 1977.

I have had help with researching and locating images from several museums and libraries. I wish to thank Allynne Lange, curator of the Hudson River Maritime Museum; Mark Procknik, librarian at the New Bedford Whaling Museum Research Library; Bow Van Riper, assistant librarian at the Martha's Vineyard Museum; and Hilary Wall, archivist and librarian at the *Vineyard Gazette* and *Martha's Vineyard Magazine*.

A number of people helped in a variety of important ways, including making images available from their own or family collections, helping to locate sources, providing answers to questions, and willingly assisting in many other ways. For these things, I thank the late Bob Allen and his wife Hazel, John Boardman, Rosemary Bottum, Mike Dawicki, Barry Eager, George Fisher, Rob Gatchell, Paul Huntington, Joe Morin, Bill Muller, Ted Scull, Alison Shaw, Mark Snider, and Carl Walker.

My thanks go also to Tom Dunlop, who wrote the foreword for this book and who helped in numerous other ways.

Special thanks go to my wife, Susan, for reading the manuscript and making many helpful suggestions. I thank her for her patience as well.

Last but not least, a thank-you is owed to my editor Caitrin Cunningham, who was a great help and a pleasure to work with.

Except where otherwise noted, all images are from the author's collection.

INTRODUCTION

The Massachusetts islands of Martha's Vineyard and Nantucket are situated off the southern coast of Cape Cod. Nantucket, the smaller of the two, is approximately 30 miles offshore and Martha's Vineyard about seven miles. The first recorded sightings of both islands were by the English explorer Bartholomew Gosnold in 1602. At the time, members of the Wampanoag Indian tribe inhabited the islands.

The first real English settlement on the Vineyard, as Martha's Vineyard is commonly called, was established in 1642 and the first on Nantucket in 1659. While Martha's Vineyard remained mostly agricultural, Nantucket steadily grew as a center for whaling and refining whale oil. In the 18th and 19th centuries, Nantucket whaling ships were traveling to points around the globe on voyages that lasted three to four years. This industry, for a time, made Nantucket one of the wealthiest communities in the country. It was said that whale oil from Nantucket lit the streets of Europe.

Transportation by water was of course critical for the islands. At first, it consisted mostly of private sailing vessels for hire. As the need for reliable and regular transportation grew, especially on Nantucket, so did the push for ferry service. As early as 1694, an act for licensing and regulating ferry service was enacted. In 1695, the two islands were put in different counties so that they and their ferry services were independent of each other.

The first tentative service by steamboat came to Nantucket as early as 1818. It was not until 1846 that Martha's Vineyard got its own direct steam-powered ferry service. Engine-powered vessels did not replace the sailing packets immediately. The steamers were more expensive to build, and at least initially, the sailing vessels were often faster. But this was the beginning. Steamboats served the two islands for about 170 years before the last one departed these waters.

While certainly not attempting to be an in-depth history of steamboat service to Martha's Vineyard and Nantucket or to include every steamer in island service, this volume will be a visual trip back to look at many of the different steamboats and companies that became lifelines to the islands. Ferry service continues today in greater numbers than ever before. However, all of the contemporary vessels are diesel powered. With some exceptions, only steam-powered ships will be included here.

One

THE EARLY YEARS

Initially, Nantucket, with its thriving commerce, had a much greater need for regularly scheduled water transportation than the Vineyard. Logically, the first attempts to establish service by powered vessels were at Nantucket. The first steamboat to cross Nantucket Sound was the *Eagle*, built in New London, Connecticut, in 1817, just 10 years after Robert Fulton's *North River Steamboat*. (That was her official name, not *Clermont*.) After initially operating on Long Island Sound, the *Eagle* made her first trip from New Bedford to Nantucket on May 5, 1818. There was public indifference to her service and an attitude that sail would remain more reliable. Without enough patronage to support her, she was sold to the Boston & Hingham Steamboat Company after only three months.

The steamer *La Fayette* was built in New Jersey in 1824 and operated there until 1828, when Barney Corey and James Hathaway of New Bedford purchased her. She was smaller and much cruder than the *Eagle* and was woefully underpowered. She was only able to complete the trip between New Bedford and Nantucket if the tides and wind were favorable. While in service to Nantucket, her name was unofficially changed to *Hamilton*, and that name was painted on her paddle boxes. In spite of this, she was still registered under her original name, and *La Fayette* remained on her stern. She lasted on the run about a year.

The last attempt at individual ownership of a steamboat to Nantucket was the *Marco Bozzaris*, built in 1826 for Jacob Barker. He was a wealthy man with many business interests and was one of the few who saw the potential for steamboats to help the island and its commerce. While more successful than her predecessors, *Marco Bozzaris* could only operate seven months of the year and was withdrawn in 1832.

In 1833, the Nantucket Steamboat Company was incorporated by a number of prominent businessmen on the island, ushering in the age of corporate ownership with sufficient funds to operate steamboat service. These men also realized the income potential of having a steamer available for towing, salvage, and ice-breaking.

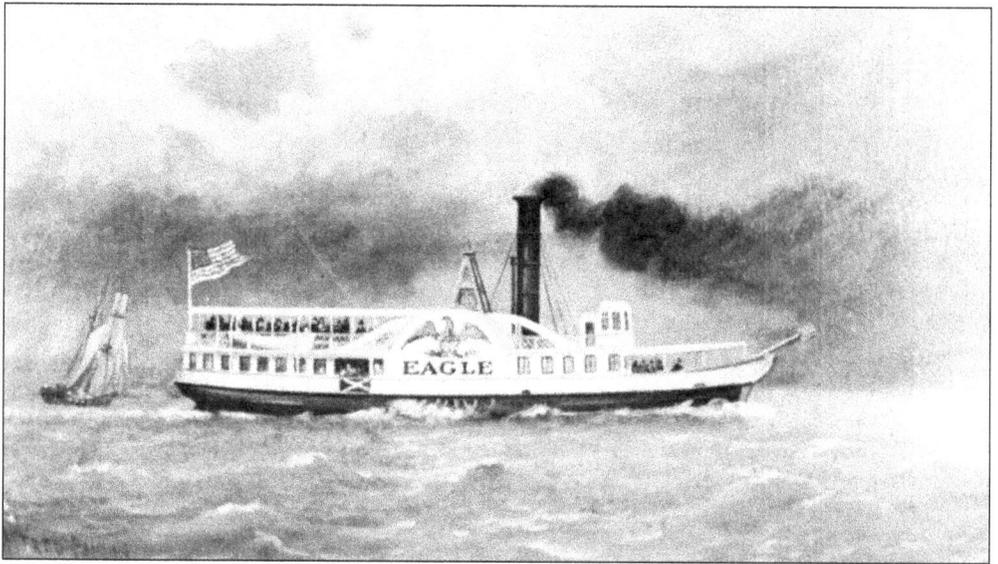

The 92-foot side-wheel steamboat *Eagle* was the first to cross Nantucket Sound. Her initial trip from New Bedford to Nantucket was on May 5, 1818, with 60 passengers aboard. On June 25, she began regularly scheduled service, the first to either of the islands. However, even her fastest trip of eight hours and seven minutes did not help patronage. She was withdrawn and sold after only three months.

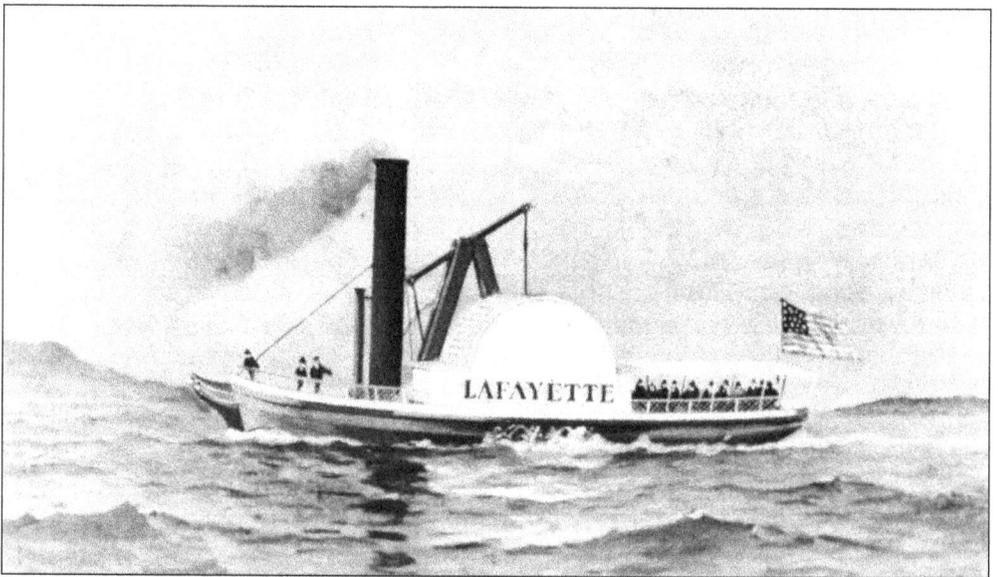

The second steamer to attempt operating a service to Nantucket was the *La Fayette*, which is not one word as depicted in this painting by Fred Pansing. She was so underpowered that she had to carry barrels of tar to throw into the boiler for more power in critical situations, such as making landings. The resultant smoke and sparks earned her the nickname "the Dragon."

STEAM-BOAT
MARCO BOZZARIS,
CAPT. GARDNER CHILD,

The *Marco Bozzaris* was built to operate to Nantucket but was first tried out on a run from Dighton and Fall River to New York. This cut from an 1827 newspaper ad probably does not accurately represent her. It is a generic image and was used by a number of different companies. Her first trip to Nantucket was in 1829, and she only lasted here until 1832.

The *Chancellor Livingston*, built in 1816, was the first steamer to arrive at Nantucket on an excursion. On July 2, 1830, she traveled from Boston for the day, with 300 passengers. She was too deep to get over the bar at the harbor entrance, so passengers had to be taken ashore by the *Marco Bozzaris*. The *Chancellor Livingston* was originally built for Hudson River service and was scrapped in 1834.

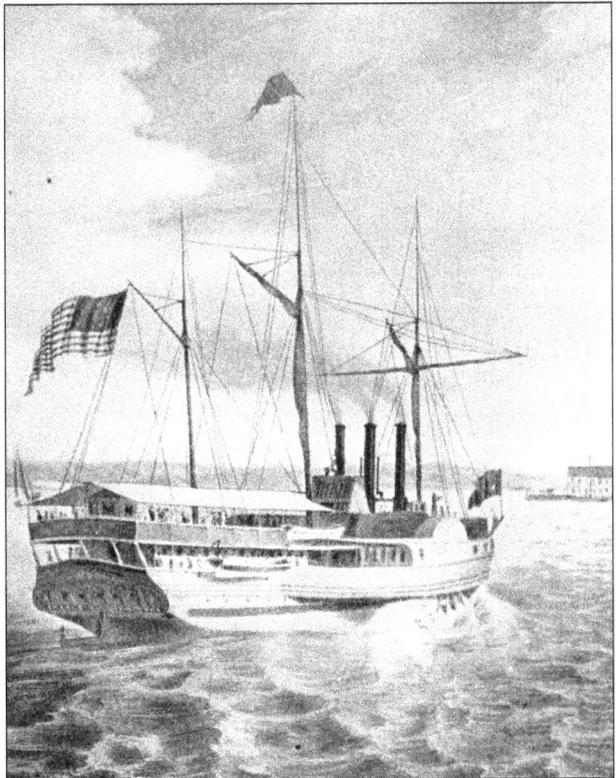

11

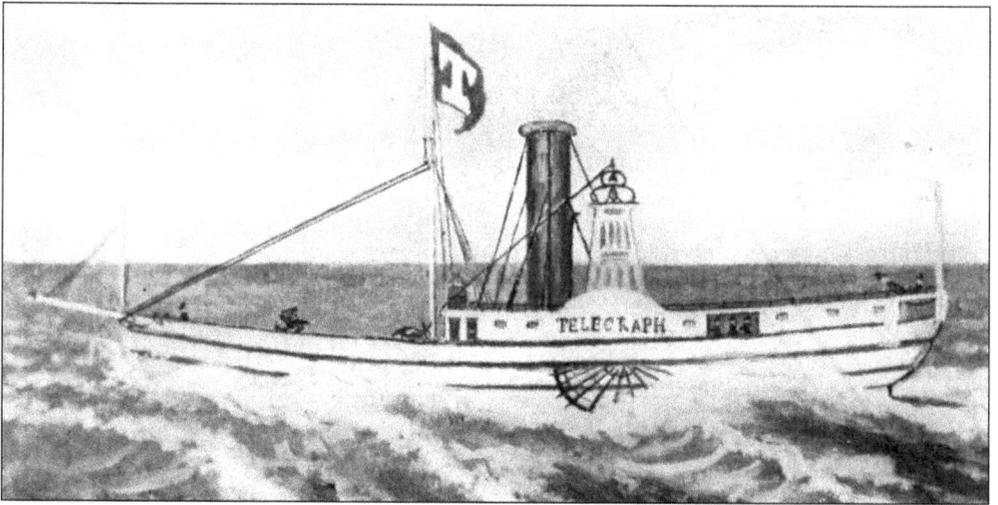

The 120-foot steamer *Telegraph* was built in New York in 1832. She made her first trip to Nantucket on October 4, 1832; her owners did not incorporate as the Nantucket Steamboat Company until the following year. For a time, she was unofficially named *Nebraska*. In 1858, she and her fleet mate, *Massachusetts*, were sold for service in New Jersey. She was last known to operate in Florida.

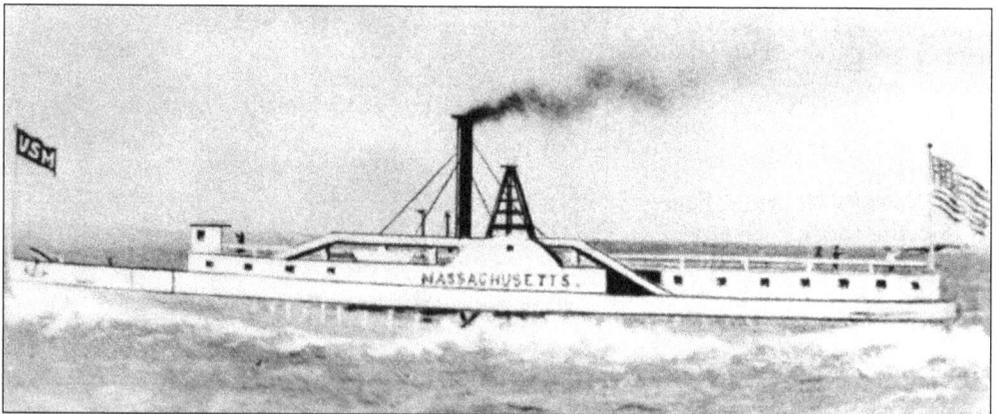

In anticipation of increased business, the Nantucket Steamboat Company built the *Massachusetts* in 1842. She was larger and faster than the *Telegraph* and was considered the finest steamer on the New England coast. In 1854, she began running from Hyannis to Nantucket, rather than from New Bedford. The next year, she was laid up, and in 1858, was sold to New Jersey. After Civil War service, she ended her days on Chesapeake Bay. (Courtesy of John Boardman.)

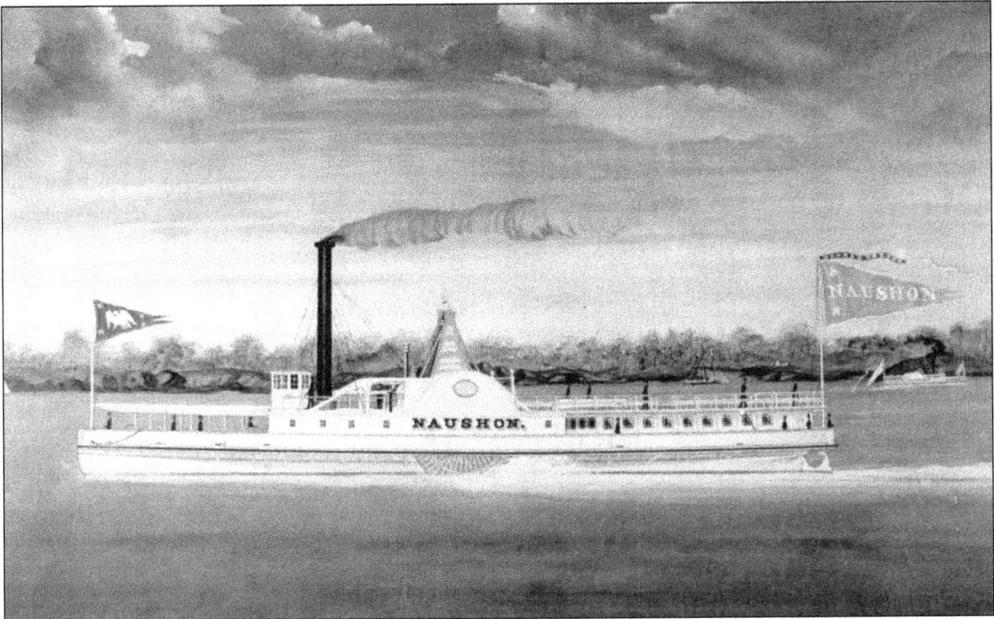

In 1845, the steamer *Naushon* was built for Capt. Holmes Smith. On March 23, 1846, she made her first trip to Edgartown for the newly formed New Bedford and Martha's Vineyard Steamboat Company. She was the first steamer to operate on a regular schedule just to the Vineyard. Unfortunately, she was withdrawn, and the company dissolved in 1848. She was sold to New York and was renamed *Newsboy*.

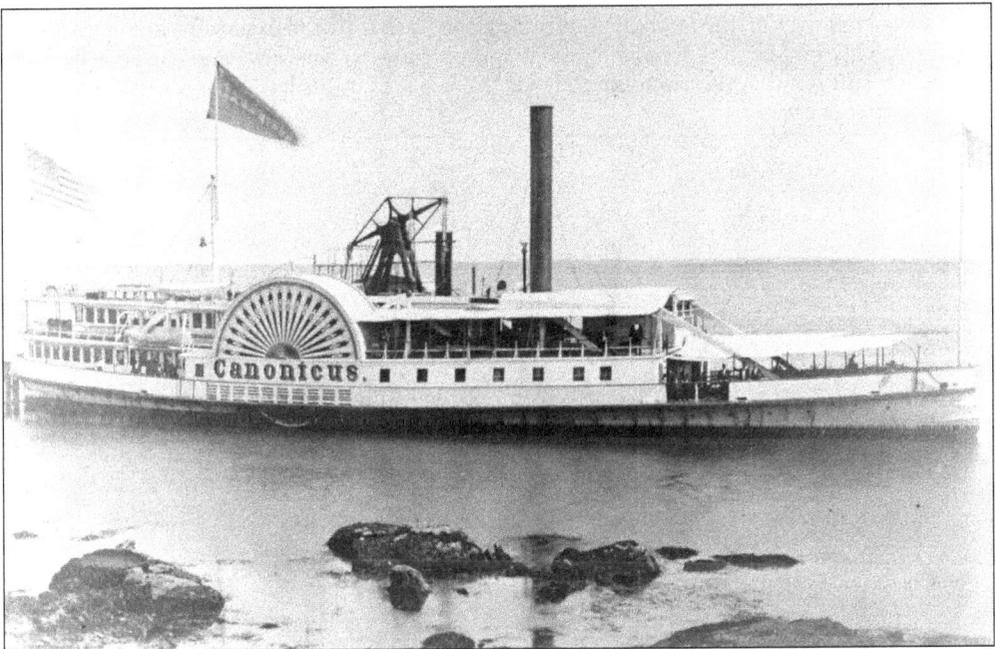

The 1849 steamer *Canonicus* was built for the Fall River Iron Works, an enterprise of the Borden family of that city. Her original service was between Fall River and Providence. In 1851, her owners placed her on a run from Fairhaven to Edgartown on Martha's Vineyard, operating as the Bay State Steamboat Company.

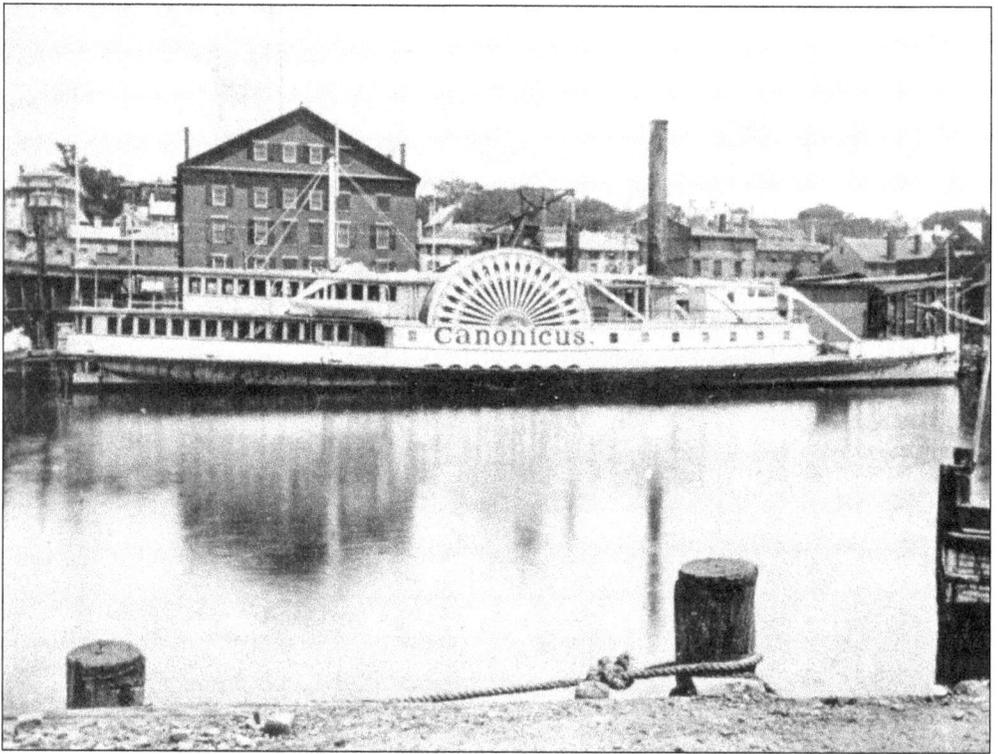

The government first chartered and then purchased the *Canonicus* in 1863, for service in the Civil War. After the war, she returned to New England waters and ran excursions from Providence to Cottage City on Martha's Vineyard. She is at Providence in this view, and the large building behind her still stands. Also standing today is the house at upper left, built for Gen. Ambrose Burnside after the war.

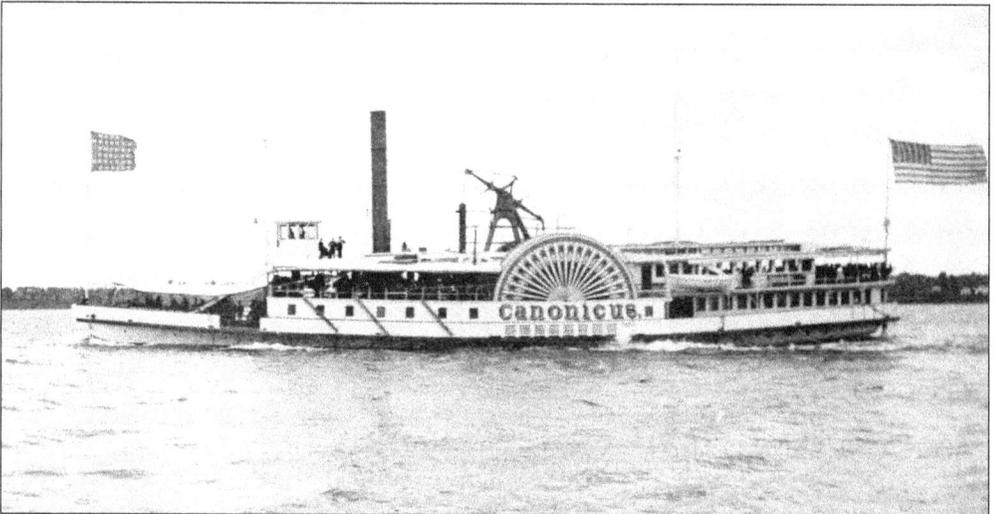

In addition to excursions to Cottage City, the *Canonicus* ran excursions on Narragansett Bay and became a regular on the Providence-to-Block Island route. In 1867, her pilothouse was raised to the third deck, which had been extended forward. She is seen here on Narragansett Bay after the modifications. In 1894, she was sold, and burned off of New Jersey that same year.

Two

COMPETITION AND
CONSOLIDATION

By mid-century, Nantucket was in economic decline, due to a disastrous fire that destroyed most of the waterfront and the gradual shift of the whaling industry to New Bedford. The citizens began promoting the island as a summer resort. With the extension of a railroad line to Hyannis in 1854 and the appeal of a shorter trip by water, the Nantucket Steamboat Company moved its mainland connection to that port. In 1855, the company was reincorporated as the Nantucket and Cape Cod Steamboat Company.

Competition increased to both islands as more companies put steamers into service. Some only lasted a short time, but travel by steamboat was now well established. As rail lines on the mainland were extended, more ports became viable terminals, and the railroads and steamboat companies became allied. After the Civil War, larger railroads began buying or leasing smaller lines. The Old Colony Railroad was a proponent of this, and eventually, it controlled the properties of 23 railroads and over 600 miles of track. In 1874, the Massachusetts General Court authorized the Old Colony to own stock in any steamboat lines that connected with the railroad. This included the island steamers.

In 1886, at the urging of the railroad, the New Bedford, Vineyard, and Nantucket Steamboat Company was finally consolidated with the Cape Cod and Nantucket Steamboat Company. The new company became the New Bedford, Martha's Vineyard, and Nantucket Steamboat Company. The railroad was the largest shareholder of the new company. Although the Old Colony was in control, it did allow the directors of the steamboat company a great deal of independence. The New Bedford, Vineyard, and Nantucket Steamboat Company was never part of the railroad's Old Colony Steamboat Company.

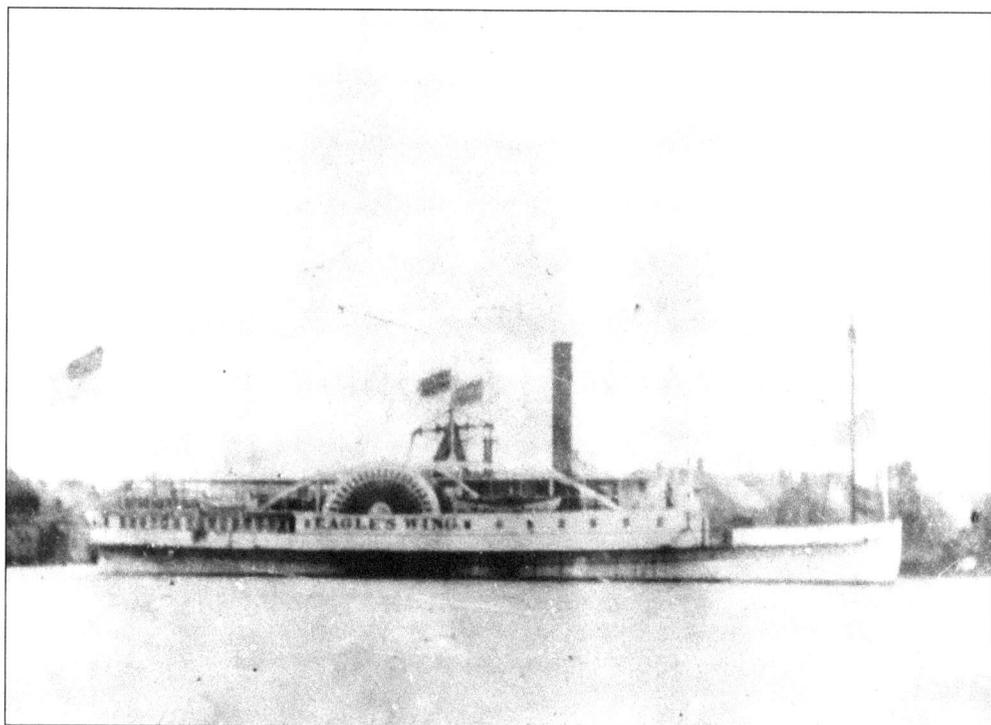

In 1854, the Nantucket Steamboat Company shifted its mainland port to Hyannis on Cape Cod. This opened the door for a new company to compete from New Bedford, and the New Bedford, Vineyard, and Nantucket Steamboat Company was formed. It built the 173-foot *Eagle's Wing* for the service. She only lasted until 1861, when she burned in Narragansett Bay on her way to Providence for an excursion. (Courtesy of the New Bedford Whaling Museum.)

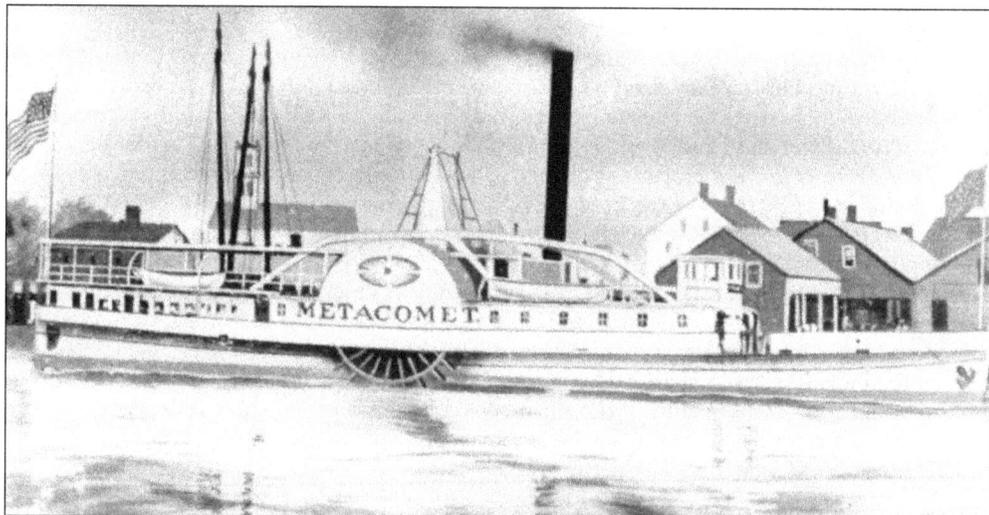

To compete with the *Eagle's Wing*, the Bay State Line had the *Metacomet* built in 1854. She replaced the older *Canonicus* but was a throwback in design. She had a crosshead engine, a type going back to Robert Fulton's steamboat. By now, most side-wheel steamers had the so-called "walking beam" engine. In 1857, she was sold to the Navy and renamed *Pulaski*. She ended her days in Uruguay. (Courtesy of John Boardman.)

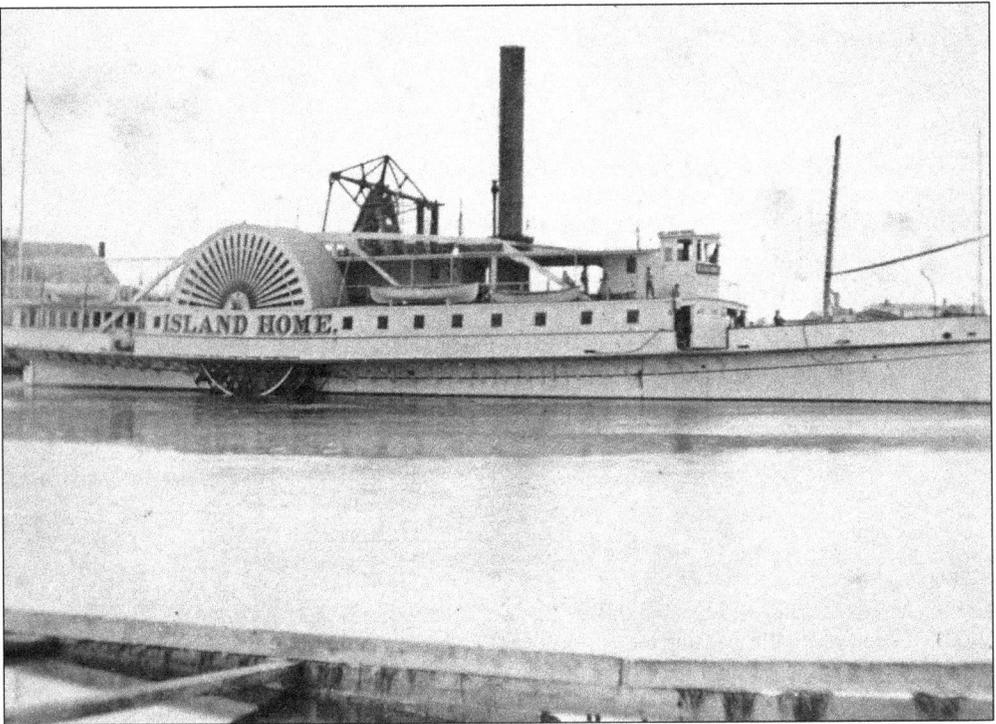

In 1855, the year that the Nantucket and Cape Cod Steamboat Company was incorporated, it had Lawrence and Sneeden of New York build the 184-foot steamer *Island Home*. She took over the run between Hyannis and Nantucket that September. (Courtesy of John Boardman.)

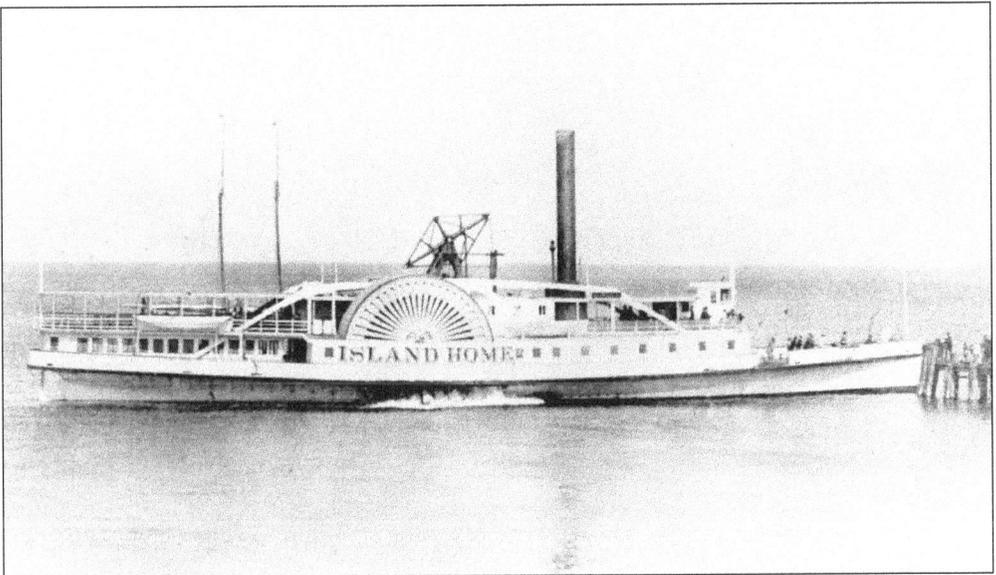

By the 1860s, Martha's Vineyard had also become an important destination for excursionists. In 1871, the Nantucket-based company ran the *Island Home* from Nantucket to the Vineyard and on to Hyannis and back. The following year, the railroad was completed to Woods Hole, and Hyannis was dropped completely as a terminus for the steamers. In this view, she is reversing her engine, landing at Cottage City on the Vineyard.

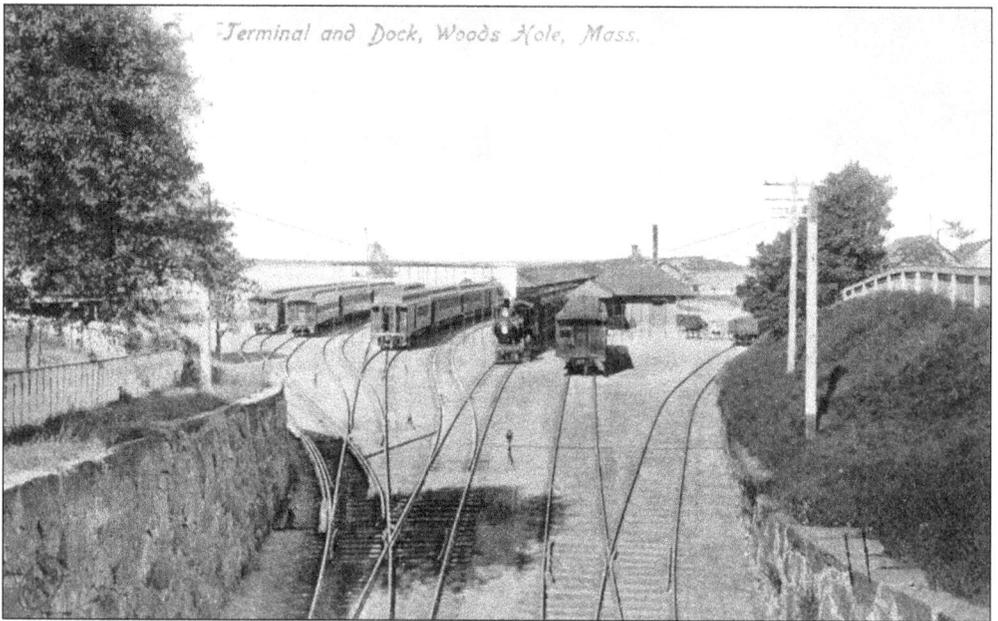

Terminal and Dock, Woods Hole, Mass.

Woods Hole eventually became an important terminal for both the railroad and the steamers. The area with tracks shown here is now the staging area for automobiles waiting to board the ferries to Martha's Vineyard. A bike path follows the old roadbed that brought trains to the wharf. (Courtesy of Mark Snider.)

The *Island home* can be seen at the wharf at Cottage City. This area, once part of Edgartown, broke away in 1880 and was incorporated as Cottage City. In 1907, it was reincorporated as Oak Bluffs. Initially there was no town, but in 1835, a Methodist campground had been established here. As the popularity of the camp meetings grew, hundreds and eventually thousands came by steamboat to attend.

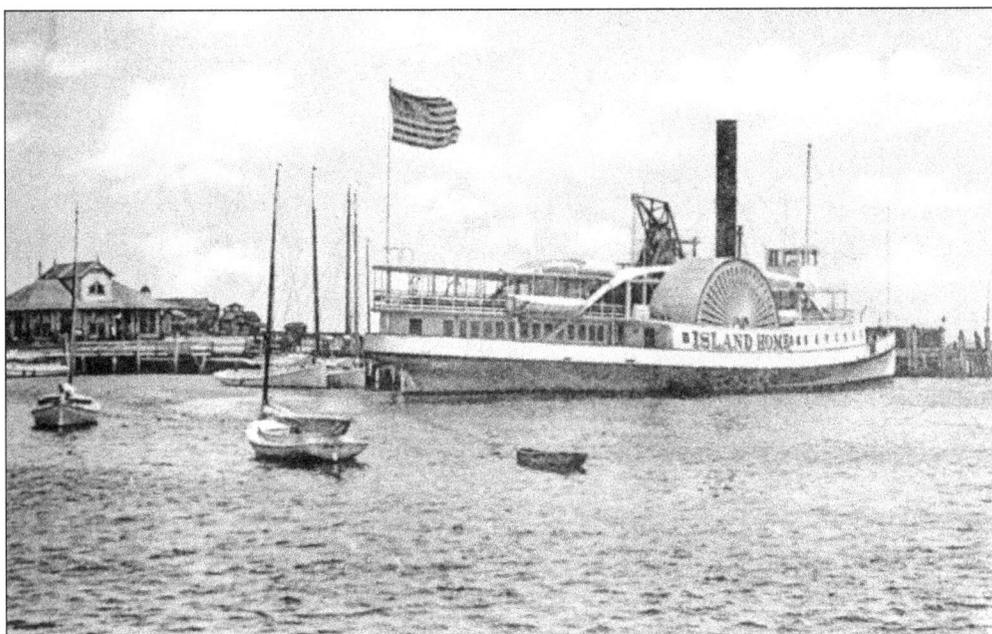

The *Island Home* was extensively remodeled in 1887. This included raising her pilothouse to the third deck, as seen in this view at Nantucket.

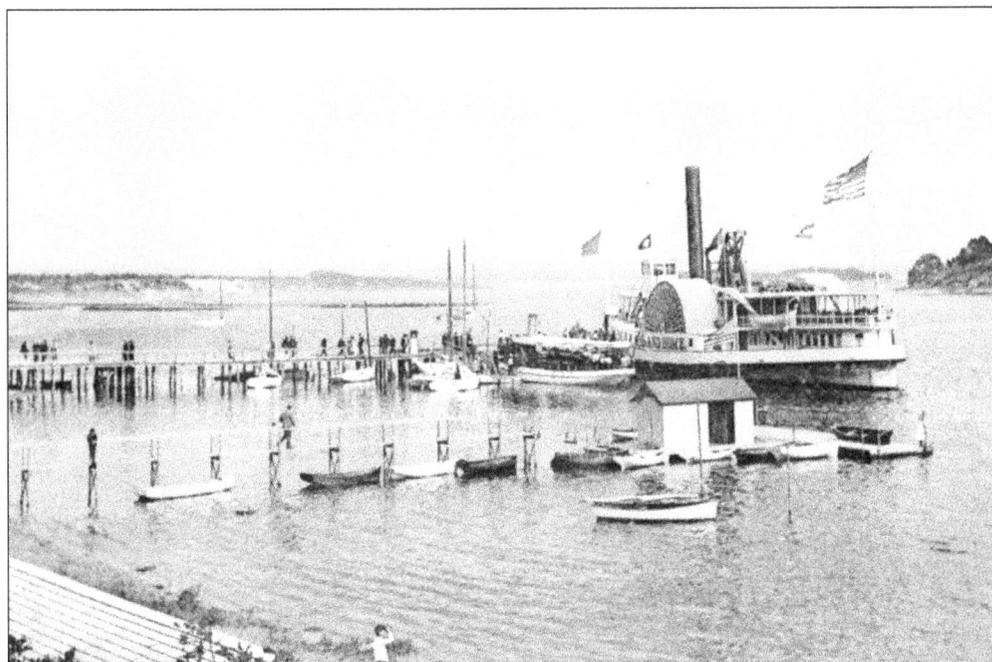

This view shows the *Island Home* at the Onset wharf. Although not part of the regular schedule, this Cape Cod town was often visited by the steamers for excursions. The *Island Home* was sold in 1896 after 41 years of service, and was cut down to a barge.

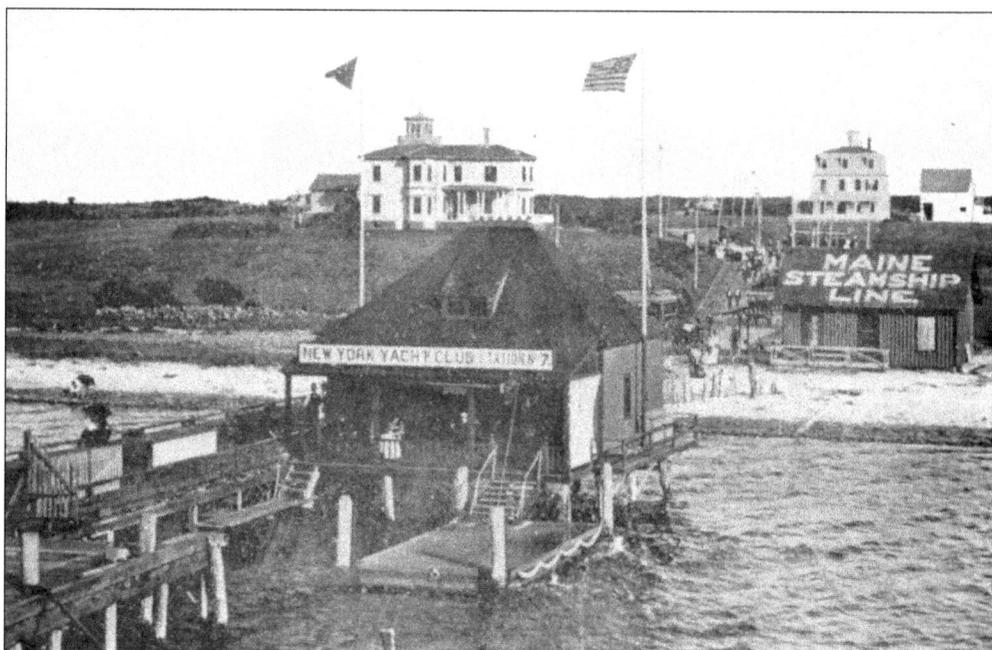

Before the wharf was built at Cottage City, steamers landed at Eastville. Visitors attending the camp meetings had to walk at least a mile over a sandy track from this point. This later became known as the New York Wharf when the New York Yacht Club established a station here. Steamers of the Maine Steamship Company also landed here on some trips between New York and Maine. (Courtesy of Rob Gatchell.)

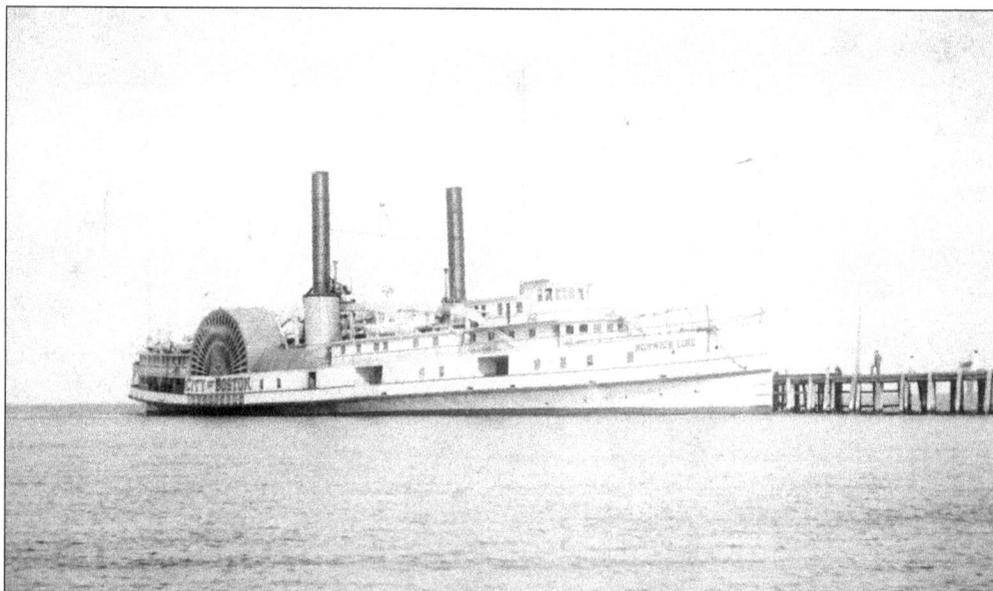

Steamers from other areas often visited the wharves on Martha's Vineyard. They would come for day excursions or with charters. Passengers on these trips could see the sights on the island or attend the Methodist or Baptist camp meetings. The *City of Boston* is seen here, probably at Highland Wharf, during such a visit. She was a night boat that regularly ran between Norwich, Connecticut, and New York. (From the collections of the Martha's Vineyard Museum.)

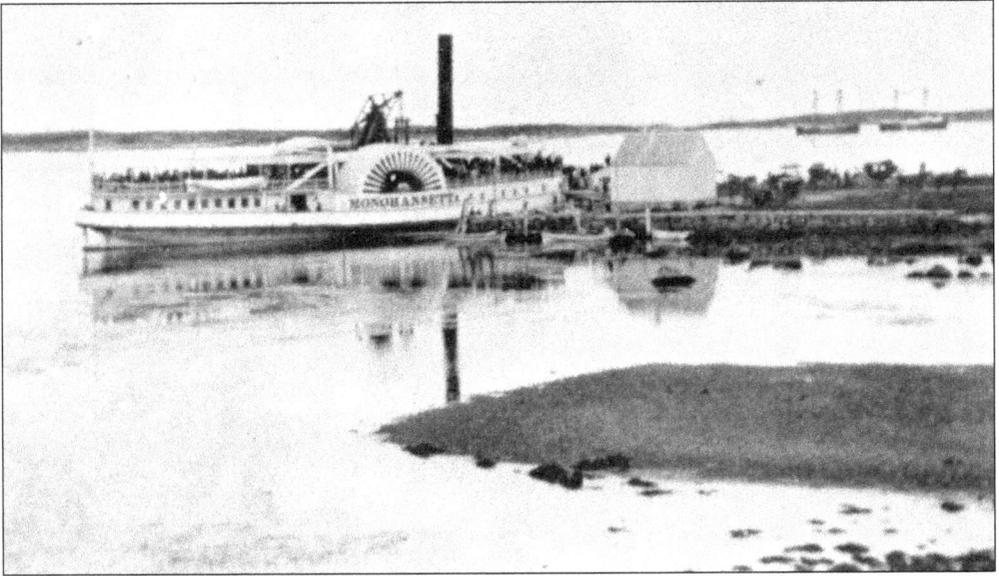

In 1862, the New Bedford, Vineyard, and Nantucket Steamboat Company had the *Monohansett* built to replace the burned *Eagle's Wing*. To save money, the engine from the *Eagle's Wing* was placed in the new steamer. This early photograph shows the *Monohansett* at the wharf in Wood's Hole.

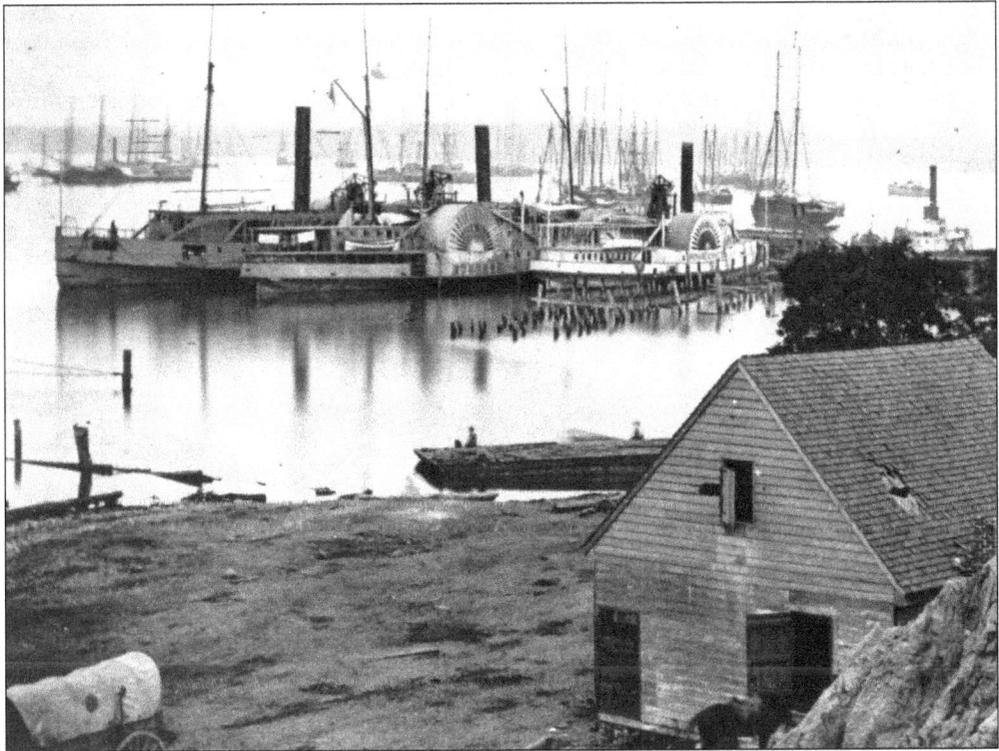

The *Monohansett* was chartered to the government for 35 days in 1862 for use in the Civil War. She was taken again in 1863. During the war, she was used to transport troops and served as a dispatch boat for General Grant. She can be seen at right center in this image at City Point, Virginia, with other vessels pressed into war service. (National Archives.)

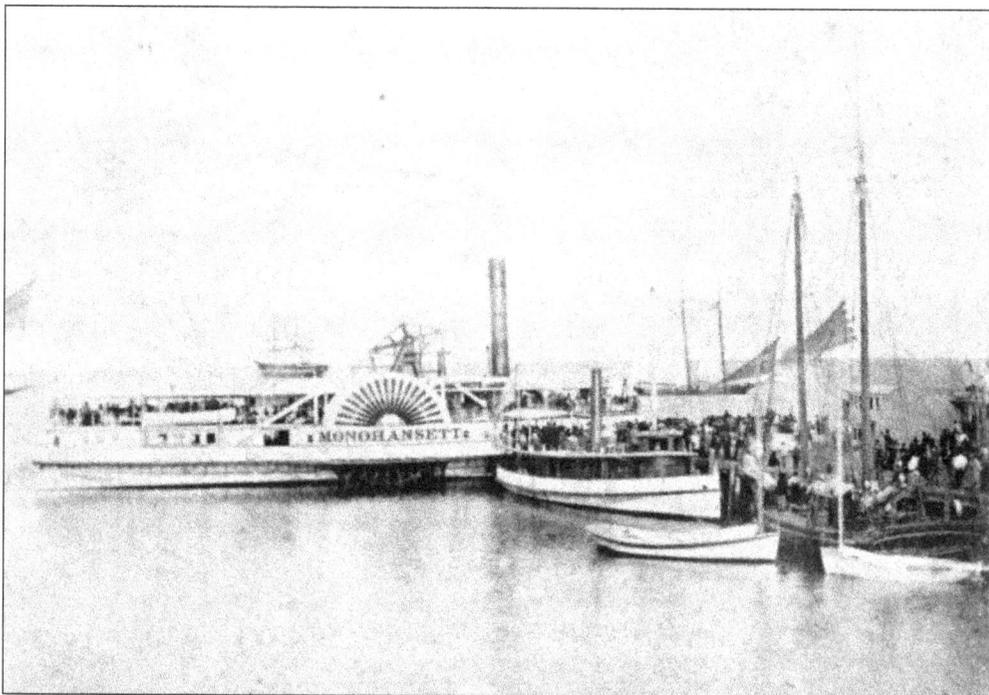

When the *Monohansett* left for war service, a new company, the Martha's Vineyard Steamboat Company, jumped in. The company purchased and operated the small steamer *Helen Augusta*. She was the first regularly scheduled propeller steamer to either island. When the *Monohansett* returned, her owners took control of the Martha's Vineyard Steamboat Company and the *Helen Augusta*. Here, she is seen alongside the wharf at Cottage City with the *Monohansett* behind her.

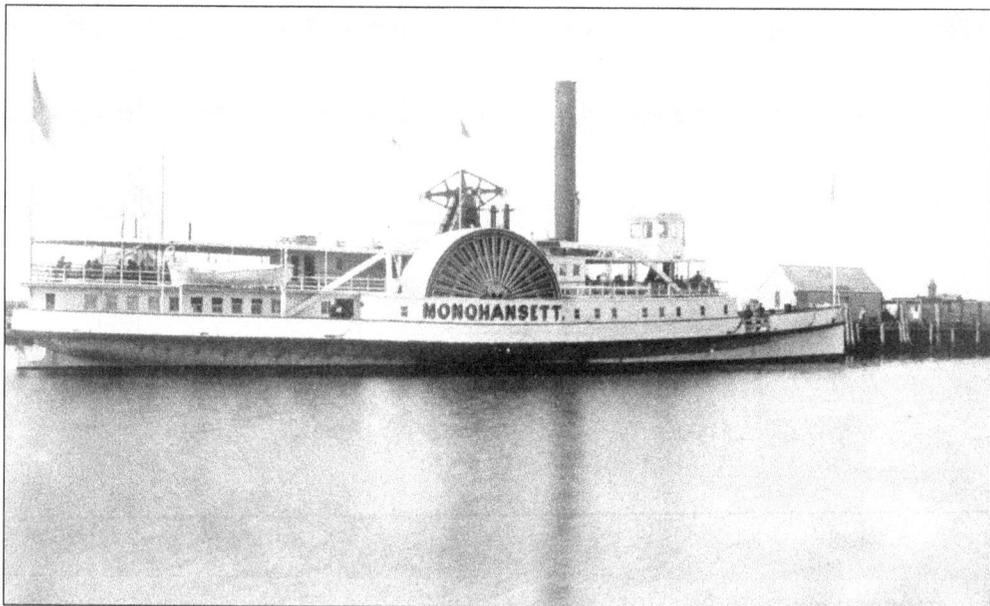

While back in island service after the war, the *Monohansett* was rebuilt and her pilothouse moved to the top deck. This view shows her at Steamboat Wharf in Nantucket after the changes were made.

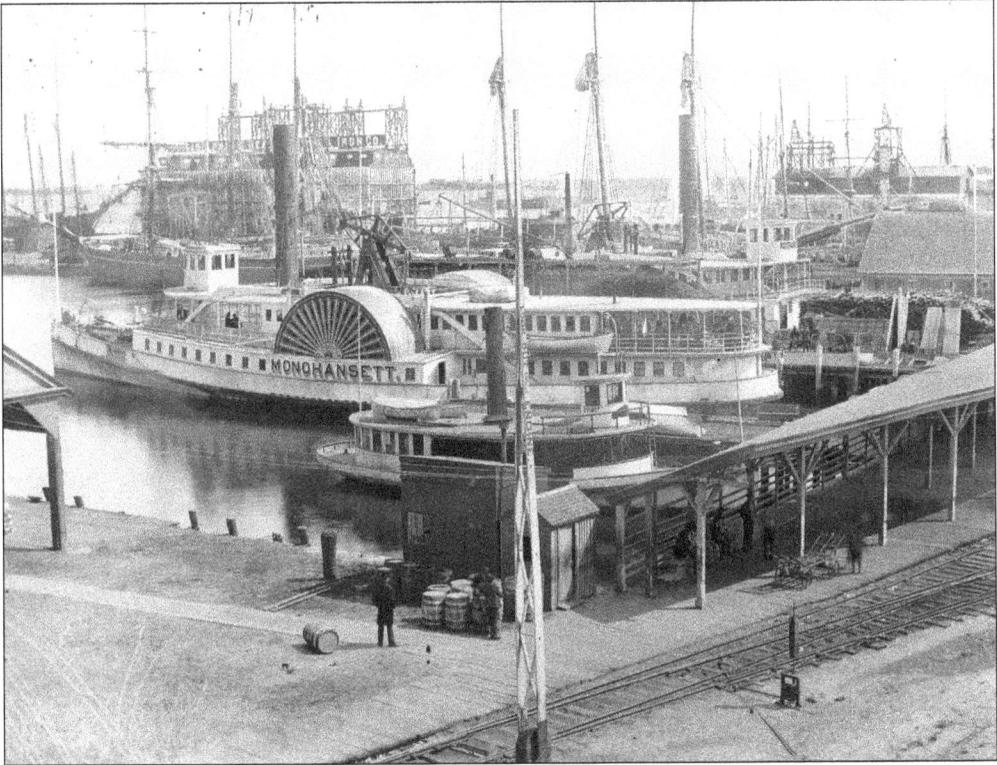

The *Monohansett* is seen at New Bedford in the early 1890s. On the other side of the wharf is the steamer *Martha's Vineyard* with large sailing vessels beyond. Note the large pile of coal on the pier. Next to the *Monohansett* is the little steamer *Cygnet*, which ran to Nonquitt. In the foreground is the rail line that connected with the mainline to Boston.

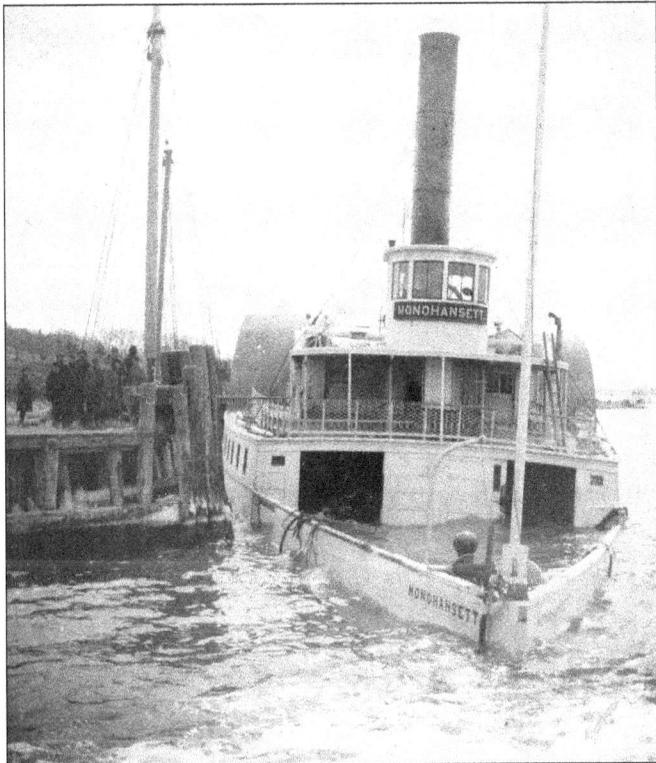

This unusual photograph shows the *Monohansett* sunk at an unknown wharf. It could be Woods Hole, but the date, occurrence, and location are not identified. However, she was raised and continued in service. (Courtesy of Mark Snider.)

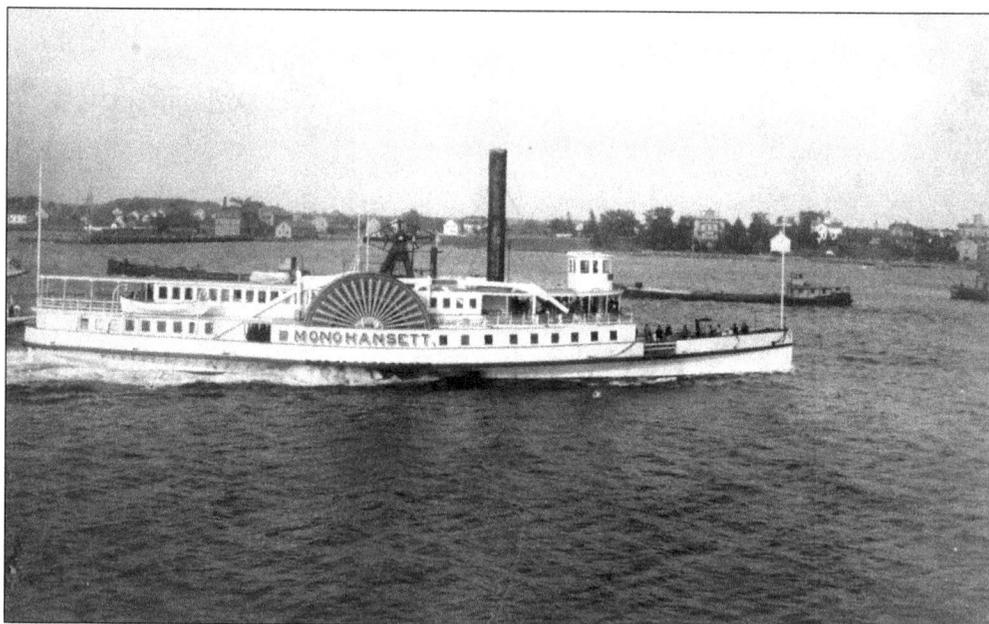

In this striking view of the *Monohansett*, her hog frame is clearly visible. That is the truss-like structure running fore and aft. There was one on each side of the vessel, and they were part of the hull structure. Most wooden-hulled side-wheelers had these to stiffen the hull to keep it from sagging from the weight of the engine and boilers. They were unnecessary with iron or steel hulls. (Courtesy of Mark Snider.)

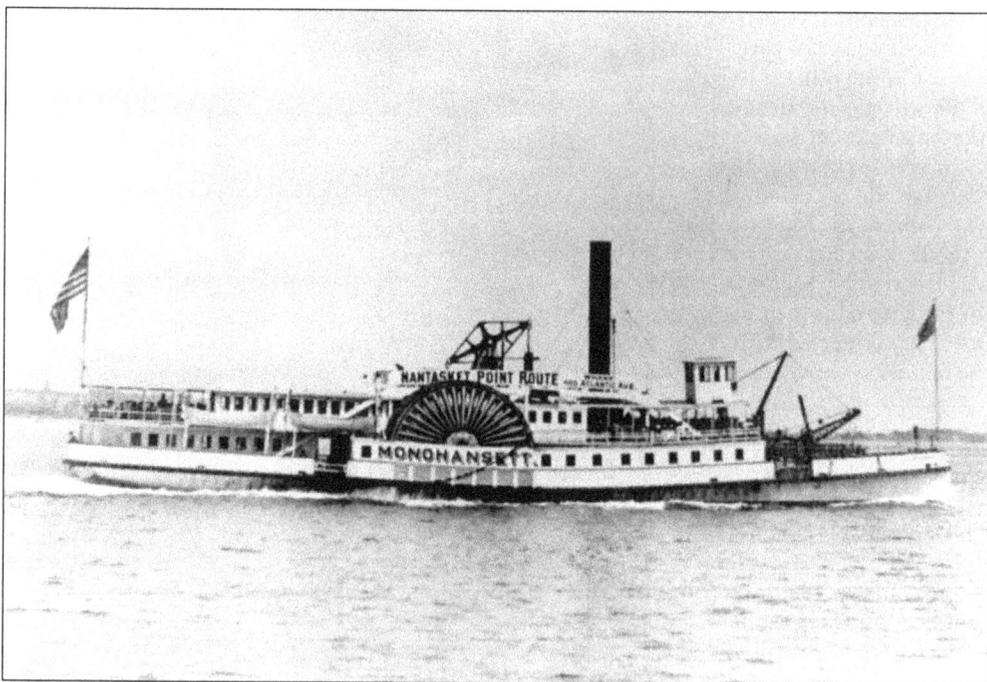

In 1902, the *Monohansett* was chartered and then, in 1903, sold for use as an excursion boat out of Boston. Her destination is well advertised by the banner on her top deck. The cranes that appear to be on her forward deck are on a floating dredge in the background. (Courtesy of Mark Snider.)

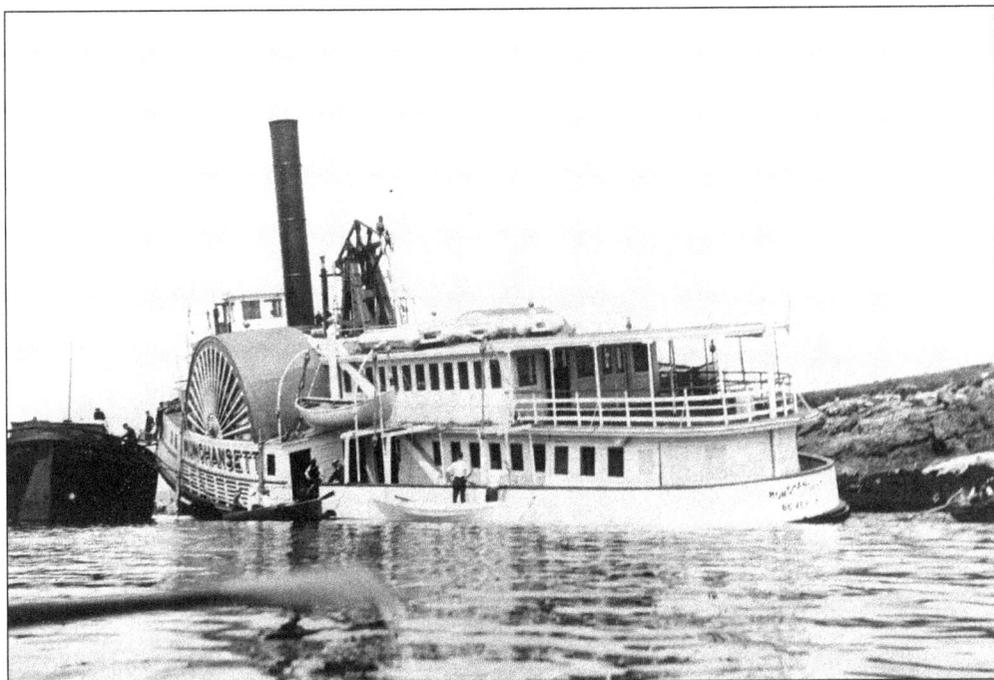

In June 1904, while returning to Boston from Gloucester in a dense fog, the *Monohansett* was wrecked on Misery Island at Salem. She had been heading for the wharf at Salem Willows and was a total loss. (Courtesy of the New Bedford Whaling Museum.)

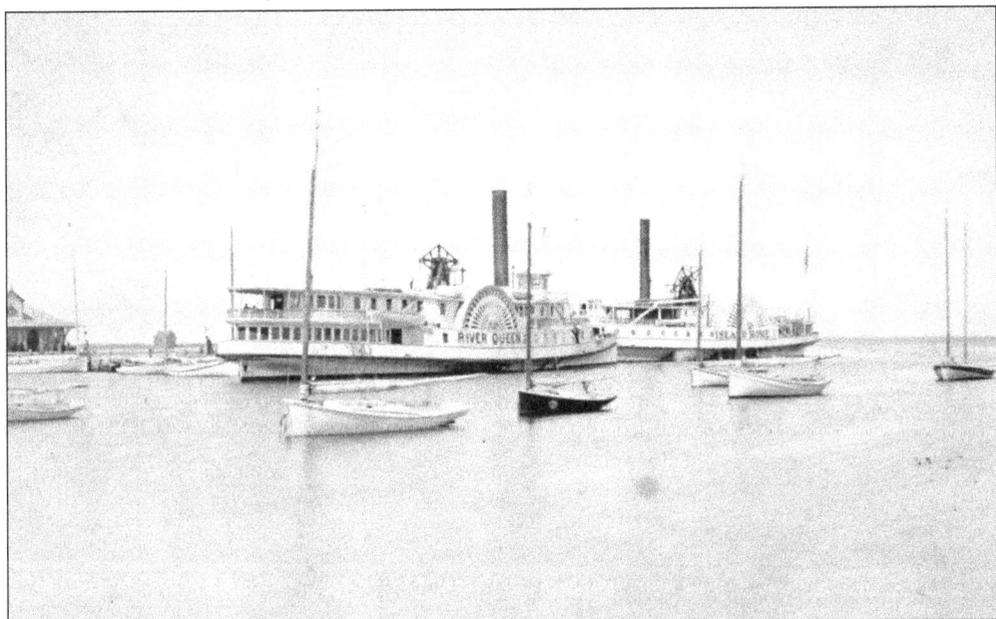

The *River Queen* was built in 1864 and was immediately taken by the government. General Grant made her his headquarters and dispatch boat. She was also a favorite of President Lincoln to get away on and relax. It was on board her that he and his staff met with Alexander Stephens, vice president of the Confederacy, to discuss ending the war. She is seen here at Nantucket with the *Island Home*. (Courtesy of John Boardman.)

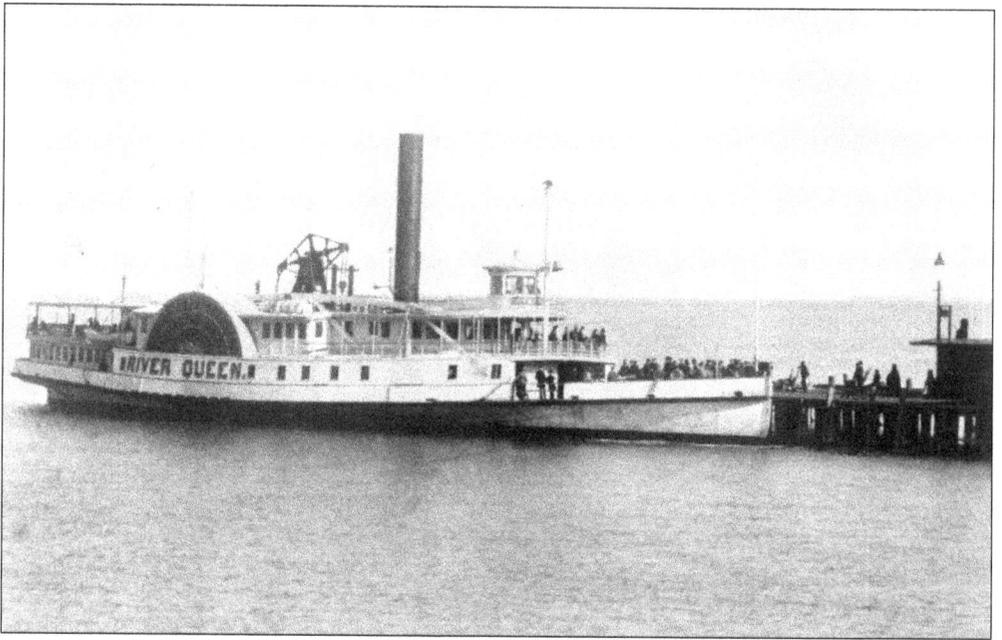

After the war, the *River Queen* operated on Narragansett Bay between Providence and Newport. In 1871, she was purchased by the New Bedford, Vineyard, and Nantucket Steamboat Company for island service. Here she is at the wharf at Cottage City.

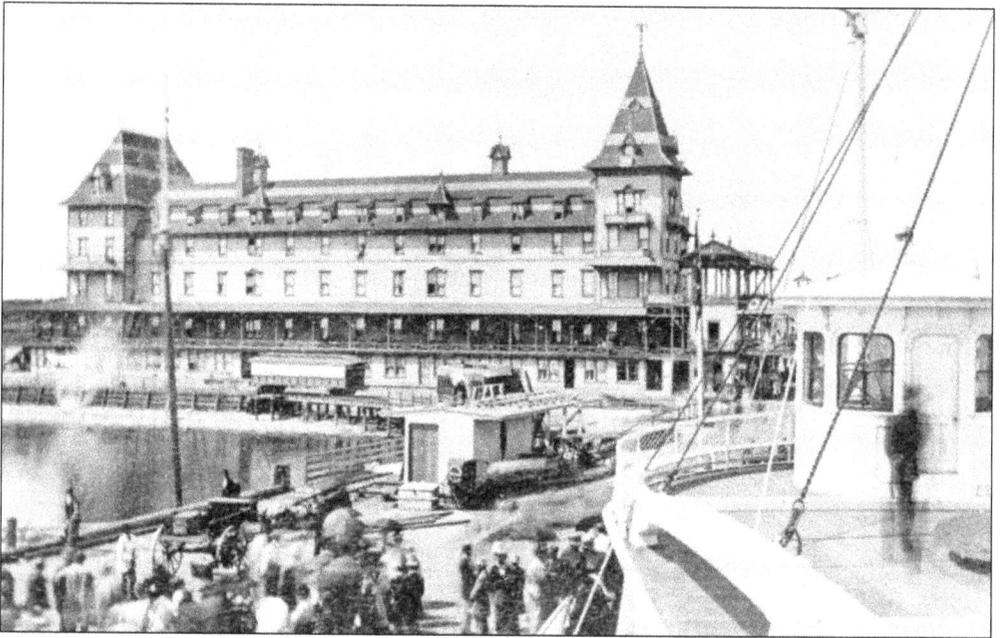

In this view, the *River Queen* is at the wharf at Cottage City. We are looking forward on the top deck toward the Seaview Hotel, which opened in 1872 and burned 20 years later. Clearly visible is the *River Queen's* circular or sentry box–style pilothouse. She was the only one of the island steamers with this type. Note the gilded eagle at her masthead. (Courtesy of John Boardman.)

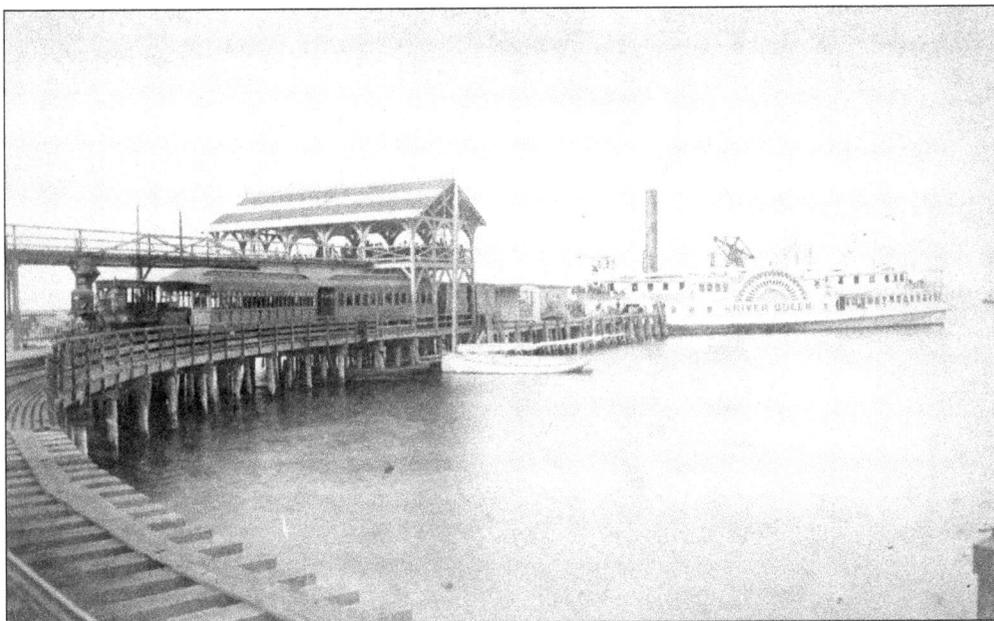

On a greatly expanded Cottage City wharf, a train is seen backed onto the wharf to receive passengers from the *River Queen*. The three-foot narrow-gauge Martha's Vineyard Railroad was built in 1874. It ran from Cottage City to Edgartown and on to Katama and South Beach. The railroad only lasted until 1896, but faint traces of the right-of-way can still be found on the island. (Courtesy of Bob Allen.)

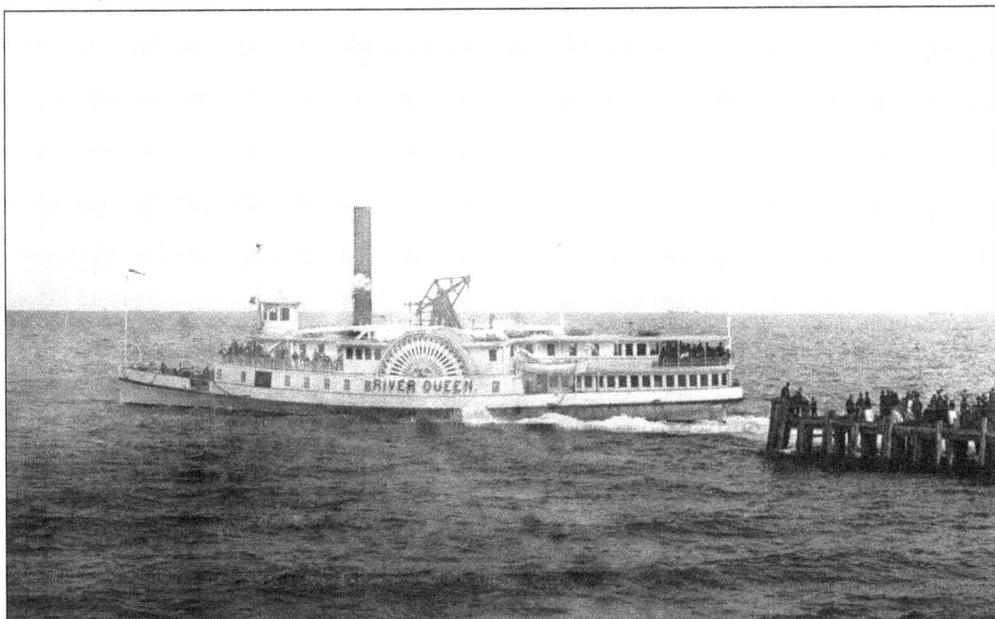

The *River Queen* is departing Cottage City. She shows the typical steep waves of a side-wheeler just getting underway. As she picks up speed, the wake from her paddle wheels will flatten out and lengthen. In 1886, when the Vineyard line and the Nantucket line merged, she became the property of the new company. In 1891, she was sold first to New York and then ended up on the Potomac River.

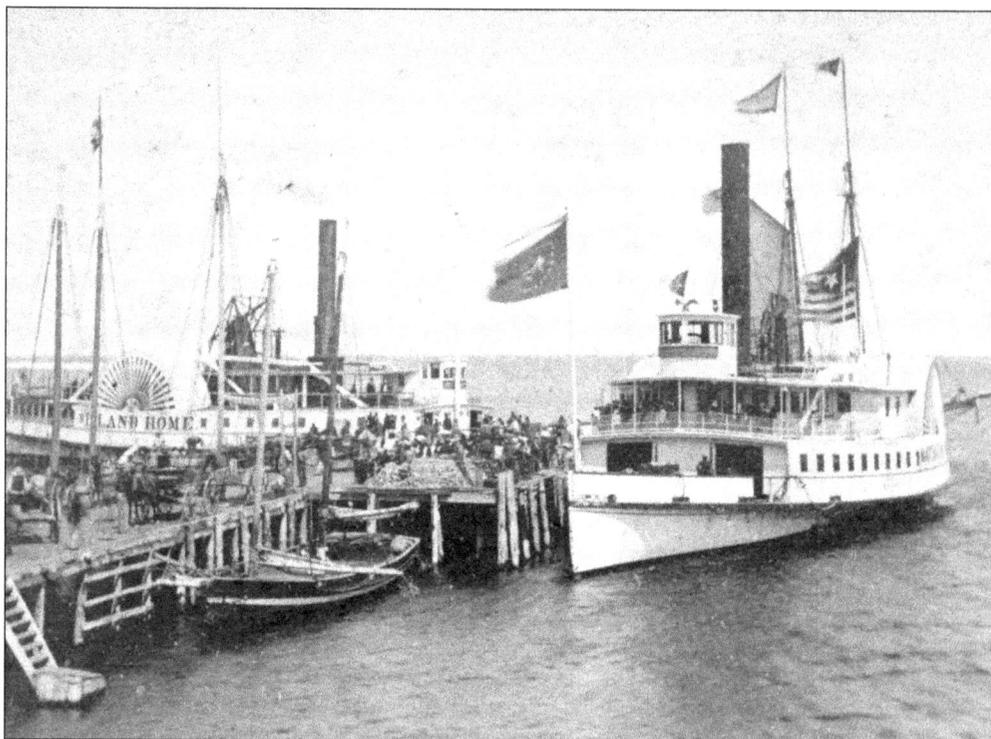

In 1871, the New Bedford, Vineyard, and Nantucket Steamboat Company built the steamer *Martha's Vineyard* for service to her namesake island. She was the last steamer the line built before it merged with the Nantucket and Cape Cod Steamboat Company. She is seen here at Cottage City along with the *Island Home*.

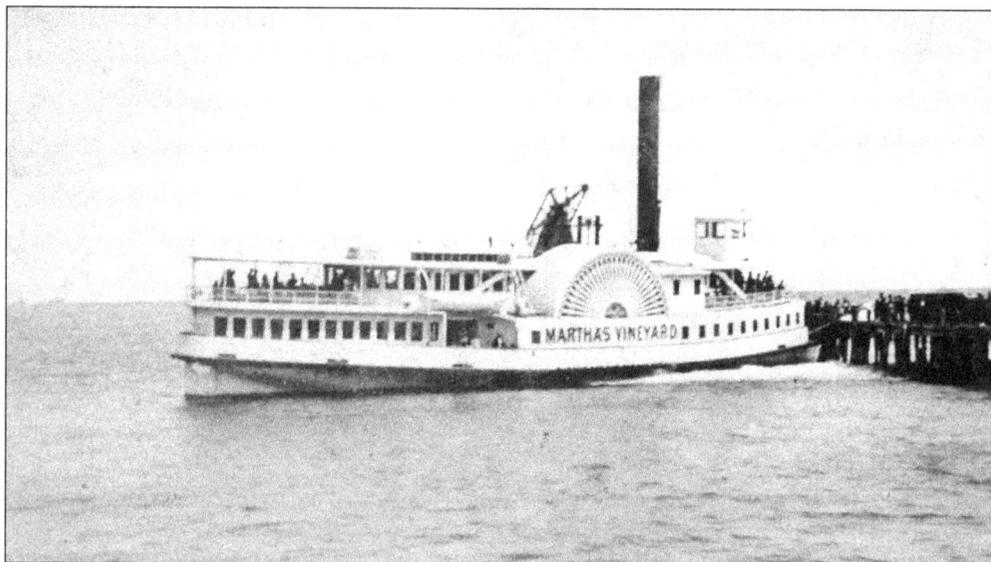

In this view, the *Martha's Vineyard* is backing around the wharf at Cottage City on a spring line. This kind of ship handling has pretty much disappeared with the advent of twin screws and bow thrusters. The Oak Bluffs Land and Wharf Company laid out the town of Cottage City, and the wharf was built in 1867. This is the same location as the present ferry wharf. (Courtesy of Rob Gatchell.)

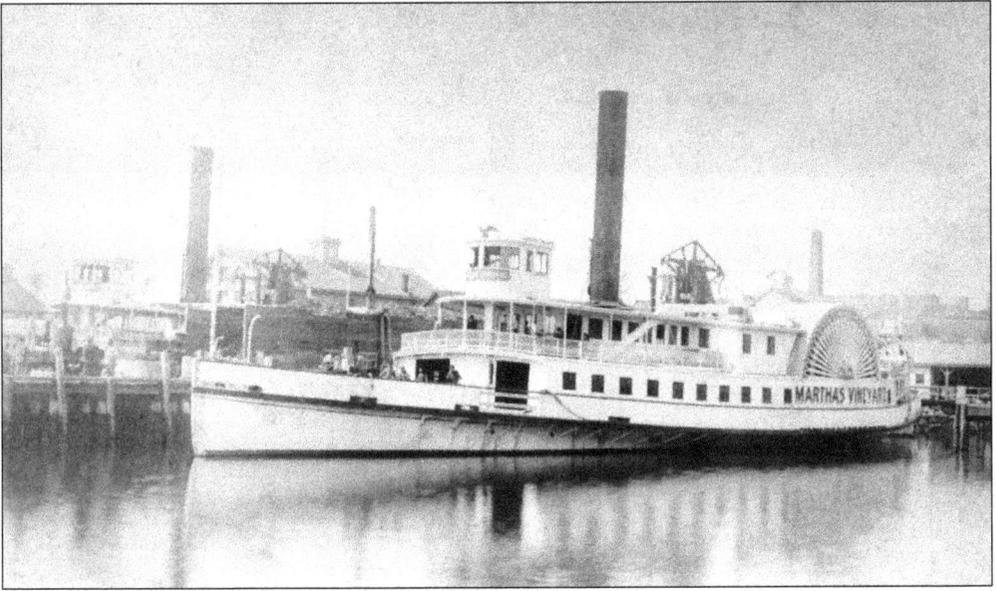

In this image, the *Martha's Vineyard* is tied up, bow facing out, at the steamboat wharf in New Bedford. On the other side of the wharf is the *Monohansett*. (Courtesy of Rob Gatchell.)

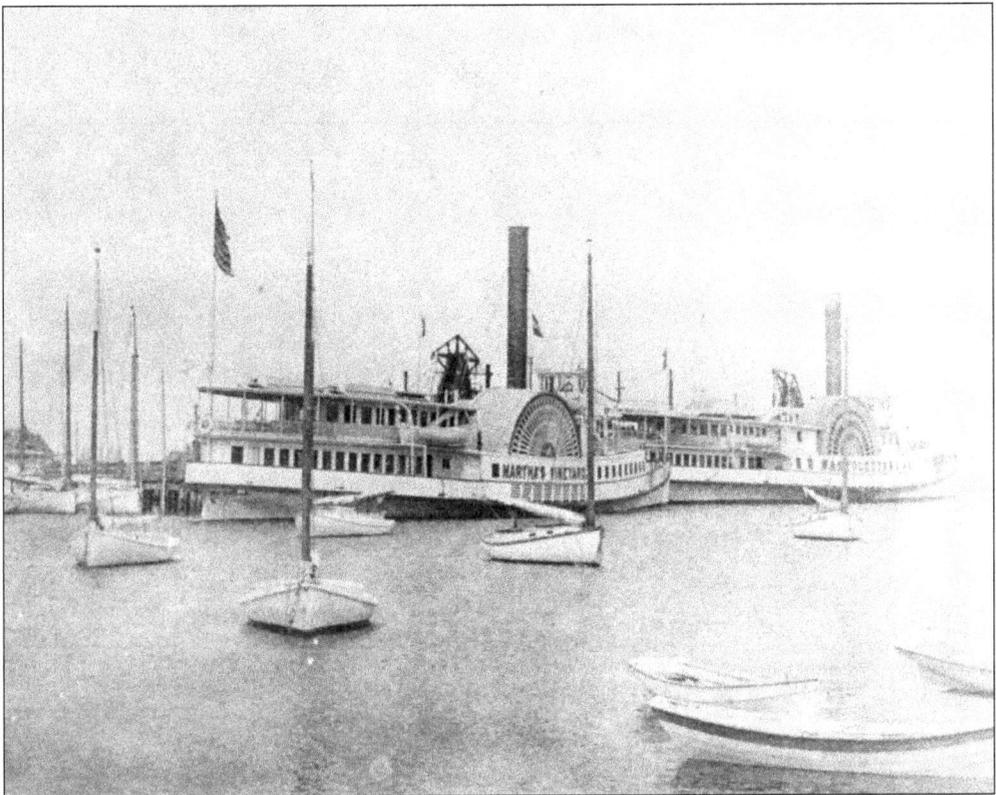

The *Martha's Vineyard* is at Steamboat Wharf in Nantucket. Tied up ahead of her is her newer fleet mate *Nantucket*.

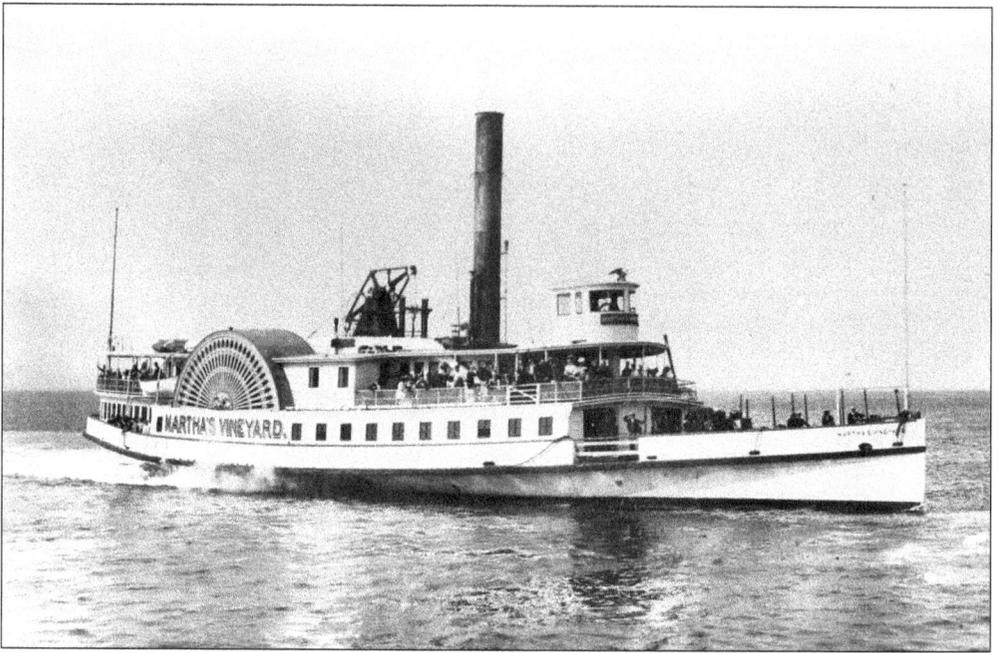

With a good load of passengers, the *Martha's Vineyard* has just backed away from a pier, probably at Cottage City, and is starting to go ahead.

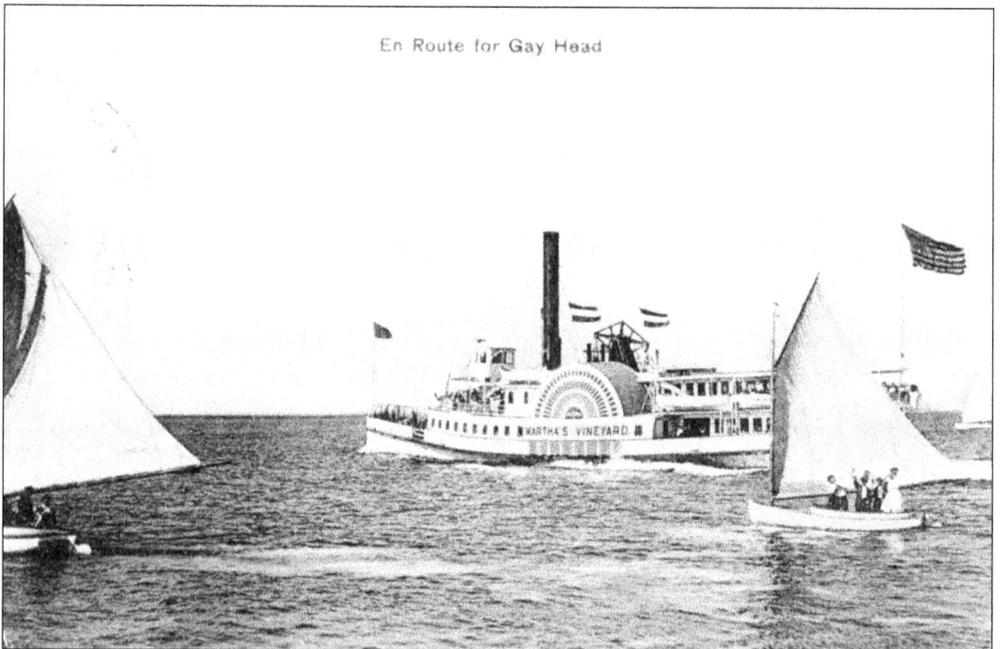

En Route for Gay Head

According to this postcard, the *Martha's Vineyard* is heading to Gay Head on an excursion. The people on the Beetle Cat to the right would be wise to sit down before the steamer's wake reaches them. (Courtesy of Bob Allen.)

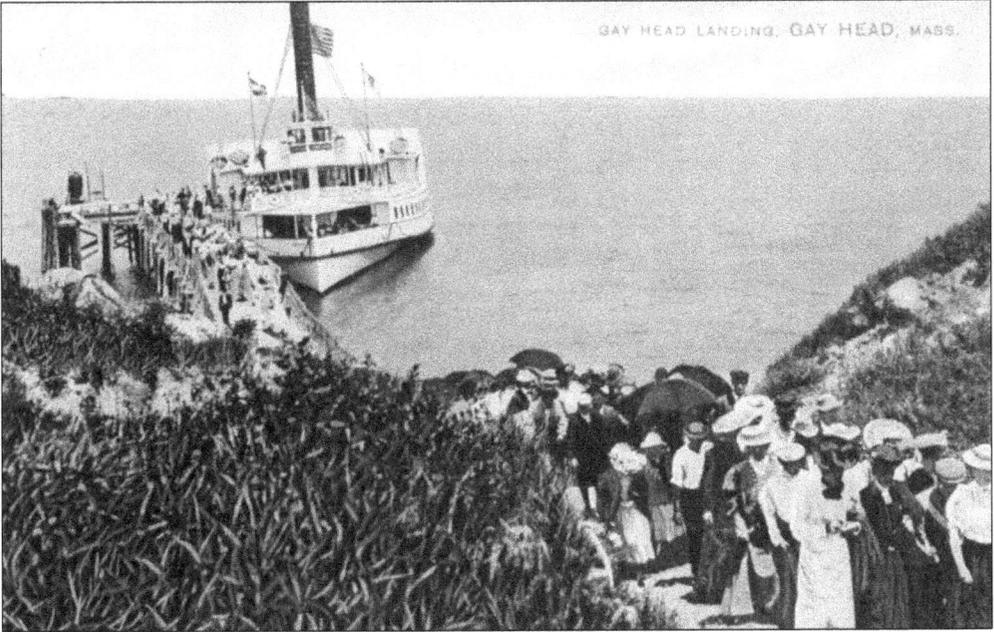

The landing at Gay Head, on the Vineyard, was not on the regular schedule but rather was an excursion destination. People came to see the impressive multicolored cliffs and to visit the lighthouse. The *Martha's Vineyard* is seen here discharging passengers at the wharf.

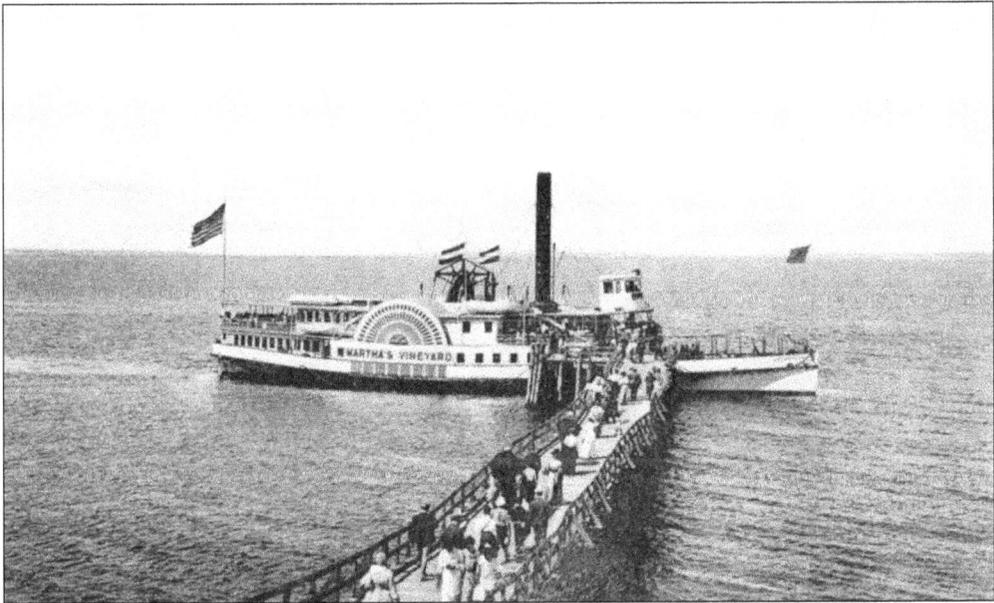

On another trip, the *Martha's Vineyard* is loading passengers at Gay Head, now called Aquinnah. By the turn of the 20th century, she had become a spare boat and was used mostly for excursions.

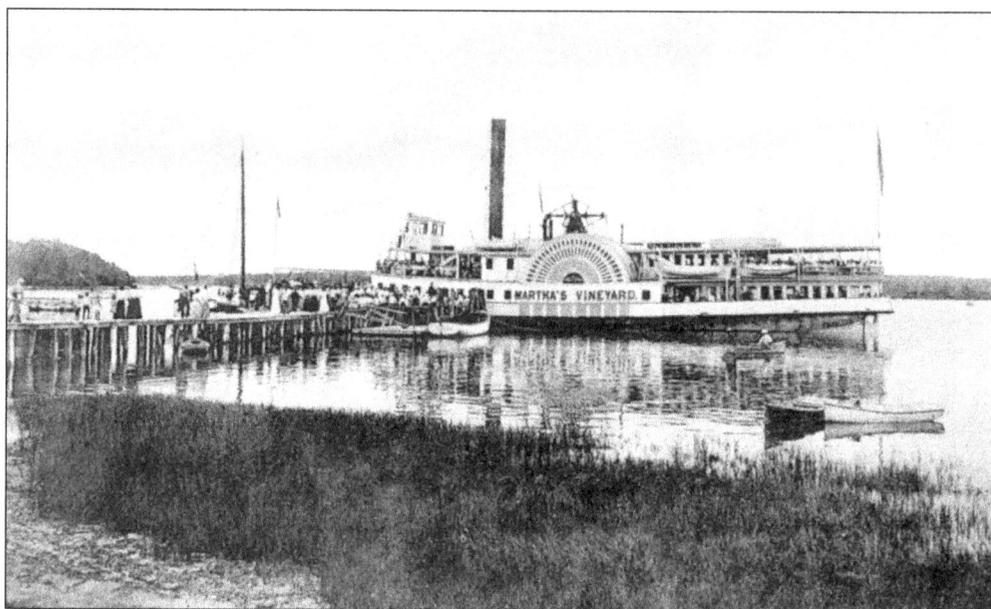

This postcard shows the *Martha's Vineyard* late in her career, at Onset. As mentioned earlier, Onset was only visited by the steamers on excursion trips and was not on the regular schedule. In 1912, the *Martha's Vineyard* was chartered for use as an excursion steamer in New York. The following year, she was chartered for the same use in Boston. (Courtesy of John Boardman.)

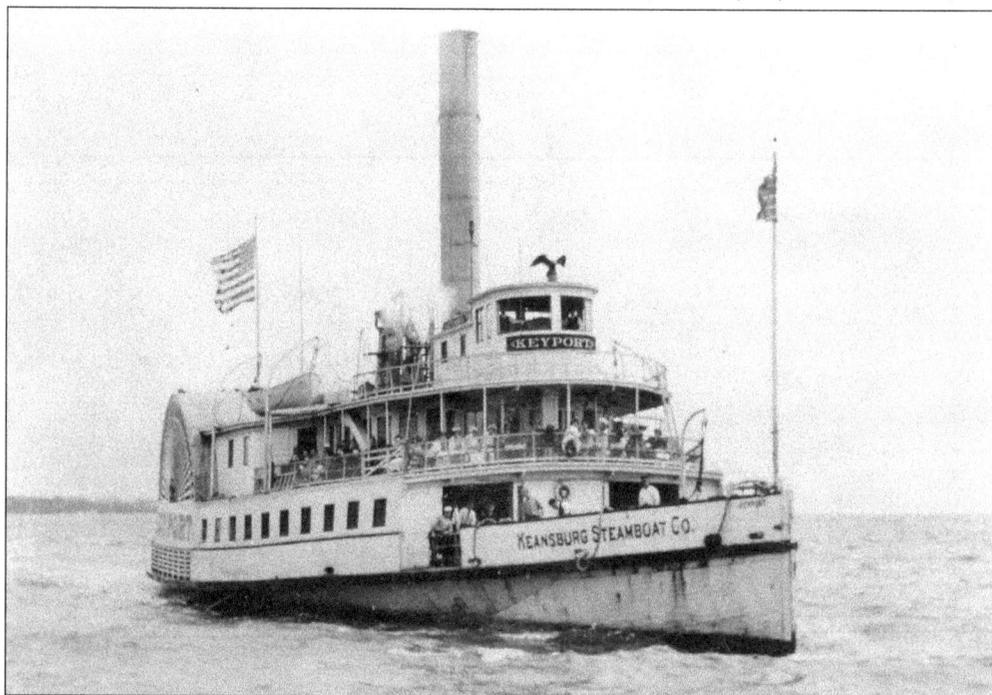

In 1913, the *Martha's Vineyard* was sold to the Keansburg Steamboat Company of New Jersey and renamed *Keyport*. She is seen here in that service, looking rather tired. In 1916, she was rammed by a lighter at the battery at the southern tip of Manhattan and sank at the seawall there. That was the end of her career.

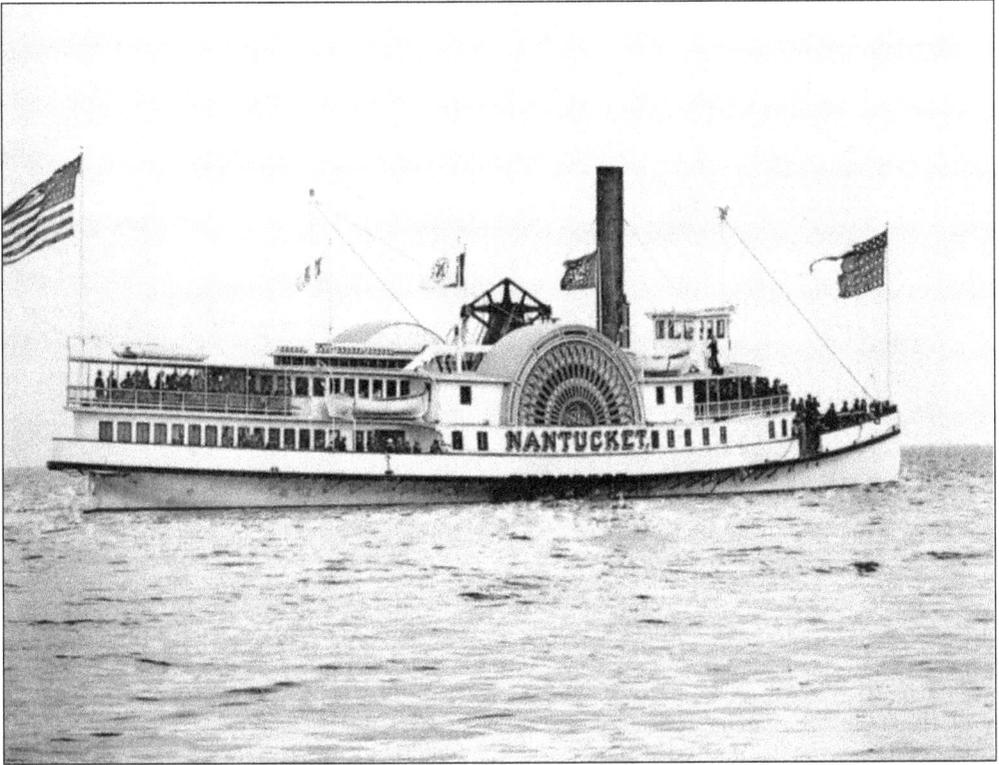

After the two boat lines consolidated, the new company immediately ordered a new steamer to ultimately replace the *Island Home* on the Nantucket run. She was the 190-foot *Nantucket* and was built by Pusey and Jones in Wilmington, Delaware. Her first trip to her namesake island was on Saturday, July 31, 1886. In this view, her graceful lines are quite evident.

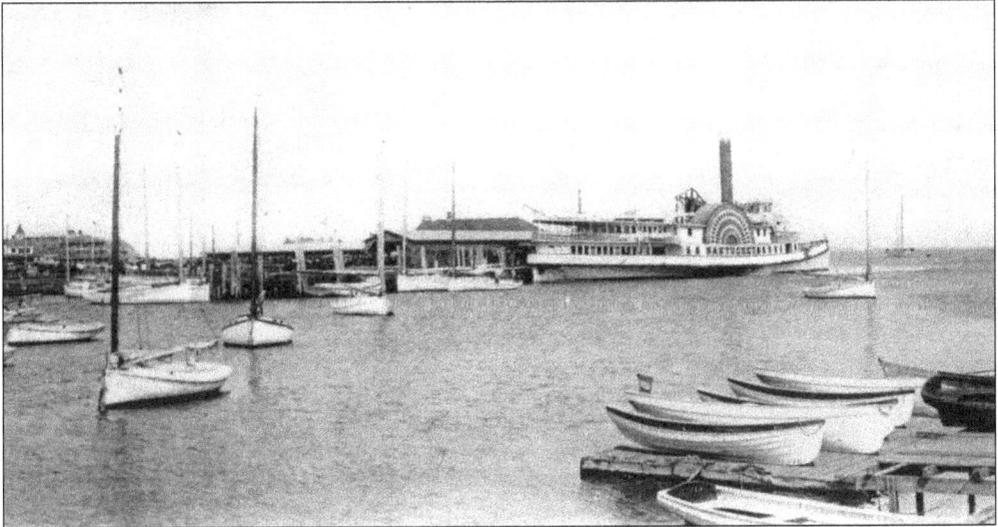

This postcard view shows the *Nantucket* alongside Steamboat Wharf at Nantucket. When she arrived here on her first trip, a huge crowd greeted her. Two days later, she made a test run from Nantucket to Martha's Vineyard in the face of a strong gale. In spite of the storm, she made the trip in two and a half hours.

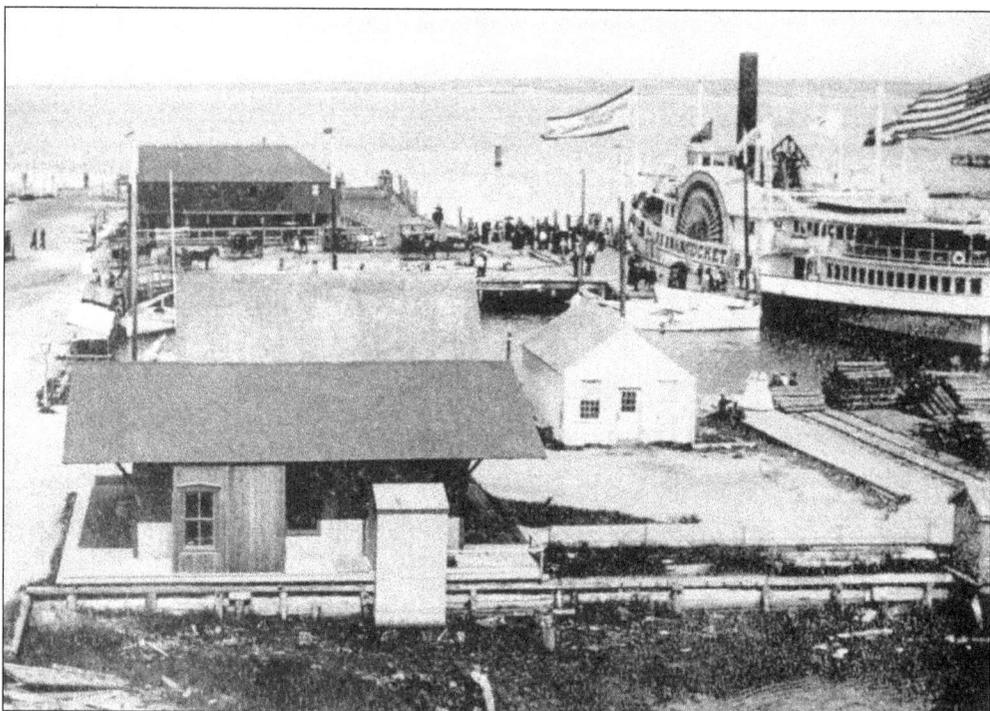

With flags flying, the *Nantucket* waits alongside Steamboat Wharf at Nantucket. Note the railroad tracks ending at a pile of railroad ties on the right. In 1881, Nantucket got its own three-foot narrow-gauge railroad to connect with the steamers.

The Nantucket Railroad ran from the wharf in town to the small fishing community of Siasconset on the other side of the island. The train was nicknamed the *Twentieth Century Limited*, and it was jokingly said that it would make a mile in more than 20 minutes and would stop for anything. The line closed in 1917, and the rails and equipment were sent to France during World War I. (Courtesy of John Boardman.)

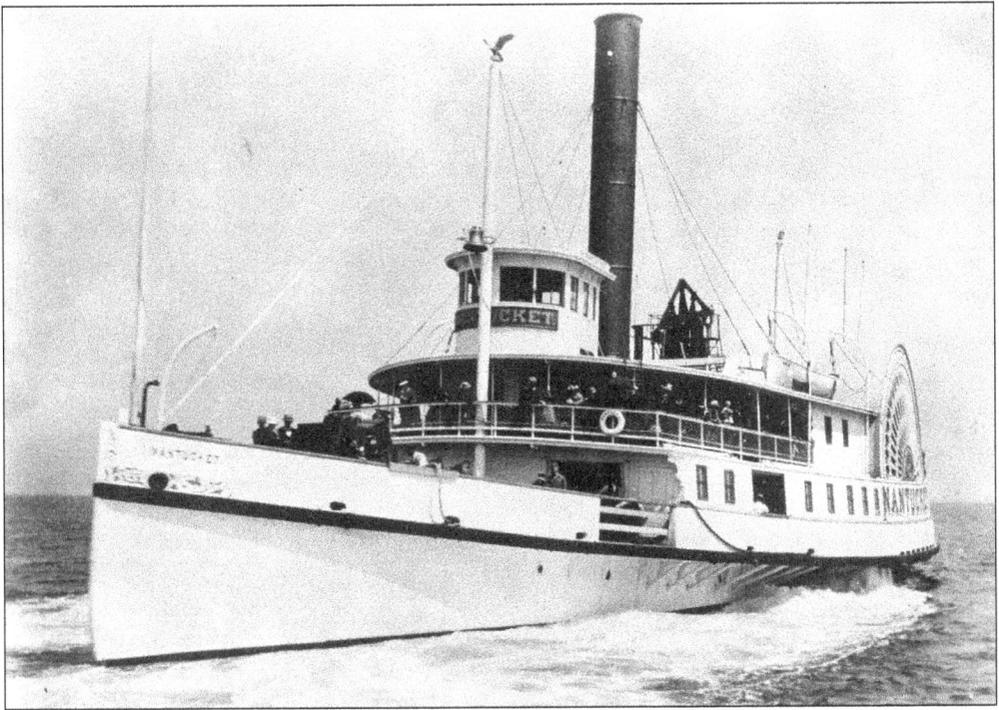

The *Nantucket* is backing away from a wharf, probably at Cottage City. The open deck in the bow was used for carriages, and later automobiles, as well as other freight. Smaller freight was stowed inside on the main deck, just aft of the open bow.

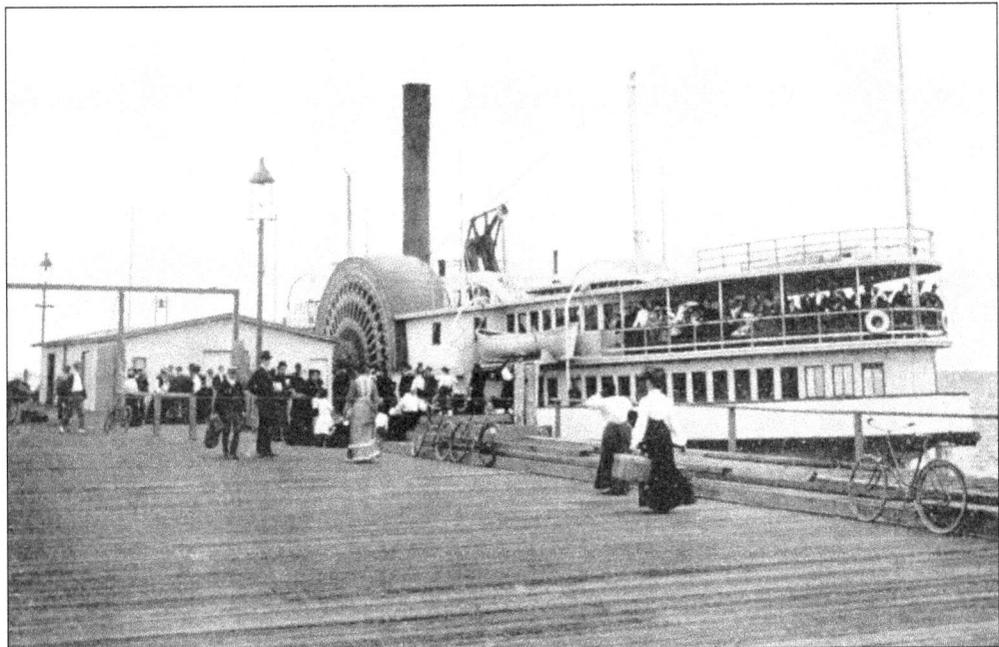

The *Nantucket* is taking on passengers on the south side of the wharf at Cottage City. It appears that the railroad has been removed, dating this view after 1896. Today, bicycles are a popular form of transportation on both islands, and it looks as if that was true over 100 years ago.

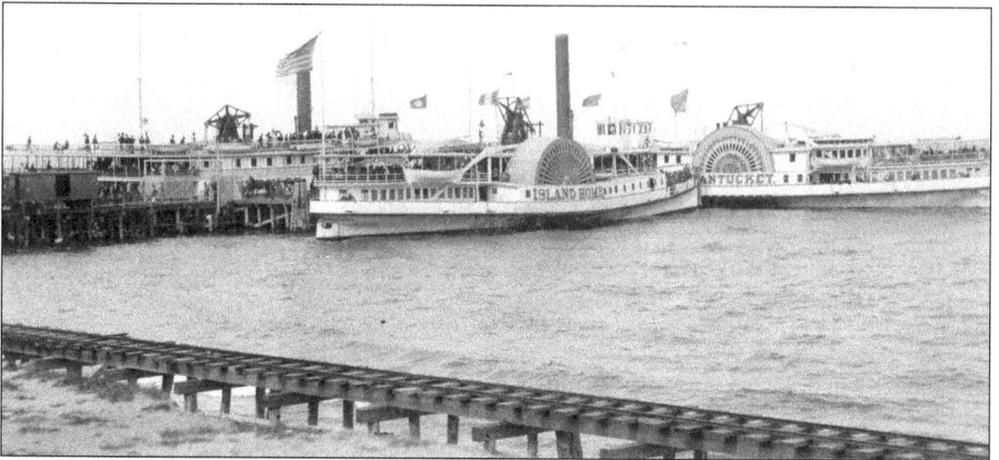

In this unusual view, the *Island Home* and *Nantucket* are at the wharf at Cottage City. On the far side is the larger steamer *Mount Hope*, visiting from Rhode Island. She was built in 1888 and ran between Providence, Newport, and Block Island. (Courtesy of Mark Snider.)

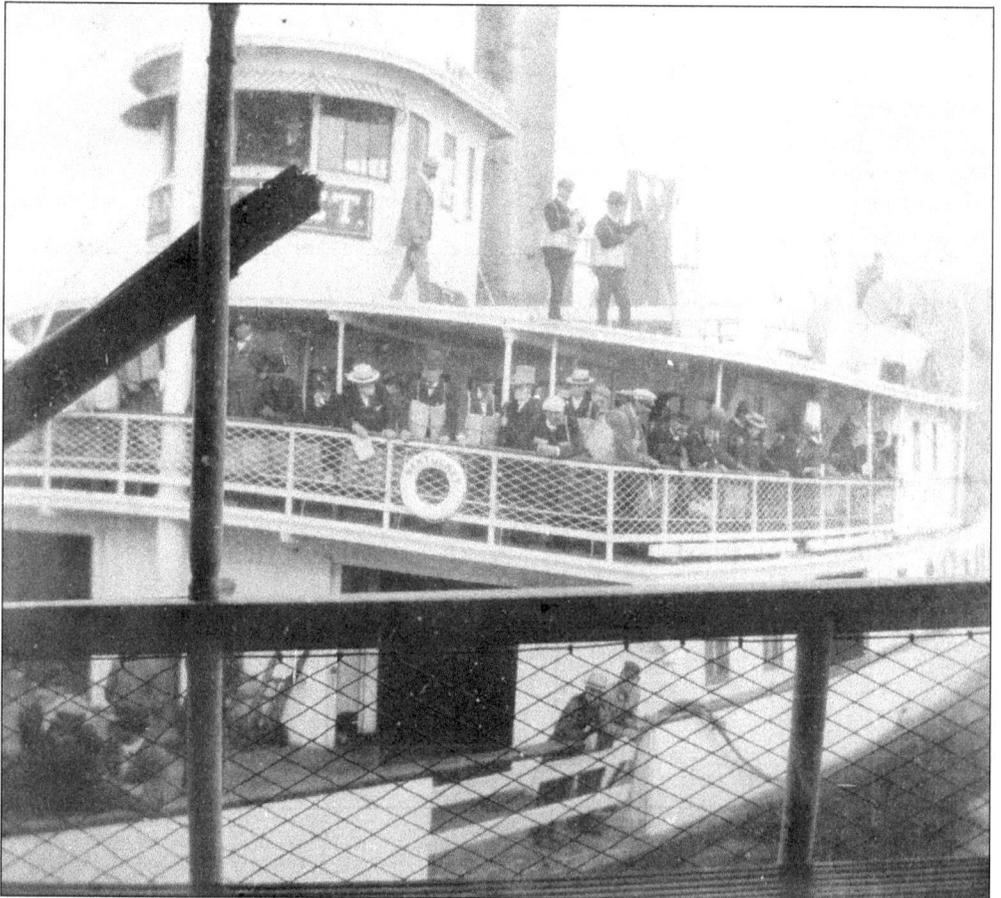

On July 8, 1898, the *Nantucket* and the *Gay Head* collided off Nobska Point. In this view taken from the *Gay Head*, the two steamers have not separated yet, and passengers on the *Nantucket* have donned life jackets. (From the collections of the Martha's Vineyard Museum.)

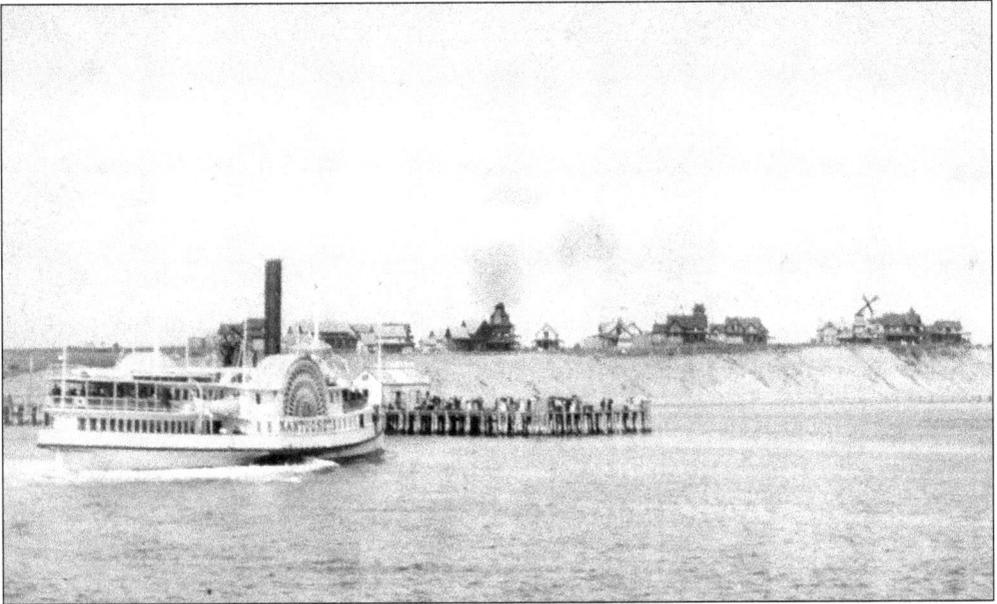

The *Nantucket* is approaching the Highland Wharf at Cottage City. Her engines have stopped, and the drag of her paddle wheels will quickly slow her forward motion. This wharf was built to serve the Vineyard Highlands section of town, but people attending the camp meetings at Wesleyan Grove also used it. A horsecar line ran from here into the Campground. Beyond are the bluffs at East Chop. (Courtesy of Mark Snider.)

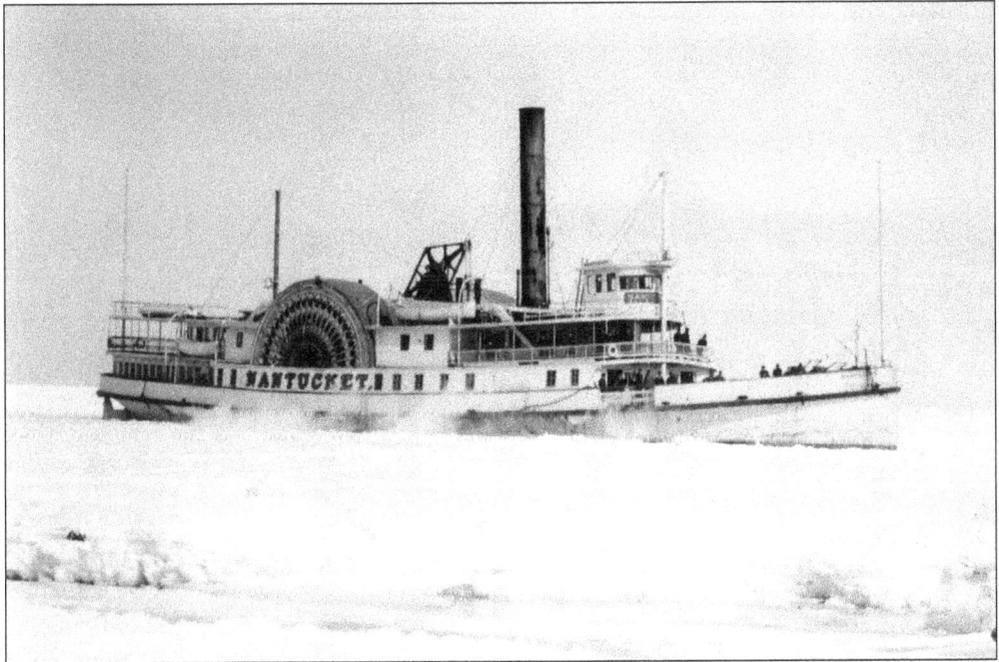

In the early 20th century, there were a number of freeze-ups that blocked Nantucket harbor, often leaving the island without service for weeks. In this view, the *Nantucket* is bucking the ice off of Brant Point. On occasion the steamers were unable to get any farther than this, and freight and passengers had to be transferred across the ice. (Courtesy of Rob Gatchell.)

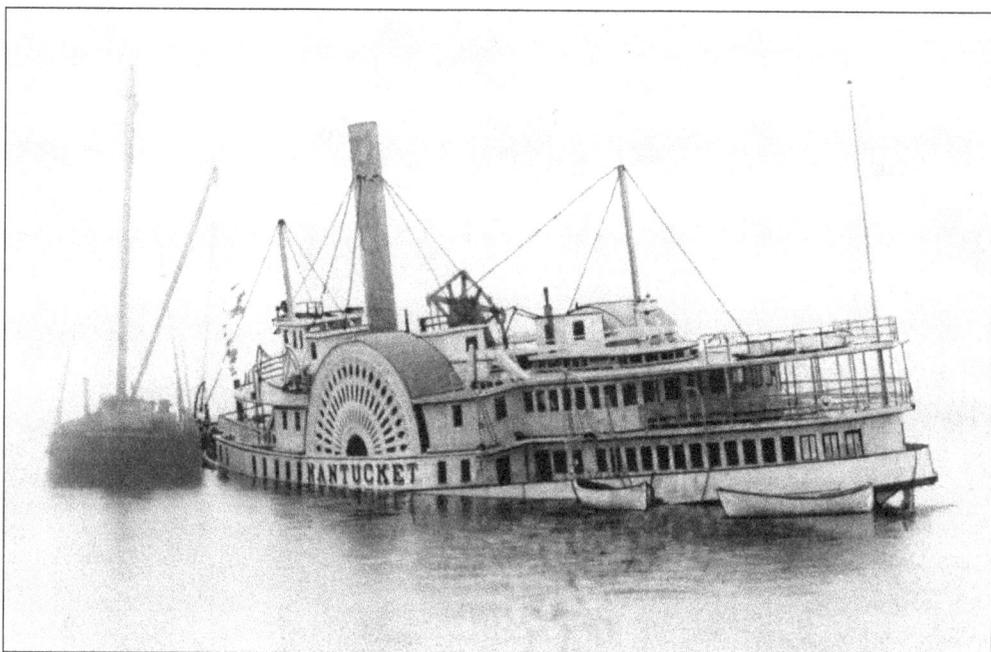

In January 1909, the *Nantucket* was proceeding in a thick fog and ran onto the rocks off of Nobska Point. She was refloated and continued in service for several more years. This photograph has been retouched to bring out some details, probably for newspaper use at the time. (Courtesy of Mark Snider.)

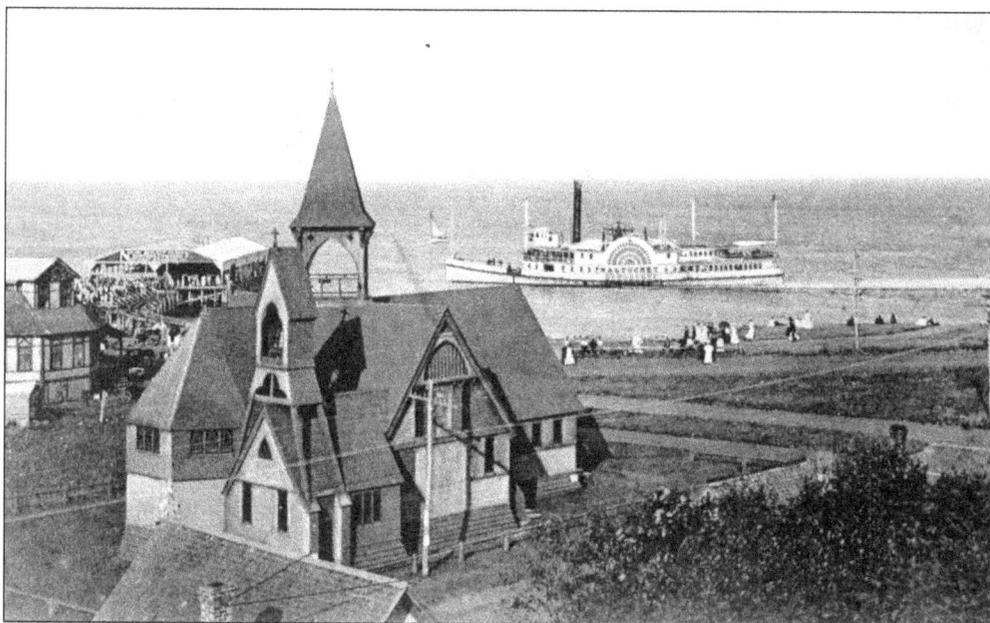

By the time of this postcard, Cottage City had been renamed Oak Bluffs. The *Nantucket* is gliding up to the wharf on a return trip from Nantucket. In the foreground is Trinity Episcopal Church, which still stands. In 1913, along with the *Martha's Vineyard*, the *Nantucket* was sold to the Keansburg Steamboat Company for use as an excursion boat in New York waters. Keansburg Steamboat Company renamed her *Point Comfort*. (Courtesy of Bob Allen.)

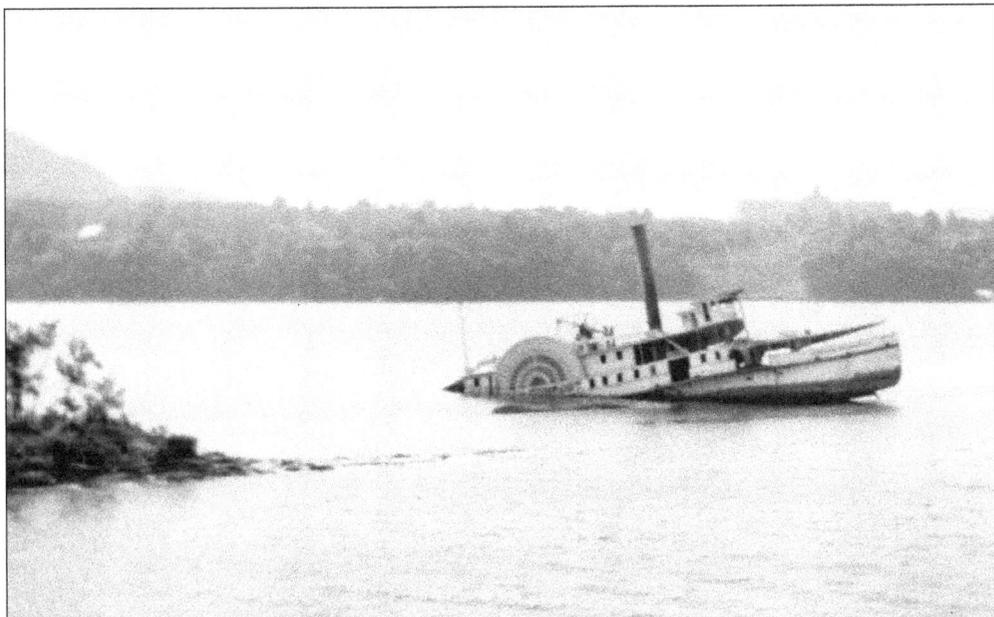

In 1919, a group of Catskill businessmen chartered the *Point Comfort* for freight service to their village. On her second trip on the Hudson River, she was wrecked in fog on the north end of Esopus Island. A woman whose estate overlooked the river asked her friend, Gov. Franklin Roosevelt, to have the "unsightly" wreck removed. Today, some of her timbers remain underwater, and divers have found some of her crockery.

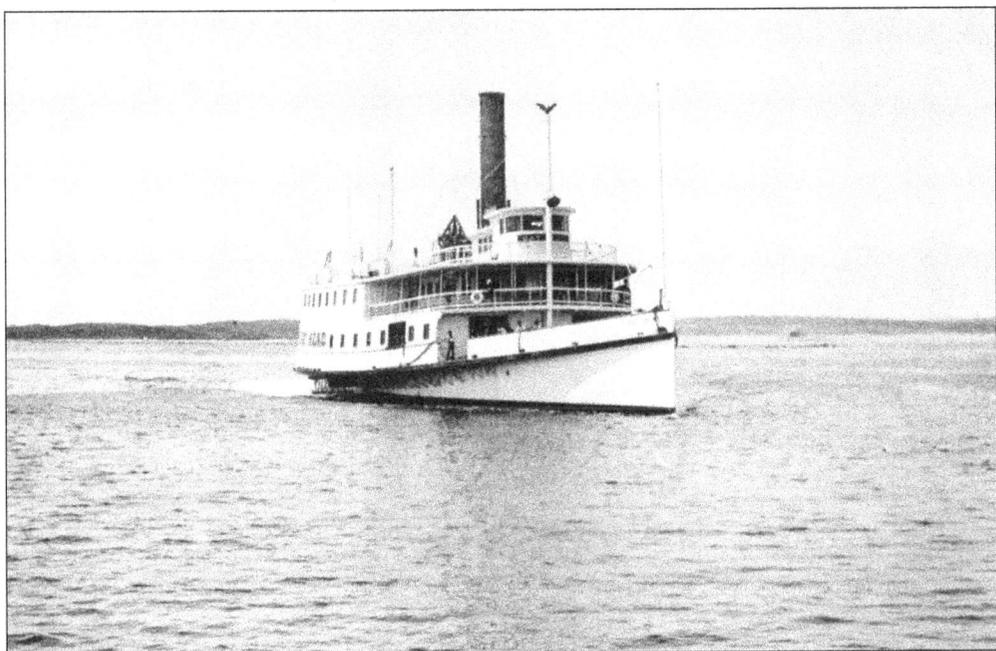

In 1890, the steamboat company ordered a new steamer to eventually replace the *Monohansett*. She was named *Gay Head* and was built by Pusey and Jones. She made her first trip on July 8, 1891. At 203 feet, she was the largest side-wheeler to run to the islands in regular service. This view shows her coming into Woods Hole about 1895.

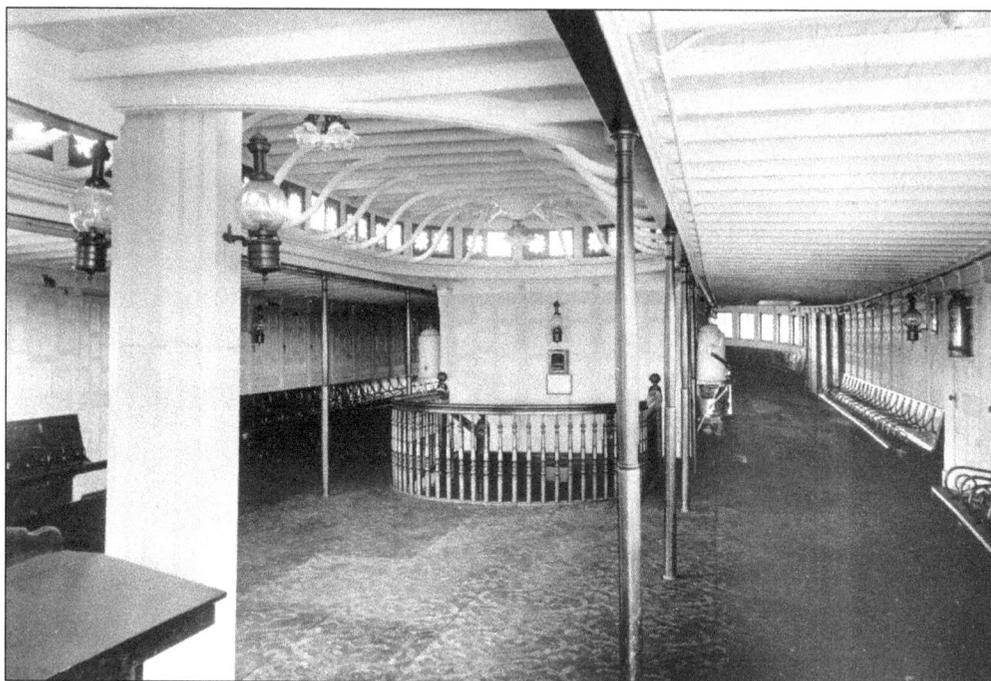

Although less elegant than the big night boats, the *Gay Head's* interior was quite comfortable. She had black walnut and maple woodwork with gold trim and a beautiful carved staircase. This view shows her saloon deck looking forward. Note the tanks of drinking water on each side. She appears to have both oil and electric lights. On this deck, there were 10 private day staterooms available for passengers to hire. (Courtesy of the New Bedford Whaling Museum.)

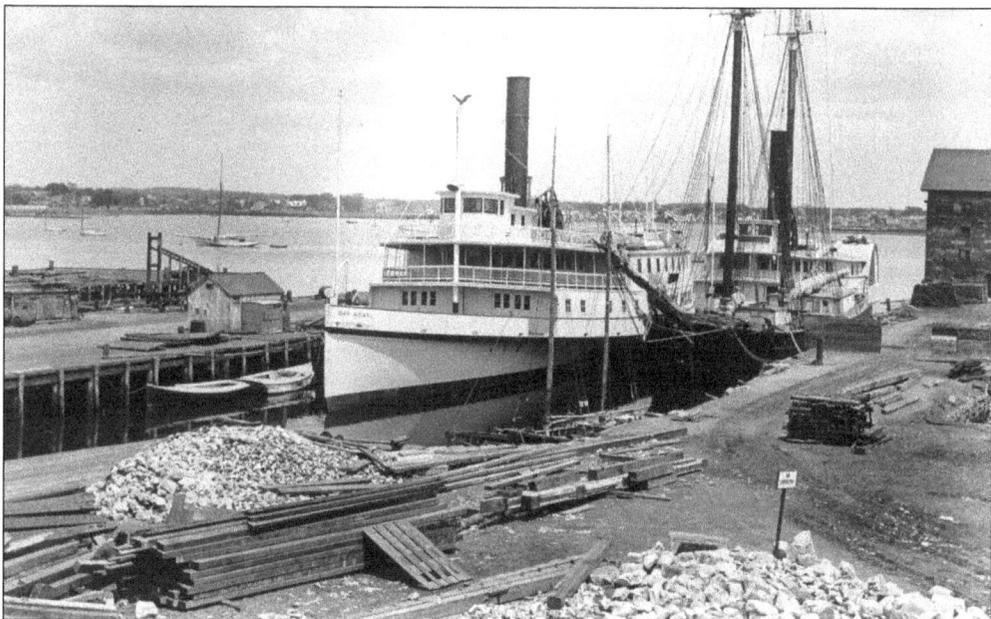

Here, the *Gay Head* is at New Bedford, probably when quite new. She and the older *Martha's Vineyard* are being made ready for the summer season. The piles of stones in the foreground are probably for rebuilding the wharves.

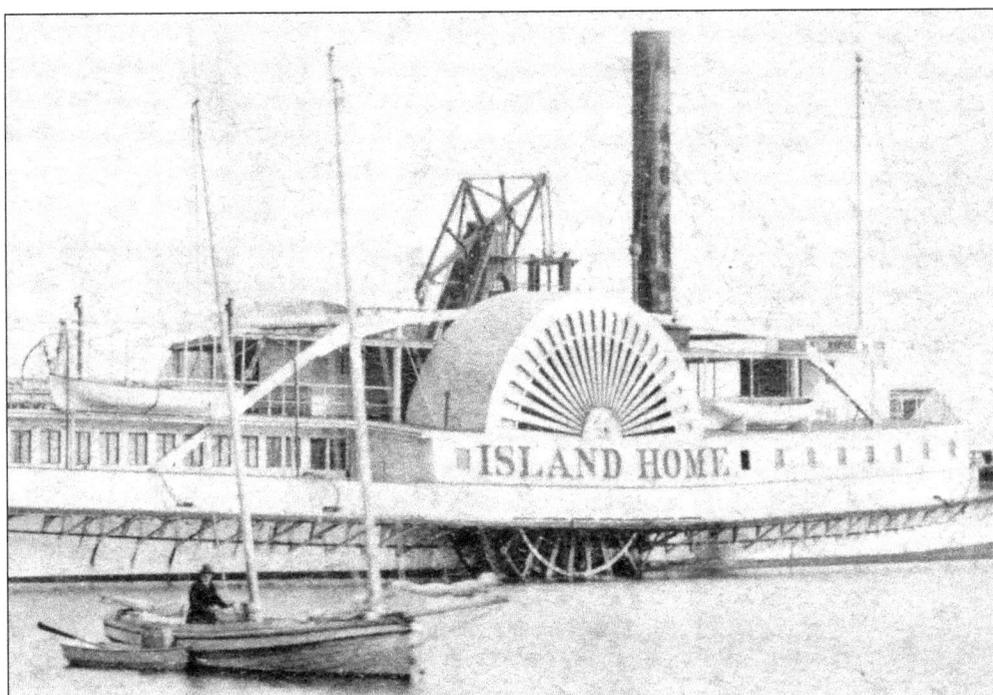

The *Gay Head* was a departure from previous side-wheelers built for island service. She had feathering paddle wheels as opposed to the older radial wheels. As seen here on the *Island Home*, radial wheels had fixed buckets, or paddles. The wheels had to be quite large to be efficient. The buckets on feathering wheels were hinged with attached rods. This design enabled them to enter and leave the water vertically. (Courtesy of Rob Gatchell.)

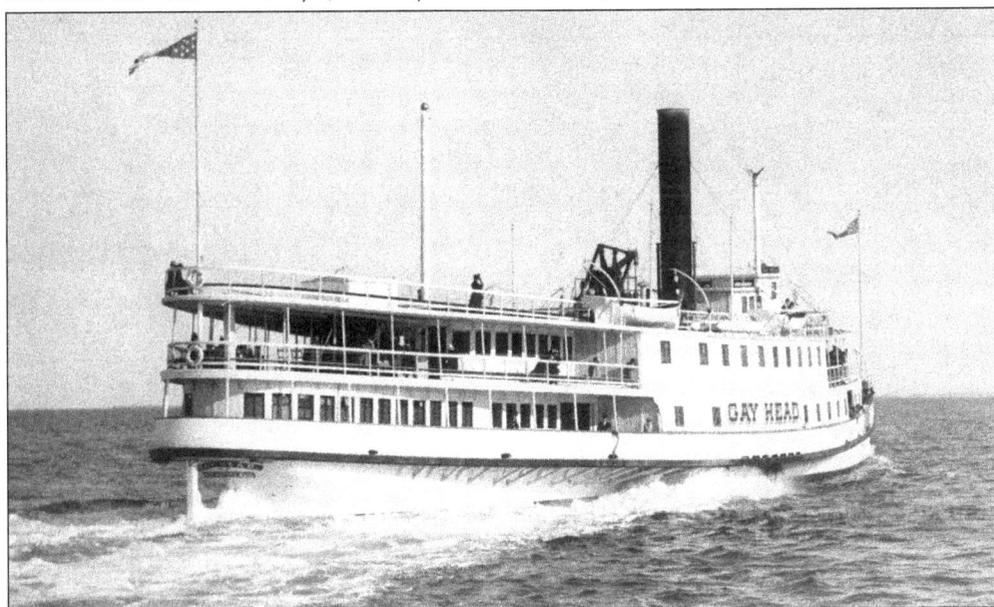

With her smaller, more efficient feathering wheels, the *Gay Head*'s side-wheels were contained within the superstructure. Large decorated paddle boxes became a thing of the past as steamers with feathering paddle wheels became more common. (Courtesy of Mark Snider.)

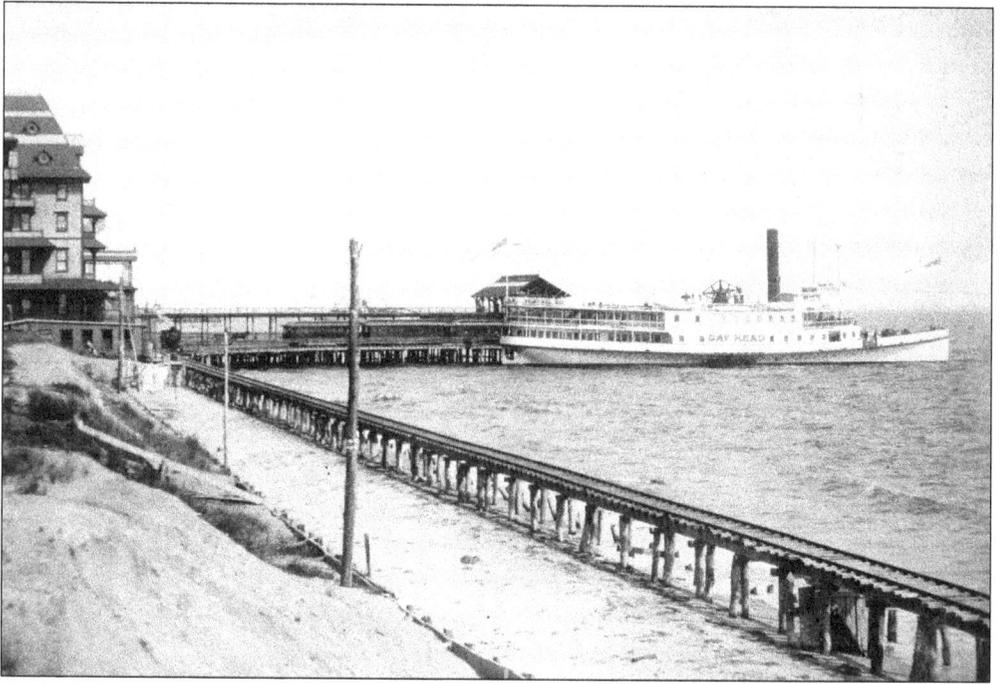

In this view at Cottage City, the *Gay Head* is less than a year old. The Seaview Hotel, on the left, burned in 1892, the year after the *Gay Head* entered service. The trestle along the beach, for the narrow-gauge railroad, is plainly visible in the foreground.

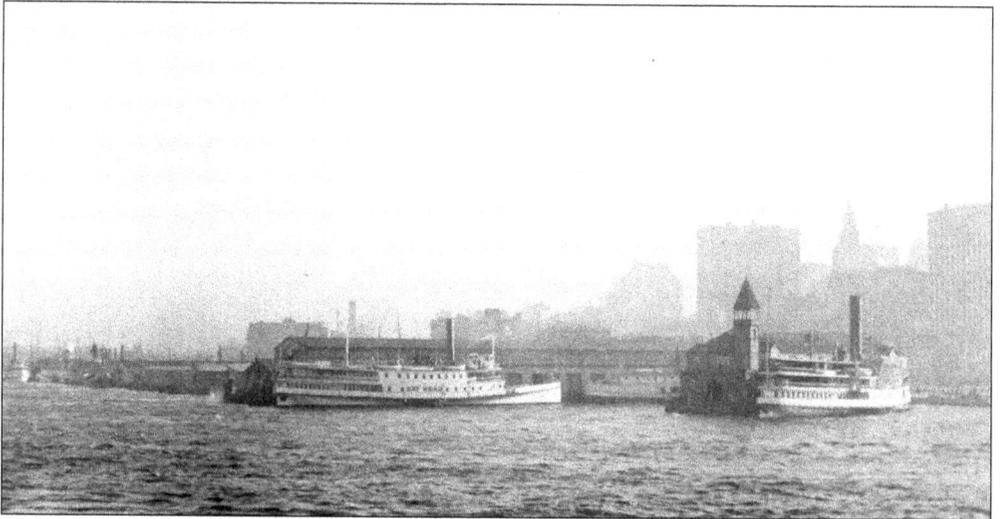

The *Gay Head* was chartered for use as a spectator boat for every America's Cup race from 1893 to 1903. At that time, the races were held off of Sandy Hook, New Jersey. This unusual view shows her at Pier No. 1 in New York during one of those charters. With the exception of Pier A, with the tower, all of the wharves visible here are now gone. (From the collections of the Martha's Vineyard Museum.)

The Old Colony, and later the New Haven Railroad after it gained control of the former, had a large maintenance facility and wharves for its marine divisions, located at Long Wharf in Newport, Rhode Island. Eventually, almost everything that could be done above the waterline was done here. In this photograph, the *Gay Head* is in for some work. The large scissor crane behind her was used for replacing boilers and machinery.

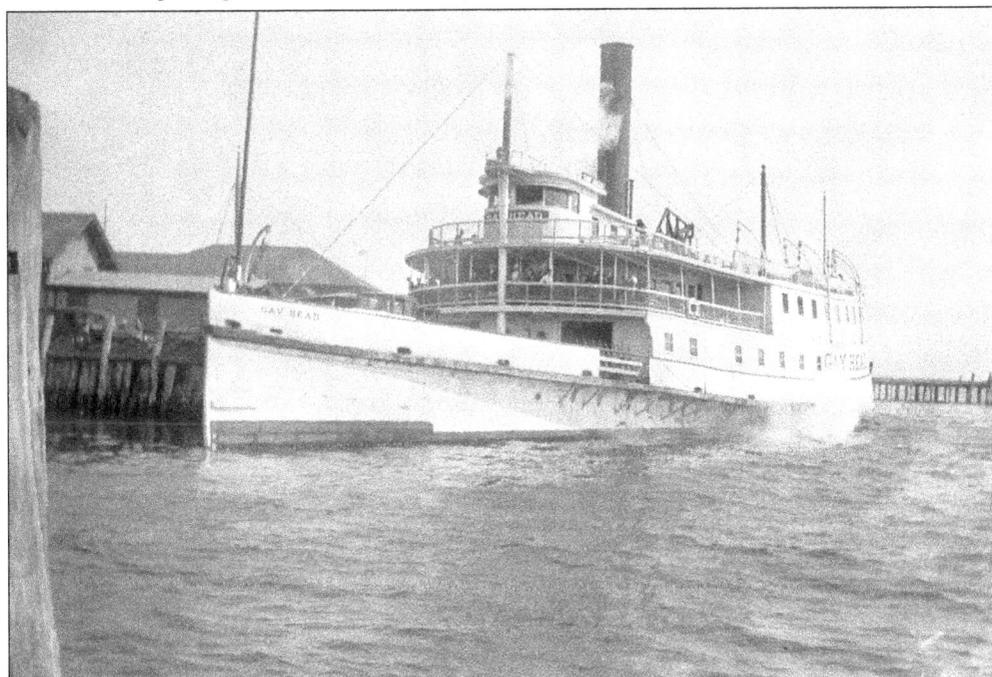

The *Gay Head* is seen at Woods Hole at the end of her career running to the islands. She is looking a bit tired. Note that automobiles are starting to show up as freight on the open bow deck. (Photograph by Harold Streeter; courtesy of Rosemary Bottum.)

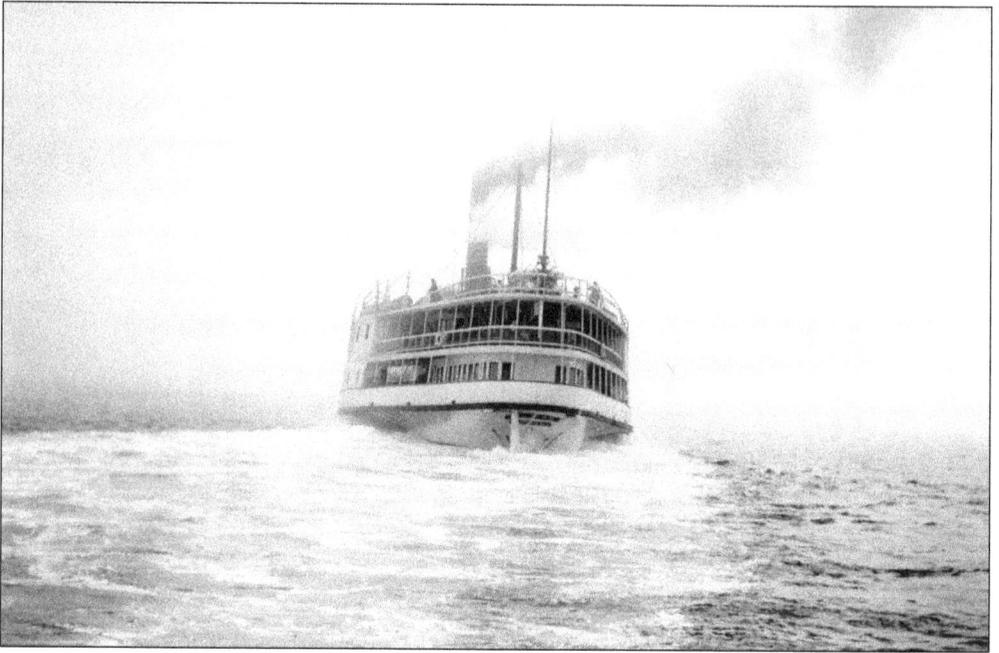

In this wonderfully atmospheric photograph, the *Gay Head* is leaving Woods Hole on August 8, 1923, her last day of service. She is disappearing into a thick fog, on her way back to New Bedford. The steam visible half way up her stack is from her whistle as she blows warnings in the fog. The next day, she steamed to Newport and was laid up. (Photograph by William K. Covell; author's collection.)

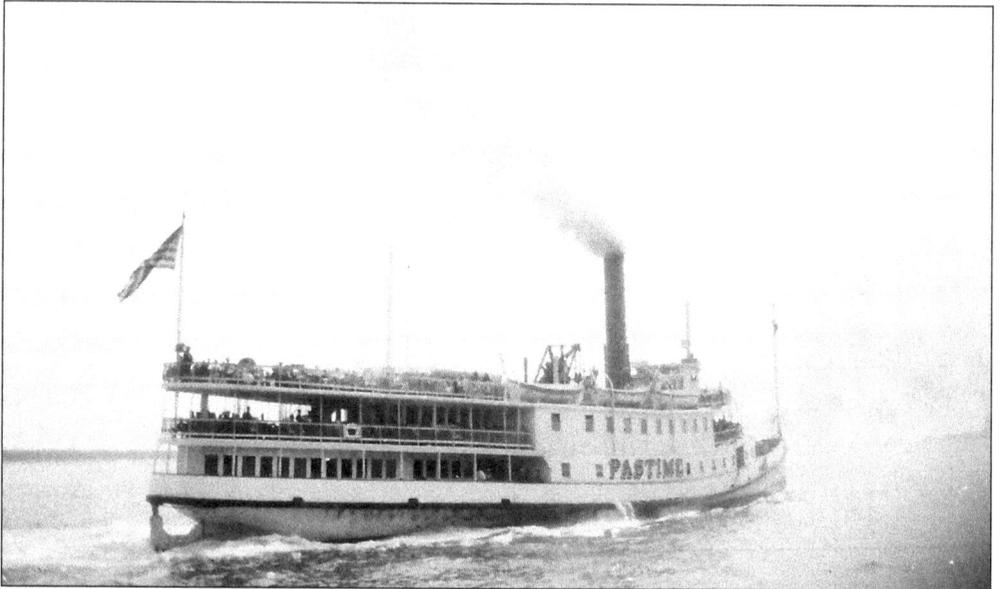

The *Gay Head* was sold in 1924 to Charles Dimon of New York. Renamed *Pastime*, she was used for excursions on the Connecticut and Hudson Rivers. In this view, she is in New York harbor. After being laid up at Newburgh, she was towed to Sheepshead Bay on Long Island Sound, and became derelict. In 1931, she was removed to Jamaica Bay and burned. (Courtesy of the Hudson River Maritime Museum; Wilton Collection.)

Three

STEEL HULLS, SCREW PROPELLERS, AND THE NEW HAVEN RAILROAD

Between 1891 and 1900, the New Bedford, Martha's Vineyard, and Nantucket Steamboat Company sold three of its older steamers, the *River Queen*, *Island Home*, and *Monohansett*. In 1902, the company had the *Uncatena*, built at the Pusey and Jones shipyard in Wilmington, Delaware. She was the first steel-hulled steamer and the last side-wheeler built for island service.

The last steamer built by the line as an independent company was the *Sankaty* of 1911. She was notable in that she was the first propeller steamer built for the service and set the trend for all subsequent island vessels.

The Old Colony Railroad was the controlling stockholder in the steamboat company but did not own it. In 1893, the New Haven Railroad leased the Old Colony, and at that time, New Haven Railroad took over the latter's stock in the steamboat company. The directors of the steamboat line still had quite a bit of independence. That all changed in 1911. The New Bedford, Martha's Vineyard, and Nantucket Steamboat Company's finances were strained, probably due in part to the cost of building the *Sankaty*. That year, they sold out to the New Haven Railroad. While the company name was retained, it ceased to be a local, independent operation. It was now owned by the New England Navigation Company, a holding company whose stock was wholly owned by the railroad. The island line was now a piece of the New Haven's transportation empire.

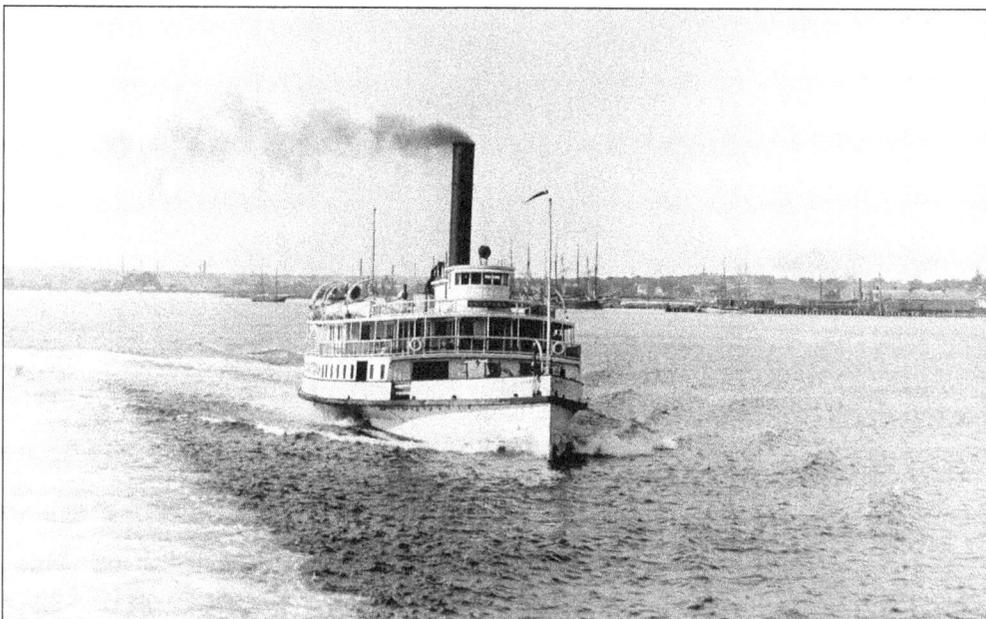

In 1902, the New Bedford, Martha's Vineyard, and Nantucket Steamboat Company needed a replacement steamer for the *Monohansett*. The company contracted with the Pusey and Jones Shipyard to build the 178-foot steel-hull *Uncatena*. In this fine image, she is leaving New Bedford and has just crossed the wake of another side-wheel steamer. This photograph was made into a postcard with everything but the ship and water removed. (Courtesy of the New Bedford Whaling Museum.)

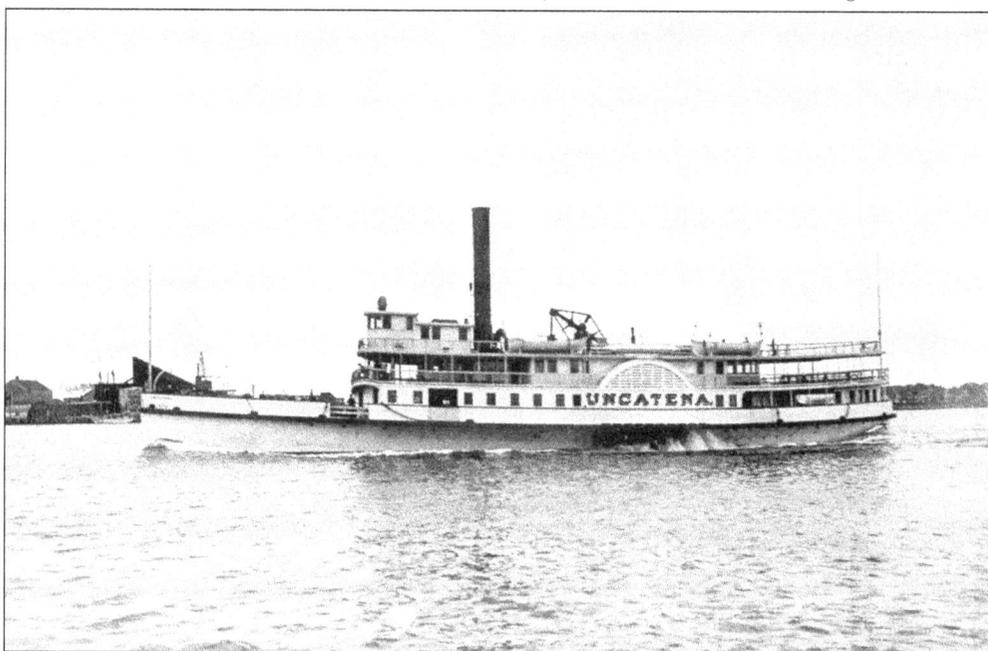

Although the *Uncatena* had feathering paddle wheels, she had a decorative paddle box above her name as a nod to the past. She was the last of the island steamers to have an open bow deck for freight and was the first to be equipped with a searchlight. On the night of her first visit to Nantucket, October 31, 1902, her searchlight was demonstrated, much to the delight of visitors.

46

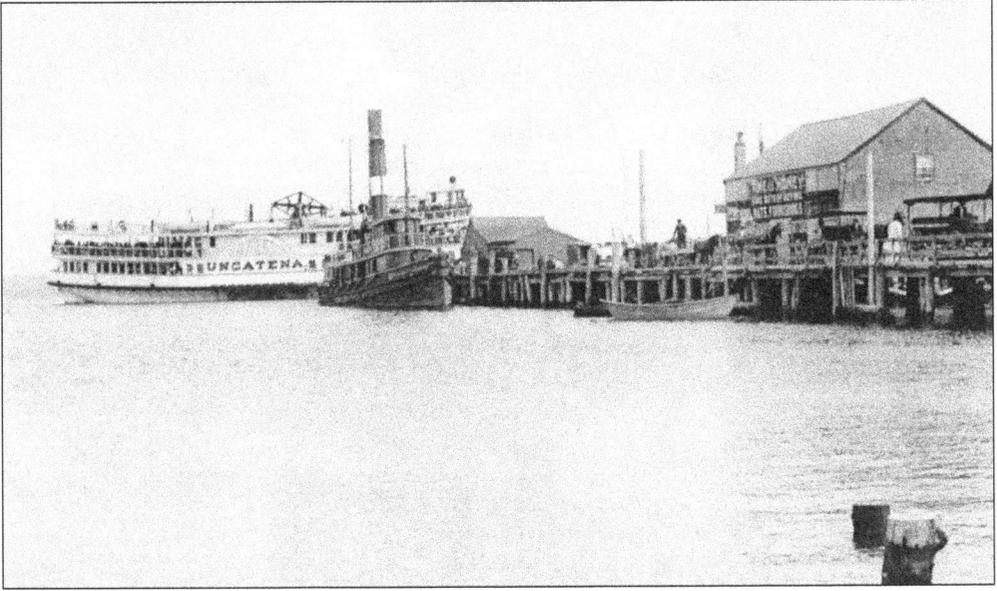

The *Uncatena* is at the end of the wharf in Vineyard Haven, formerly called Holmes Hole. Her walking beam is clearly visible above her top deck. Except for some very early steamers, all of the side-wheelers in island service had vertical beam engines. This was an American marine engine and was common on side-wheel steamers of bays, rivers, and sounds of both coasts, as well as large lakes.

This drawing shows how a walking beam engine worked. The beam at the top rocked, or "walked," up and down. This converted the vertical motion from the cylinder on the right to a rotary motion on the paddle shaft on the left. Although these engines were slow turning, due to a long stroke, the steamers that had them were usually quite fast. If well maintained, they could outlast the ship.

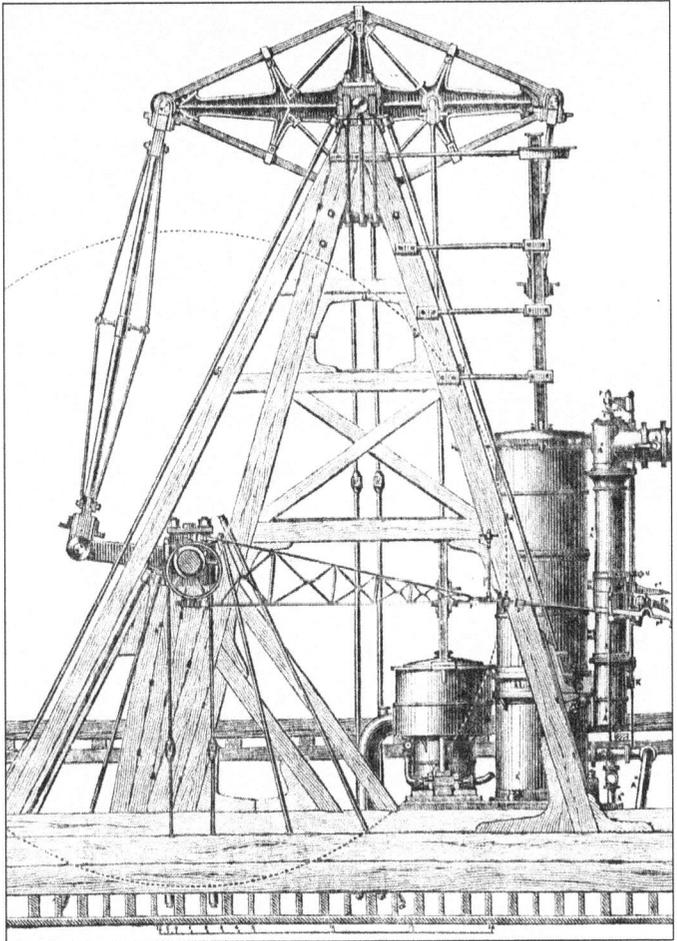

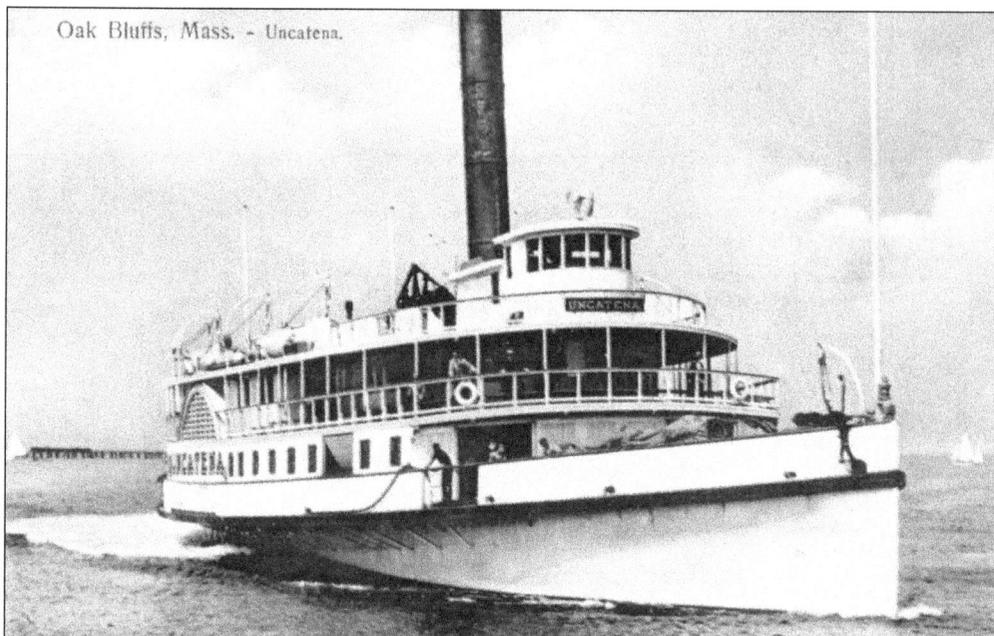

Oak Bluffs, Mass. - Uncatena.

The *Uncatena* is approaching the wharf at Oak Bluffs. Her engine is stopped, as evidenced by the foam caused by the drag of her paddle wheel. The deckhand will throw a light heaving line to the line handlers on the wharf. They will then use that to haul in the heavy mooring line, seen draped over the rail.

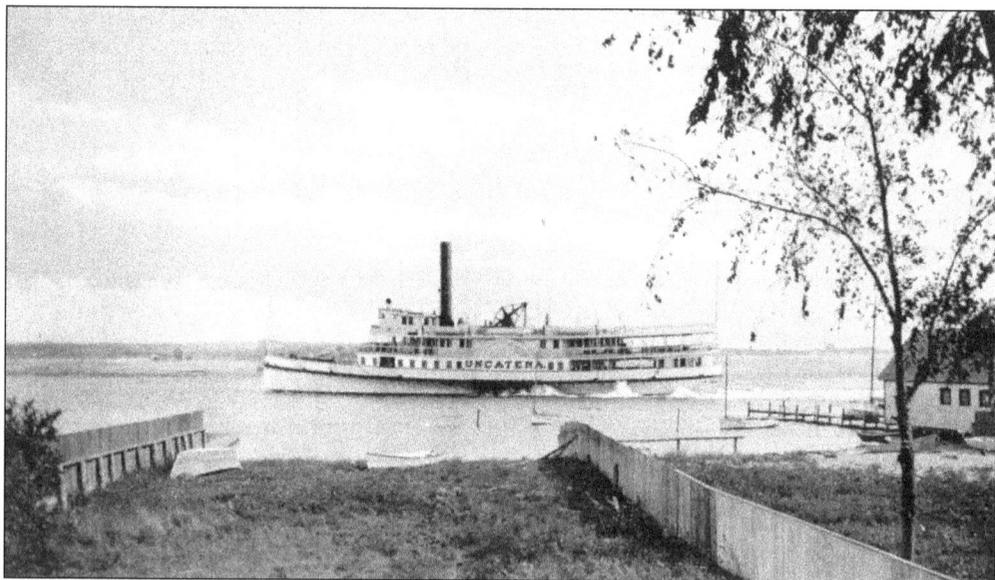

In this rather bucolic view, the *Uncatena* is departing Edgartown on Martha's Vineyard. Again, the typical steep wake of a side-wheeler just getting underway is clearly evident.

Edgartown was once the major port on the Vineyard and was the primary destination for steamboats. Holmes Hole (Vineyard Haven) had occasional service as early as 1847, and the wharf at Cottage City (Oak Bluffs) was built in 1867. Eventually, these gained most of the traffic, and the last steamer out of Edgartown was the *New Bedford* on November 9, 1934. This shows the Edgartown steamboat wharf with several schooners alongside.

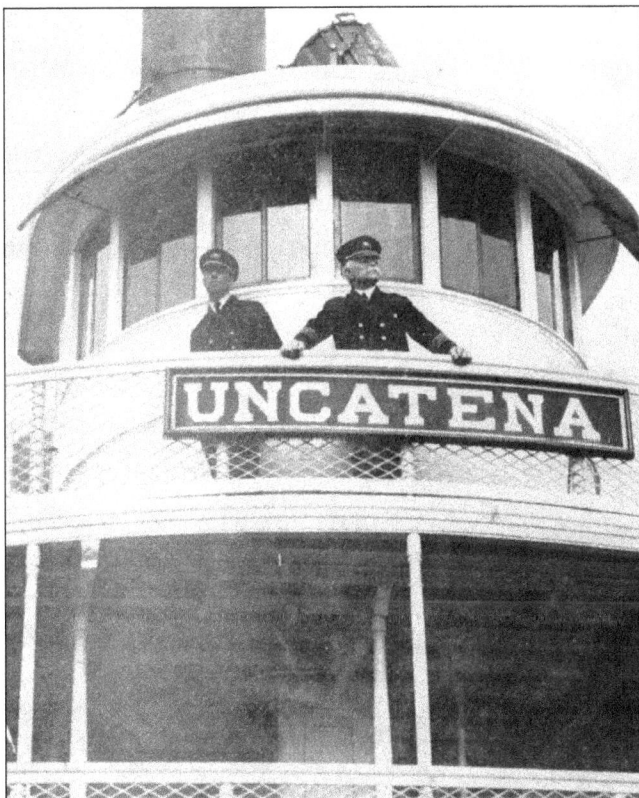

Standing in front of the pilothouse in this 1928 view are Quartermaster Charles Leighton, on the left, and Capt. Francis Marshall. By this time, an "eyebrow" has been added to the *Uncatena*. That is the awning over the pilothouse windows. (Courtesy of Mike Dawicki.)

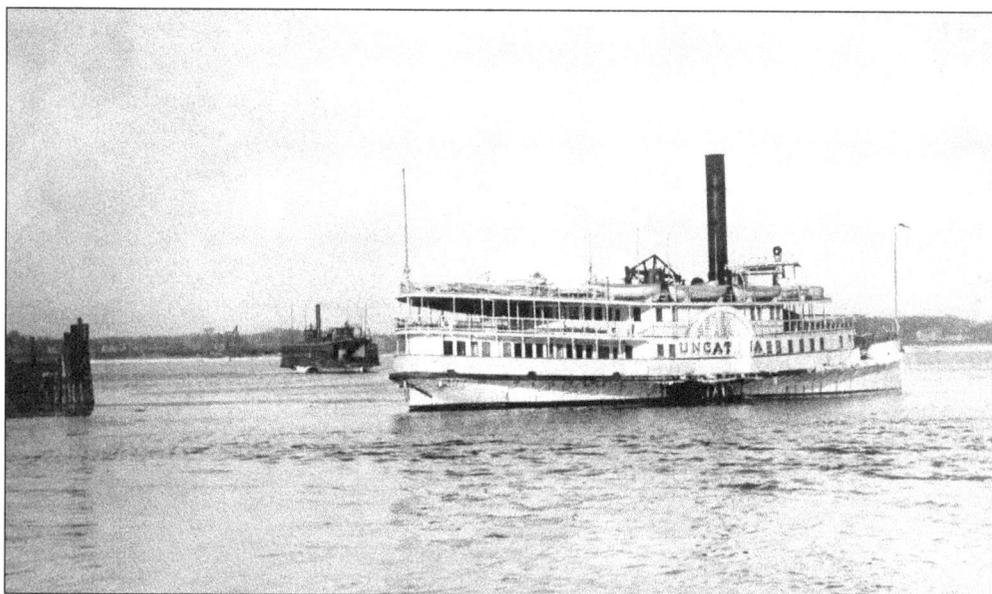

It is a cold winter day, and the *Uncatena* is off of her wharf in New Bedford, with saltwater ice hanging from her guards and paddle box. Approaching in the background is the ferry *Fairhaven*, running between New Bedford and her namesake city. (Courtesy of Mark Snider.)

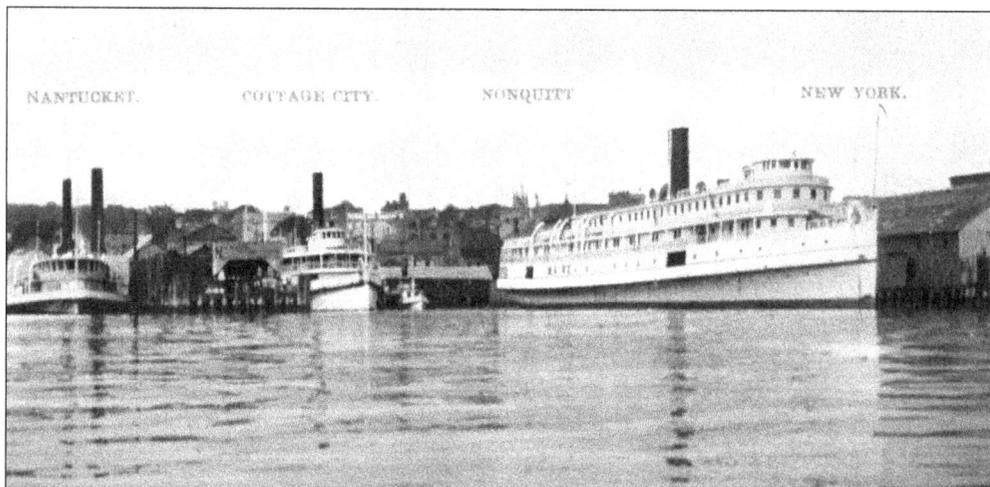

NANTUCKET. COTTAGE CITY. NONQUITT NEW YORK.

In spite of the fact that today there is no historical signage on the New Bedford waterfront that mentions steamboats, the city was a major port for steamboat connections. This postcard view shows, from left to right, the steamers *Nantucket*, *Uncatena*, *Cygnet*, and *Maine*. The *Maine* and her sister ship *New Hampshire* were two of a number of overnight steamers from New York that connected with the island steamers over the years.

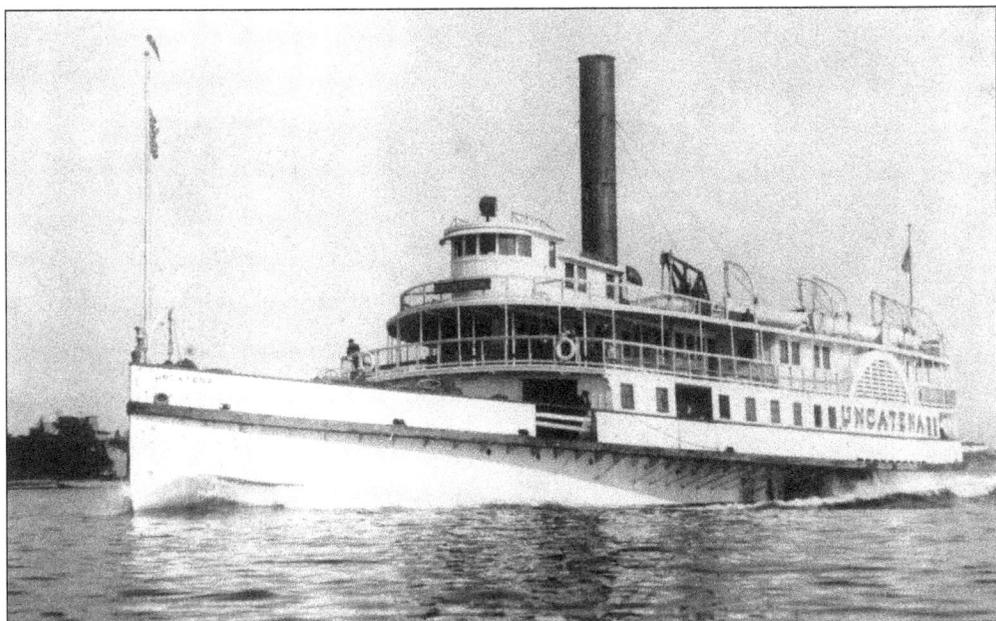

This is a water-level view of the *Uncatena* underway on a nice summer day. She appears to be approaching Woods Hole.

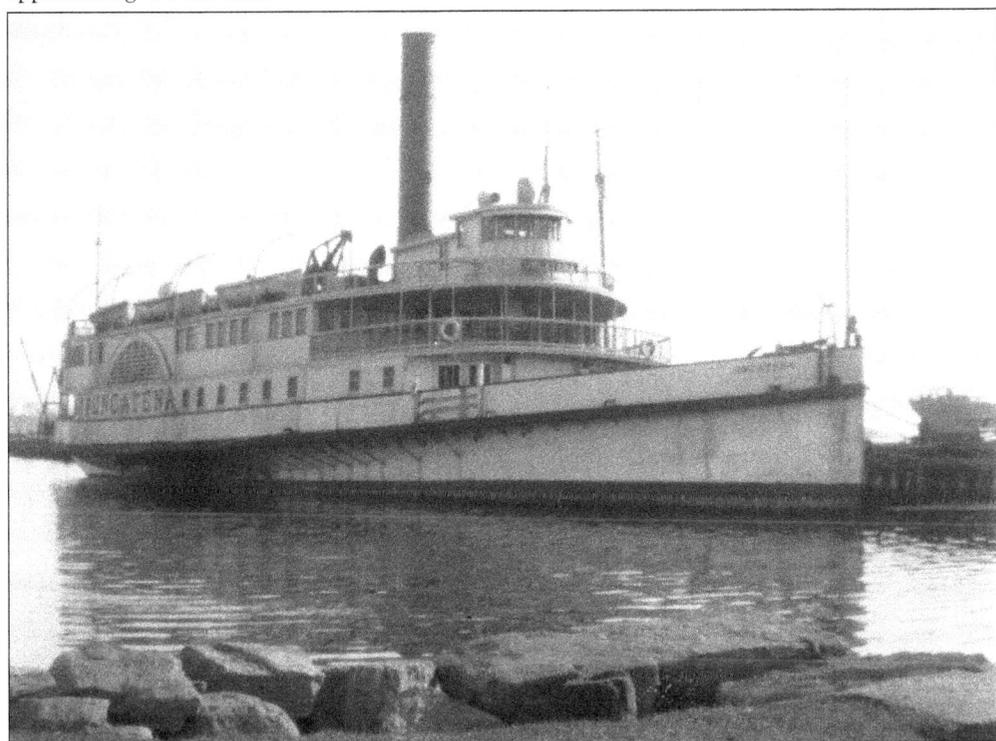

The *Uncatena* was taken out of service at the end of the 1928 season. Two years later, she was sold to the Nantasket Beach Steamboat Company of Boston and renamed *Pemberton*. This photograph of her at New Bedford was possibly taken during the time she was laid up, waiting for a buyer. (Photograph by Harold Streeter; courtesy of Rosemary Bottum.)

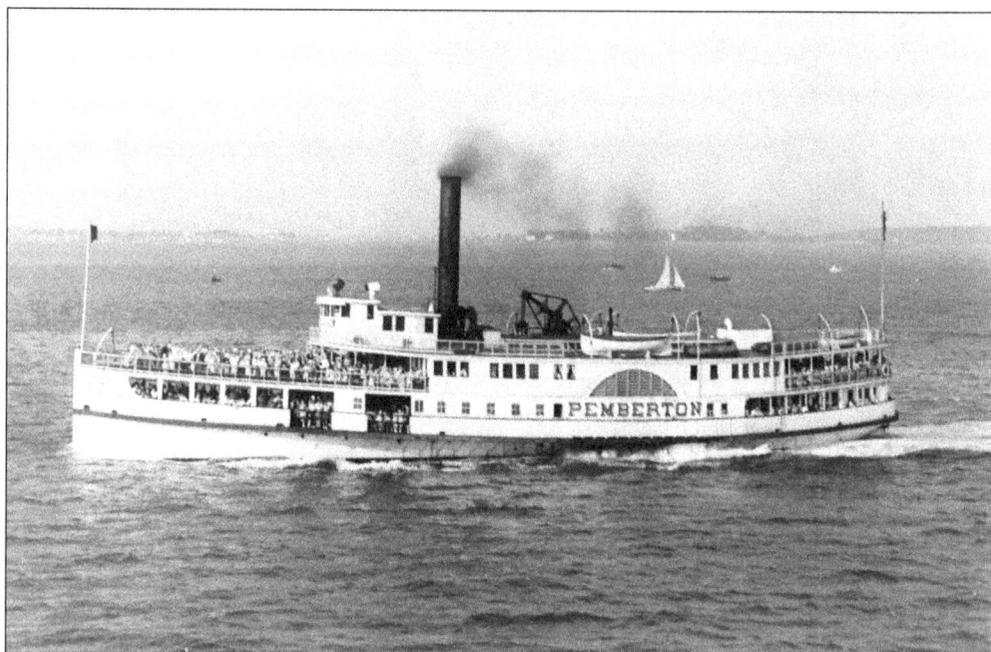

As *Pemberton*, the *Uncatena* had a new lease on life as an excursion boat out of Boston. The most noticeable modification the Nantasket Beach Steamboat Company made was to extend her second deck all the way to the bow.

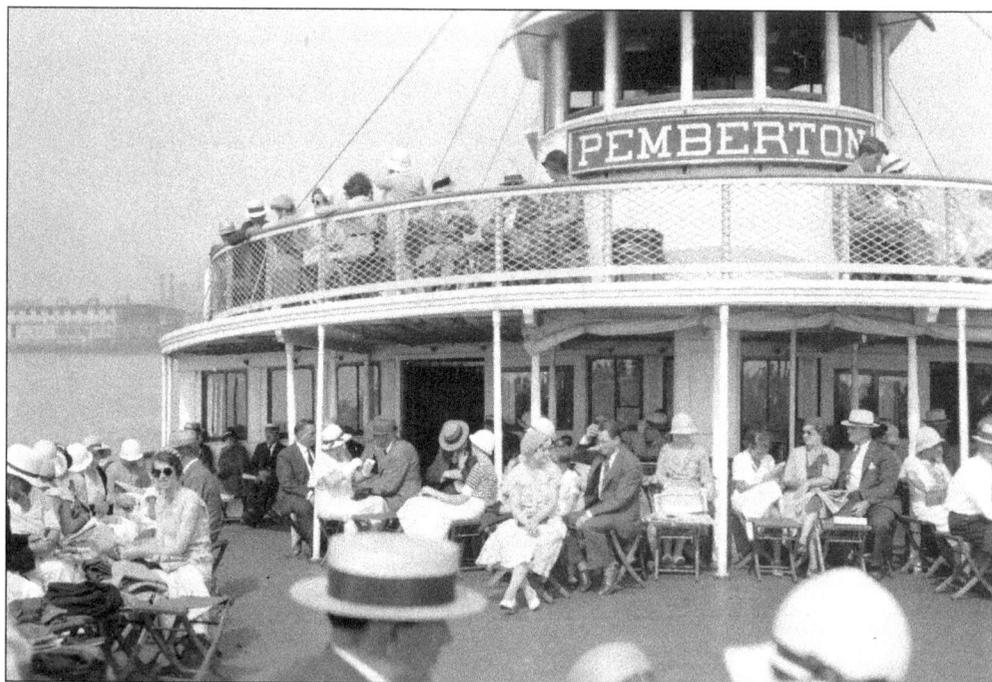

As can be seen in this view on board, the extended second deck afforded additional open space for passengers. This was a time before shorts and T-shirts became the usual apparel for day-trippers. As *Pemberton*, her name board was affixed to the pilothouse rather than to the railing in front. (Photograph by Joseph Allen; author's collection.)

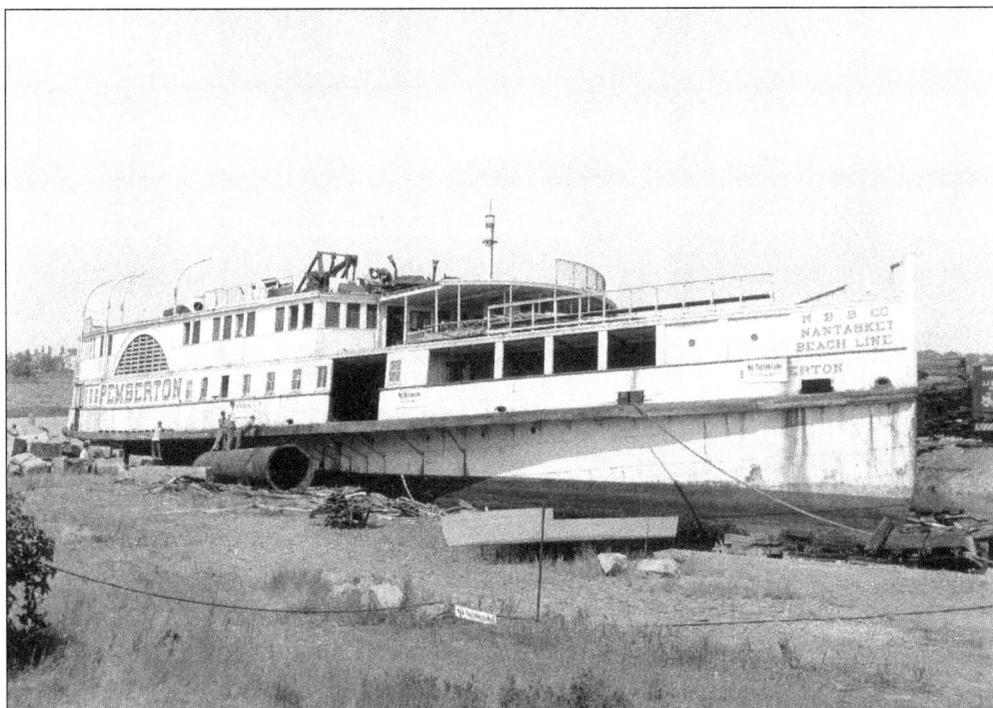

The *Pemberton*, formerly *Uncatena*, was finally scrapped at Quincy, Massachusetts, in July 1937. (Photograph by R. Loren Graham; author's collection.)

The *Sankaty*, the first propeller steamer built for the island service, was launched at the Fore River Shipyard in Quincy on February 2, 1911. Her maiden voyage was from New Bedford to Nantucket on May 2 of that year. On the way, she went into Woods Hole, Vineyard Haven, and Oak Bluffs but did not land. In this postcard view, she is rounding Brant Point at Nantucket.

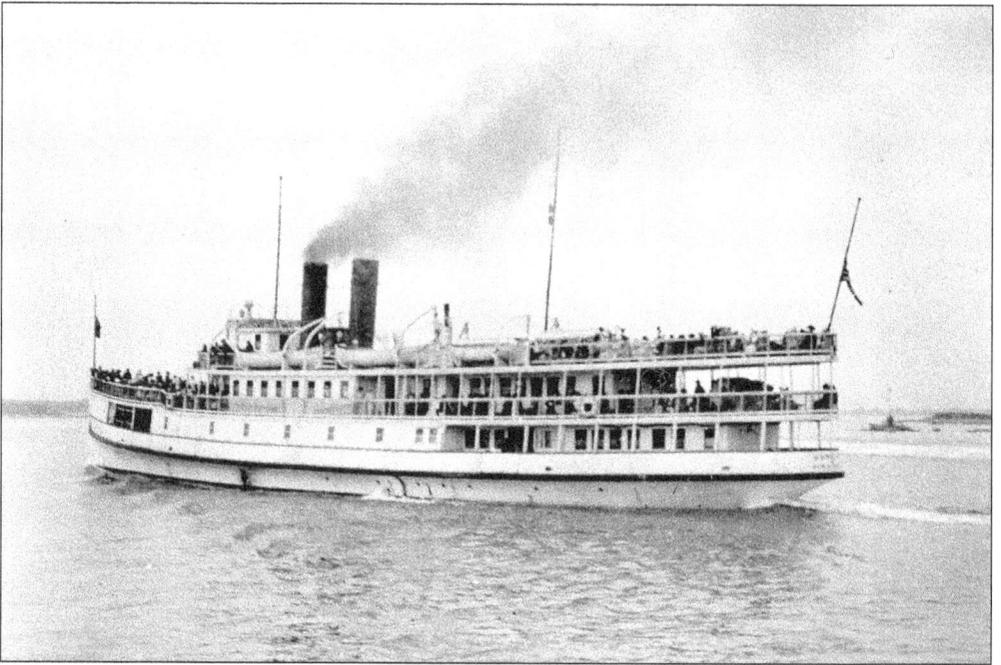

The *Sankaty* was the first of the island steamers to have an enclosed bow for carrying freight rather than the single open deck of her predecessors. She is seen here leaving the wharf at Woods Hole.

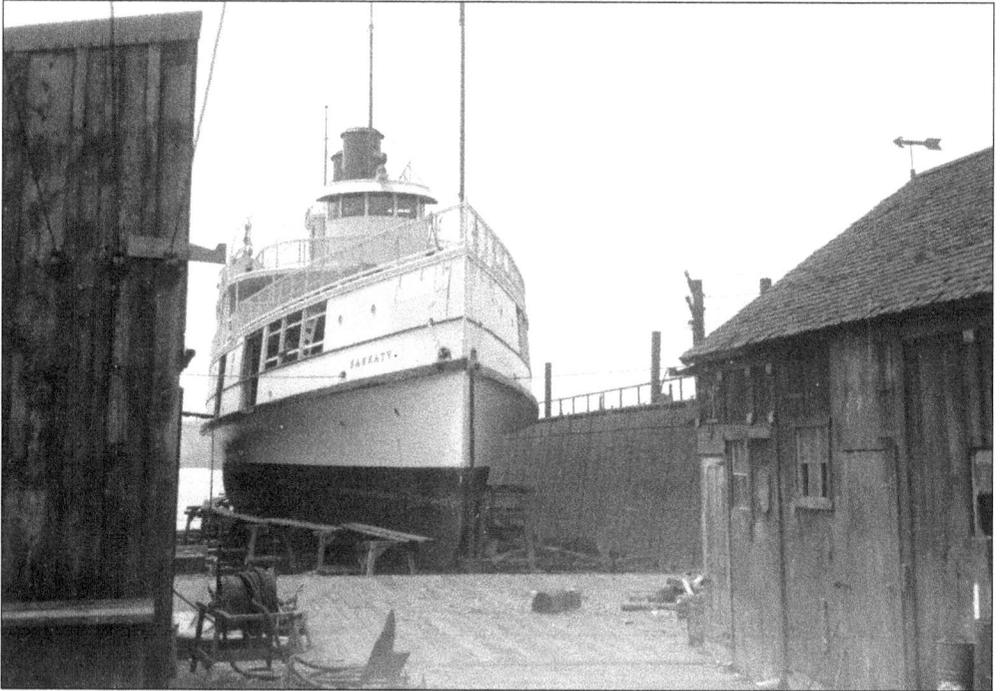

In this unusual view, the narrow hull of the *Sankaty* is evident. She rolled more than the sidewheelers but still proved to be an able sea boat. Here, she is seen in the floating drydock at Bold Point in East Providence, Rhode Island, probably to have her bottom painted. (Photograph by Jess Welt; author's collection.)

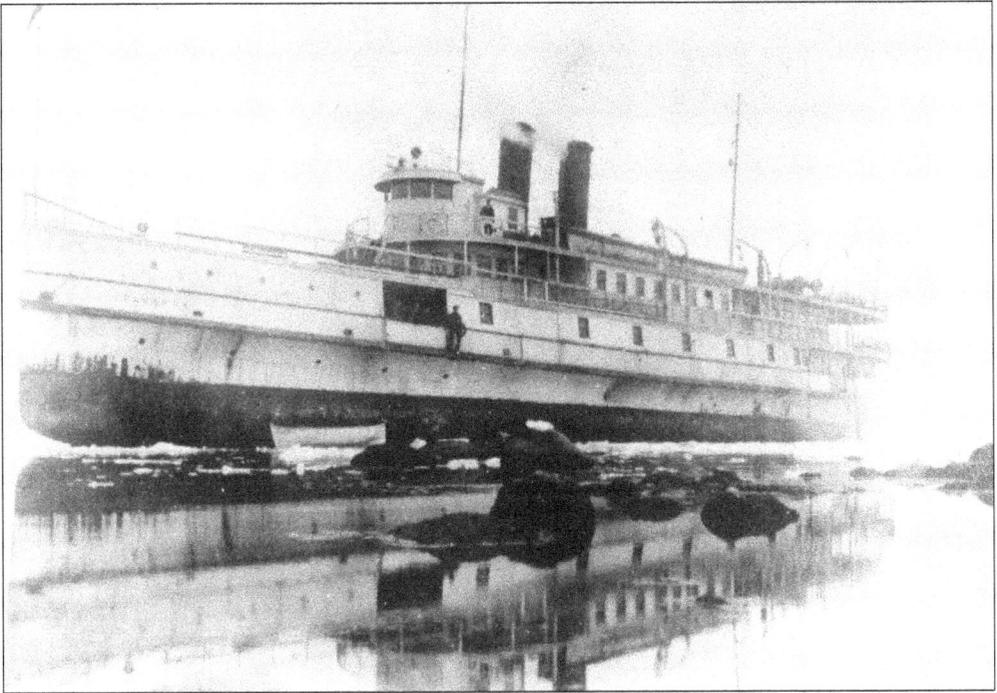

On February 20, 1917, while bound from Edgartown to New Bedford in a thick fog, the *Sankaty* ran aground off Wilbur's Point. She was refloated but was out of service for over a month.

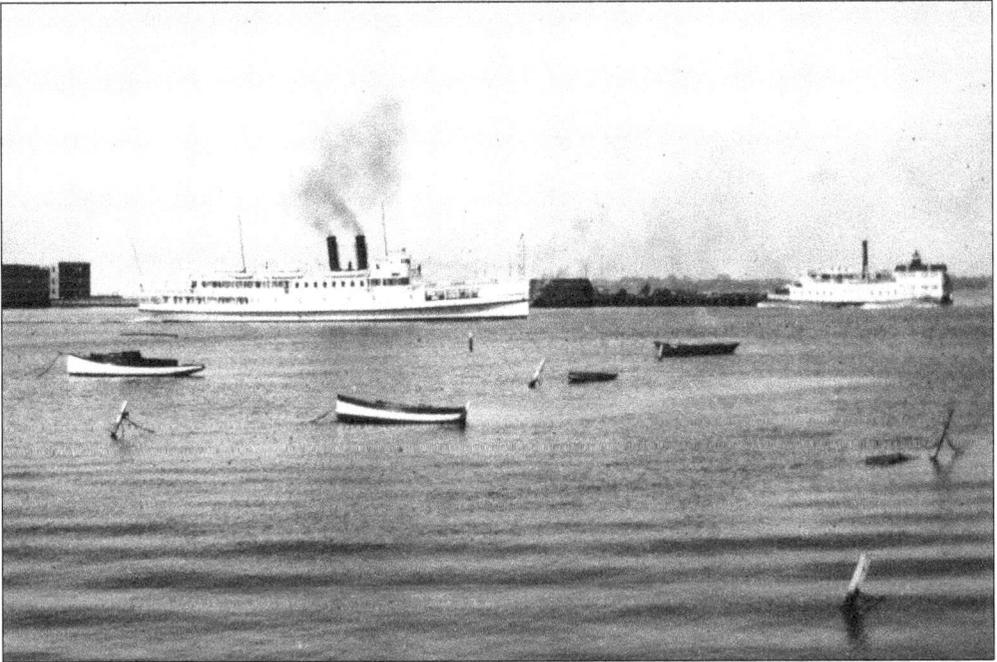

The *Sankaty* is slowly leaving the harbor at Newport, Rhode Island. This is where the company had its maintenance and design shops. With a fresh coat of paint, she is heading to New Bedford to go back on the line. To the right is the Newport-Jamestown ferry *Conanicut*. (Photograph by William K. Covell; author's collection.)

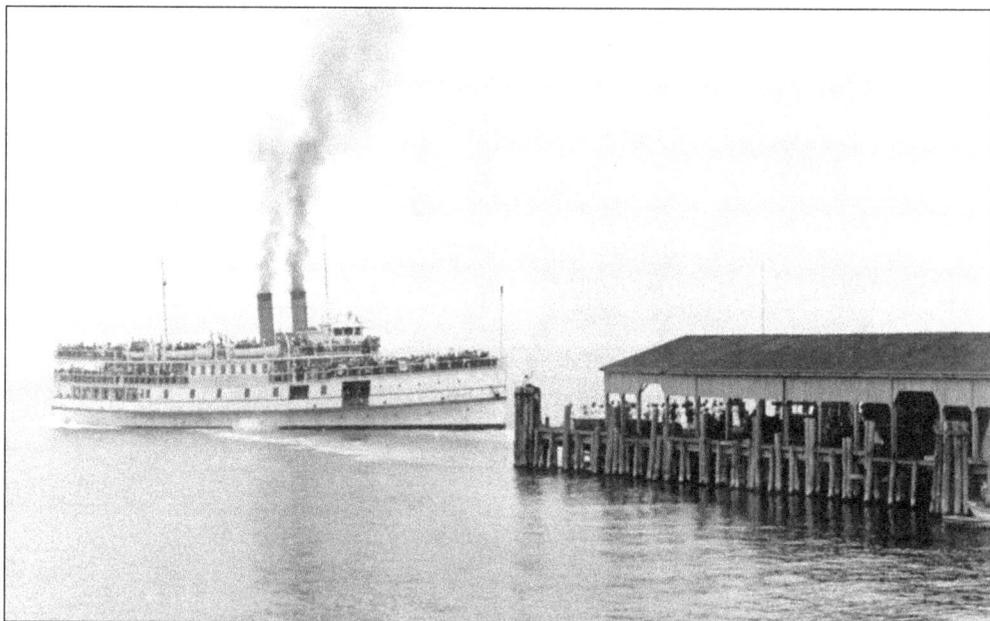

The *Sankaty* has a full compliment of passengers as she backs away from the wharf in Vineyard Haven on a hazy day.

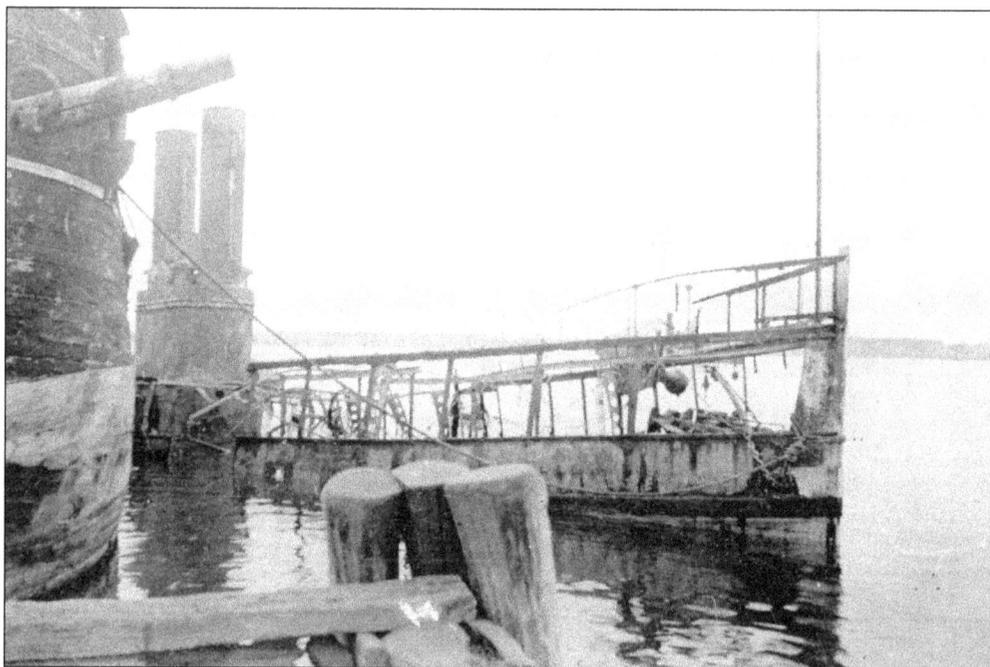

The *Sankaty's* career on the island line was relatively brief. On the night of June 30, 1924, a fire started on the wharf in New Bedford and spread to the steamer. Her mooring lines burned through, and she drifted, on fire, across the harbor to Fairhaven. She came to rest next to the historic whaling bark *Charles W. Morgan*. Firemen were able to save the *Morgan* but not the *Sankaty*.

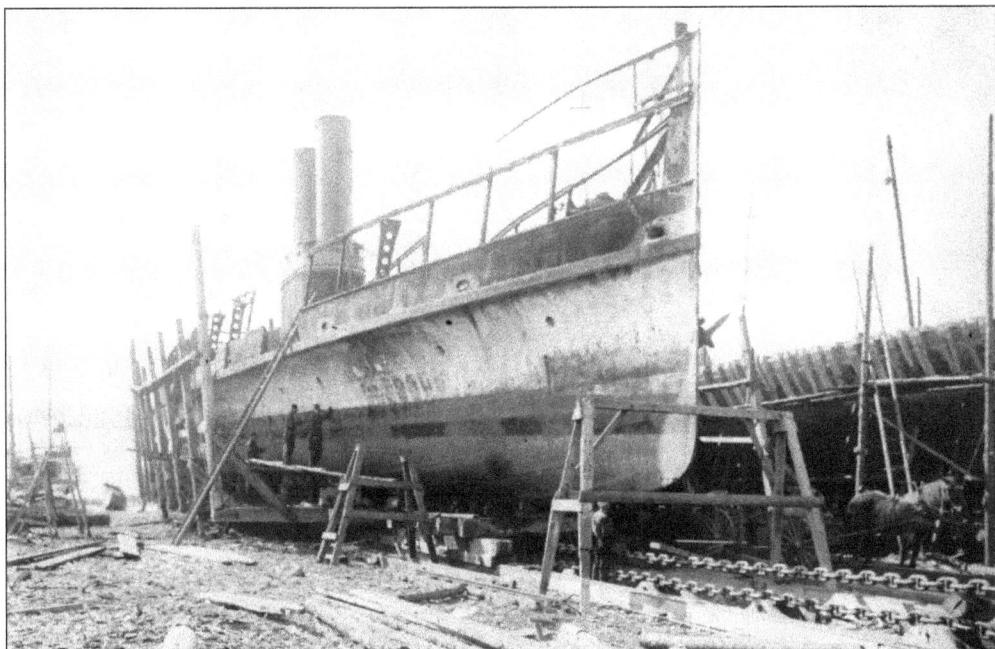

The wreck of the *Sankaty* was sold "where is, as is," to Capt. John Snow of Rockland, Maine. He raised her, cleaned the boilers and engine, built a temporary engine housing and steering platform, and steamed her to Rockland. This view shows her hauled out on a marine railway in Maine after the trip from New Bedford.

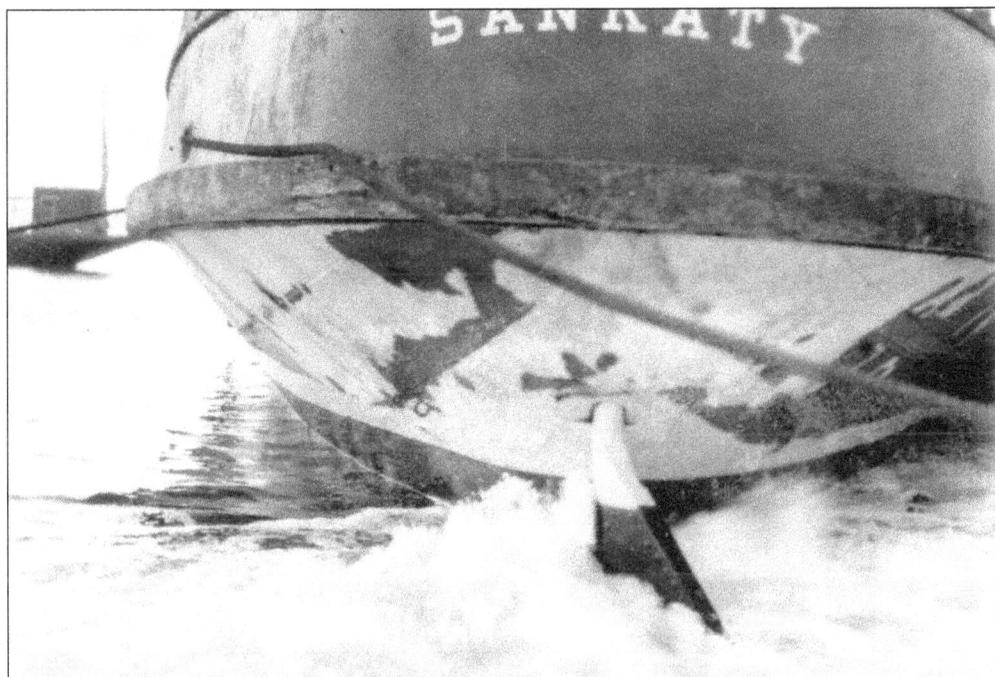

Here is a close-up of *Sankaty's* stern while the engine was being tested at a wharf in Rockland. She was rebuilt as a very plain-looking automobile ferry. After several years waiting for a buyer, she was finally sold to the Stamford–Oyster Bay Ferry Corporation for service across Long Island Sound.

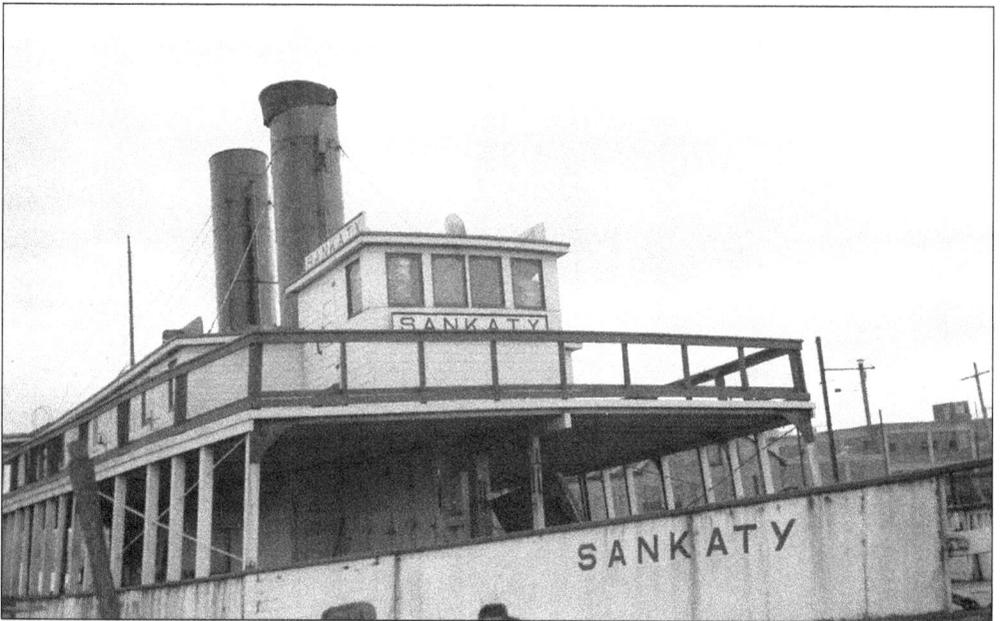

This image shows the boxy appearance of the *Sankaty* after she was converted to an automobile ferry. The photograph was taken at Stamford, Connecticut, in 1936. She is out of service and is looking worse for wear. She was next sold for use as a ferry in Nova Scotia, but the Canadian government took her and converted her to a minesweeper for service in World War II. (Photograph by William Ewen Sr.; author's collection.)

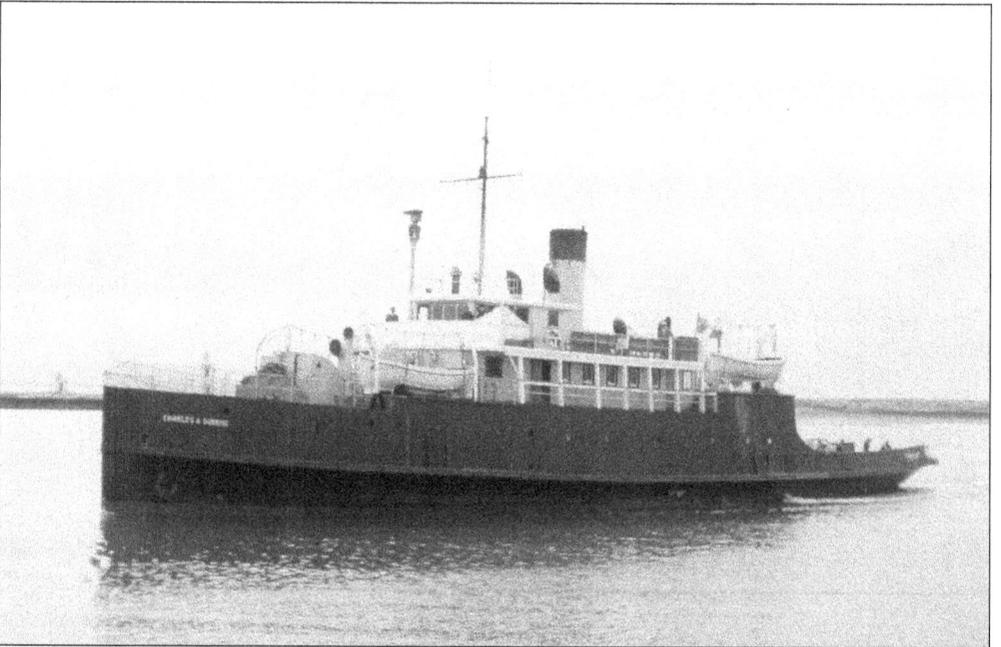

After the war, the *Sankaty* was purchased by the Northumberland Ferry for service between Caribou (Nova Scotia) and Prince Edward Island. She was rebuilt once again and renamed *Charles A. Dunning*. As a minesweeper, she had been converted to a single smokestack and remained that way after the war, as seen here. (Photograph by Dan Streeter; courtesy of Rosemary Bottum.)

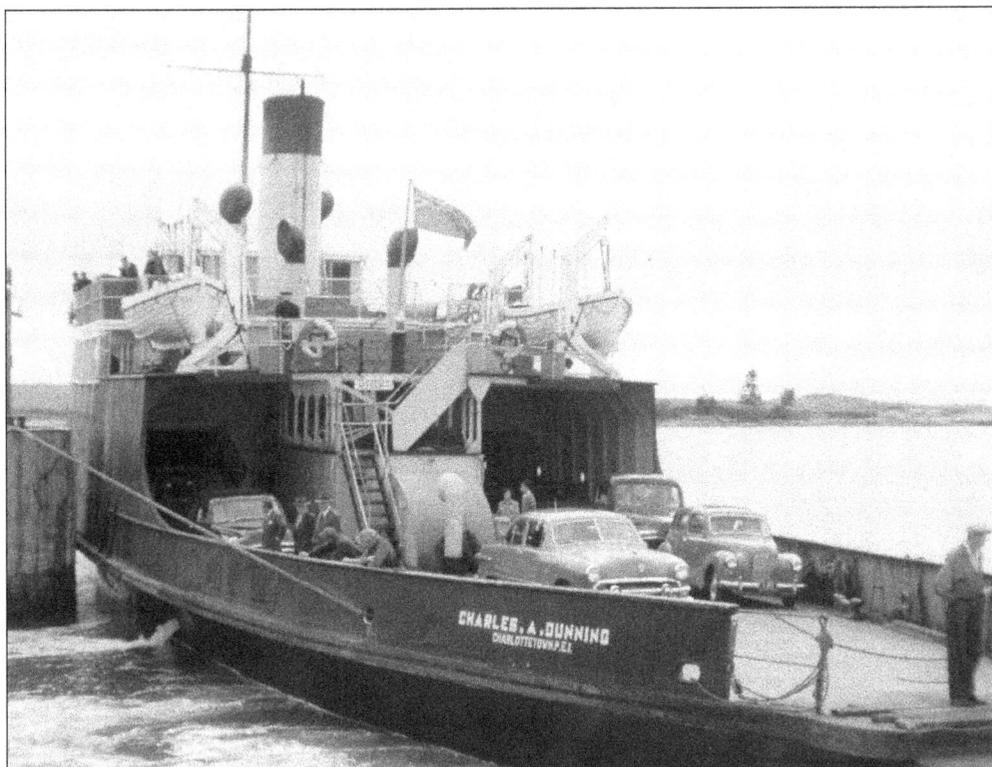

The *Dunning* is shown here backing around on a spring line into her slip. In 1964, she was sold once again. While being towed to North Sidney, Cape Breton, her towline parted and she disappeared. (Photograph by Dan Streeter; courtesy of Rosemary Bottum.)

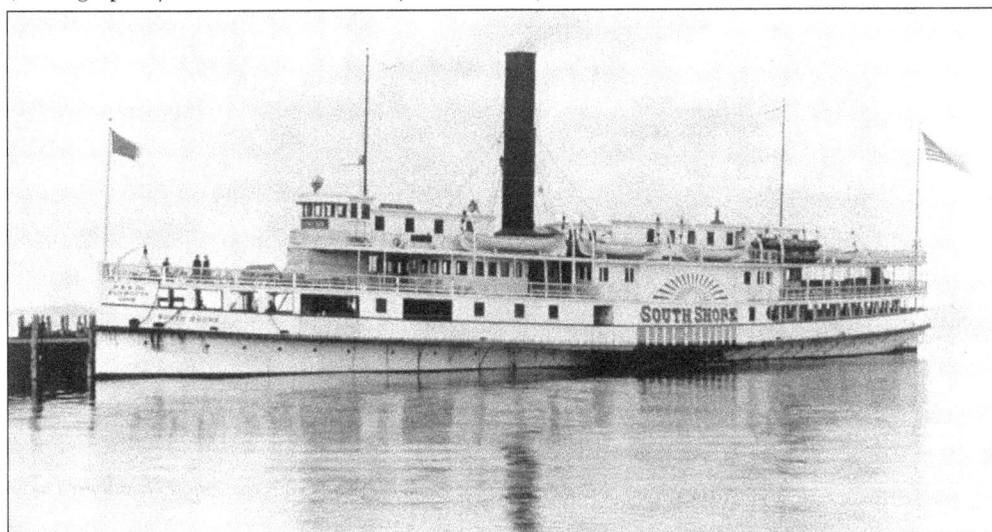

With the loss of the *Sankaty*, another steamer was quickly needed to replace her on the island line. The company first chartered the former Boston steamer *Myles Standish*. When she was damaged hitting a rock between Vineyard Haven and Oak Bluffs, the side-wheeler *South Shore* was chartered from the Nantasket Beach Steamboat Company. She is shown here while in service on the Plymouth line of the Nantasket Company.

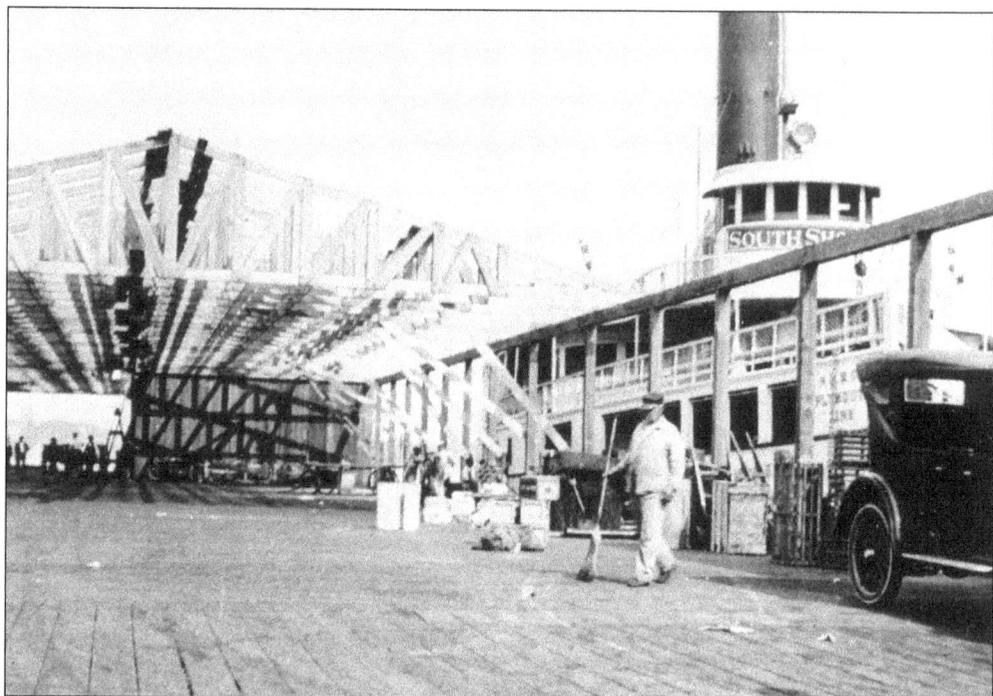

The 1924 fire in New Bedford not only destroyed the *Sankaty* but also the steamboat wharf. This photograph was taken while the pier was being rebuilt. The *South Shore* had already arrived from Boston to fill in on a short-term basis. Note that she still has Plymouth Line painted on her bow. (Photograph by Richard Berry; author's collection.)

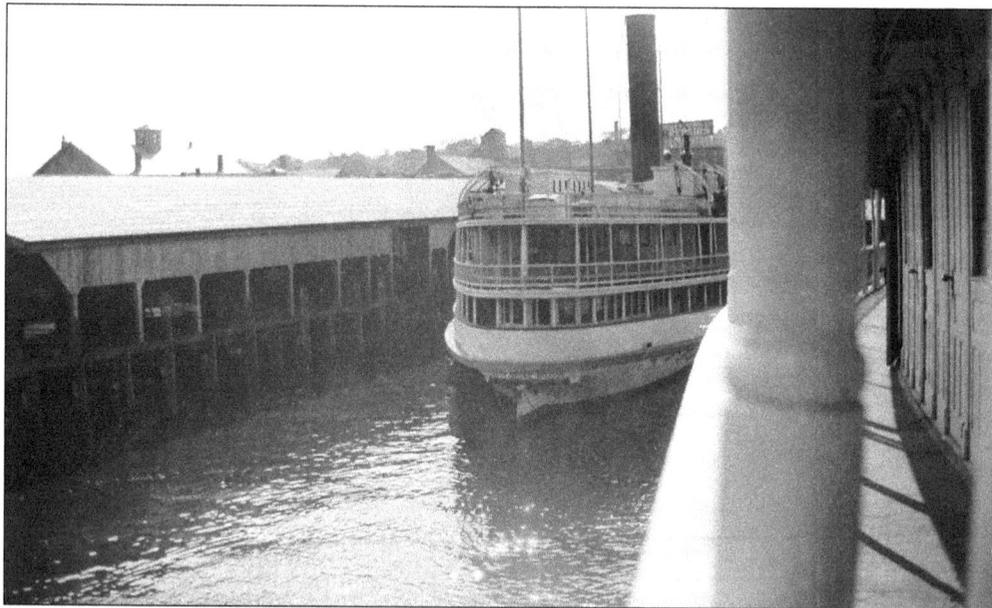

This unusual view was taken from the deck of one of the New England Steamship Company's New Bedford Line night boats from New York. The island line wharf has been rebuilt, and the *South Shore* is tied up on the north side of the pier. (Photograph by Harold Streeter; courtesy of Rosemary Bottum.)

Four

THE WHITE FLEET

In 1917, the General Court of the Commonwealth of Massachusetts forced the New Haven Railroad to dissolve its holding company, the New England Navigation Company. The railroad was, however, able to retain ownership of the island line. In 1922, the stockholders voted to sell all stock in the line to the New England Steamship Company, the railroad's operating company for marine operations.

By the time the New England Steamship Company took over, the steamers in the fleet were becoming old and obsolete. One of the biggest concerns was the transportation of automobiles. This traffic was increasing steadily every year and was an important source of revenue for the line. This was not a factor when the earlier steamers were built. In its first year of ownership, the New England Steamship Company had its Newport shops design a new class of steamer.

The first of this fleet was the *Islander*, later renamed *Martha's Vineyard*. She was followed by two near-sister ships, the *Nobska* and the *New Bedford*. The fourth was the similar but much larger *Naushon*. J. Howland Gardner oversaw the design of these steamers, nicknamed the White Fleet. He was a respected marine engineer and naval architect, and at the time, he was vice president of the New England Steamship Company. Also involved in the designs were Warren T. Berry, superintendent of the Newport repair shops, and Albert F. Haas, the chief designer of the steamers.

For their time, the steamers of the White Fleet were probably the most successful, recognizable, and popular of any to serve the islands of Martha's Vineyard and Nantucket. If any vessels can be said to be symbolic of boats to the islands, it is these four. Even today, the *Islander* is featured on the logo of the present Woods Hole, Martha's Vineyard, and Nantucket Steamship Authority.

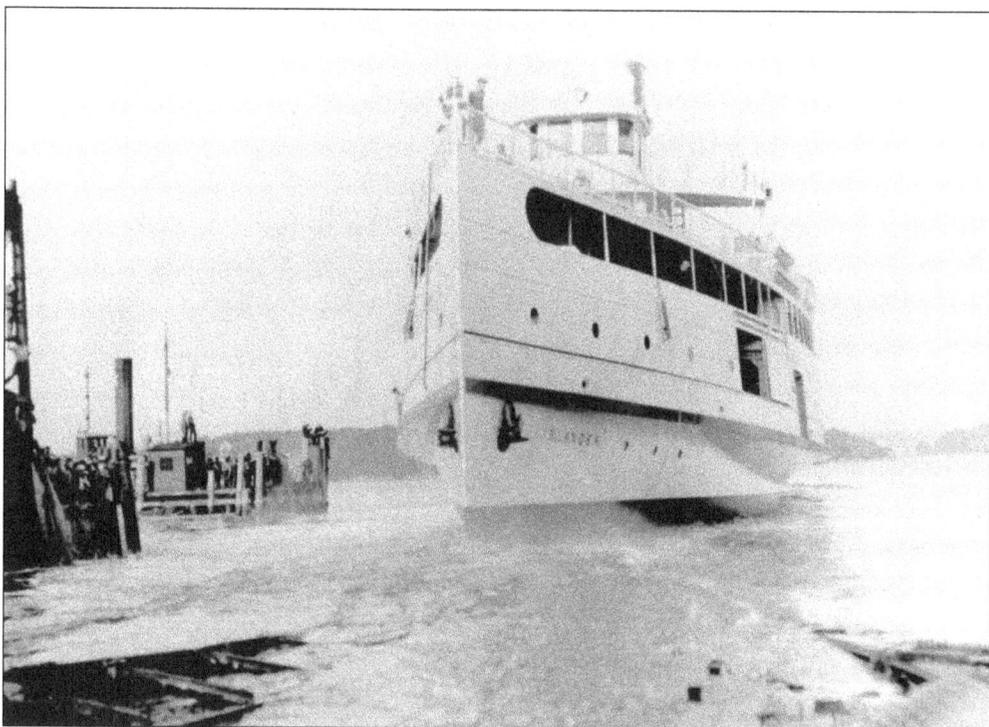

The *Islander*, the first of the new class of island steamers, slides down the ways at the Bath Iron Works on July 19, 1923. She was launched with steam up and her whistle blowing. After work at the yard was completed, she steamed to Newport, Rhode Island.

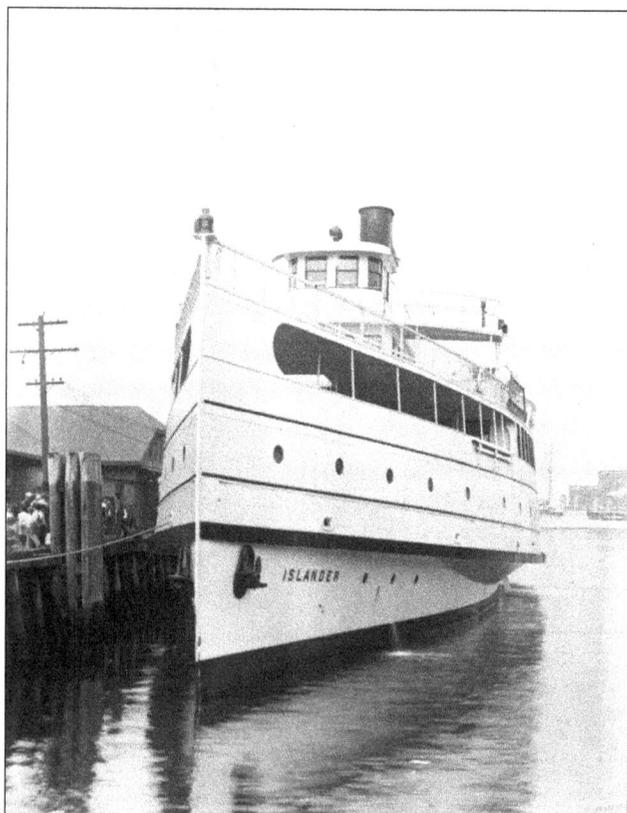

The brand new *Islander* is shown at the Long Wharf complex of the New England Steamship Company in Newport. Likely, this was when provisions, furniture and other fittings were being brought aboard. Her maiden voyage took place on August 8, 1923. (Photograph by William K. Covell; author's collection.)

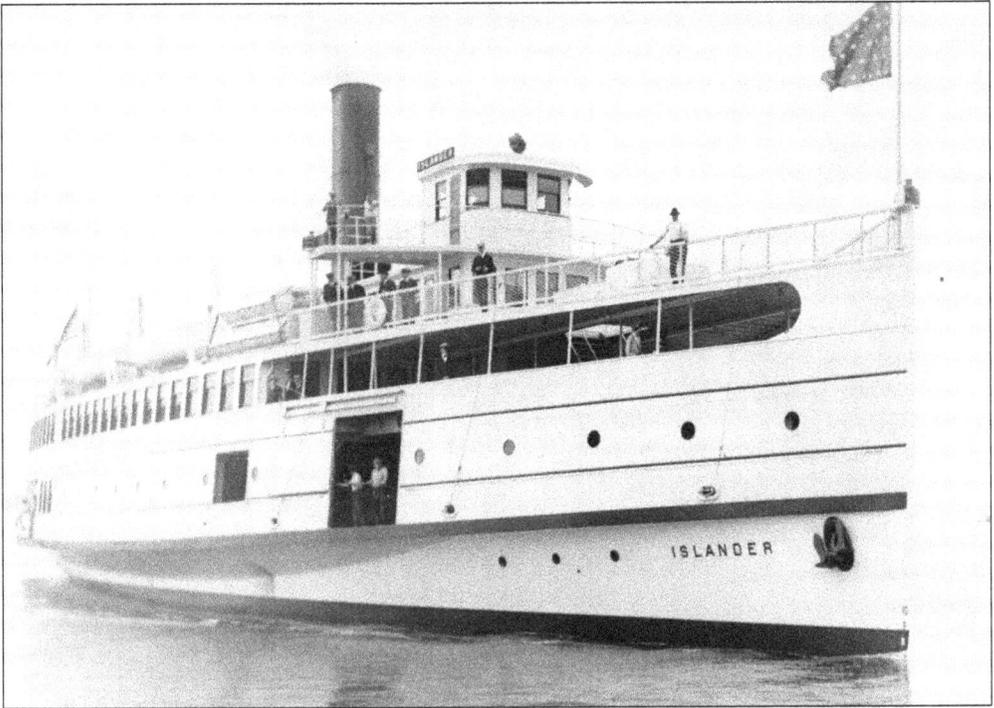

The *Islander* is seen arriving at Woods Hole for the first time on August 8, 1923. She has no passengers, just guests and officials of the line. She was the first of three island vessels (so far) to have the name *Islander*. (Photograph by William K. Covell; author's collection.)

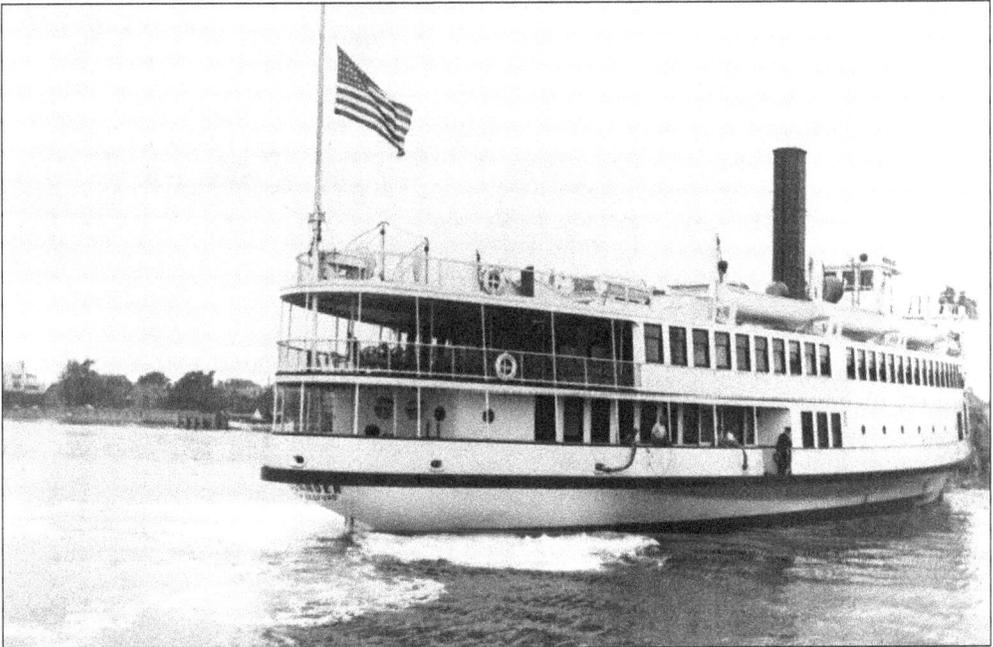

This photograph of the *Islander* was taken at Woods Hole just a few minutes after the previous photograph. Her flags are at half-mast for President Harding, who had passed away on August 2, 1923. (Photograph by William K. Covell; author's collection.)

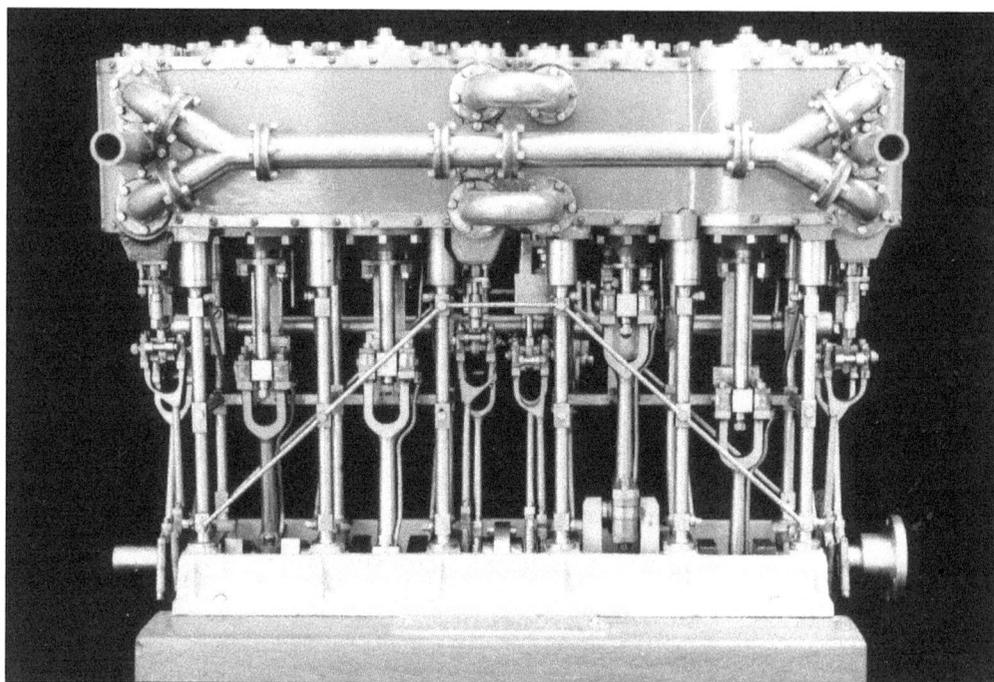

All of the White Fleet steamers were powered by four-cylinder, triple-expansion steam engines. The craftsmen at the Bath Iron Works who constructed the real engine built this beautiful model, now in the collection of the Maine Maritime Museum. (Photograph by the author.)

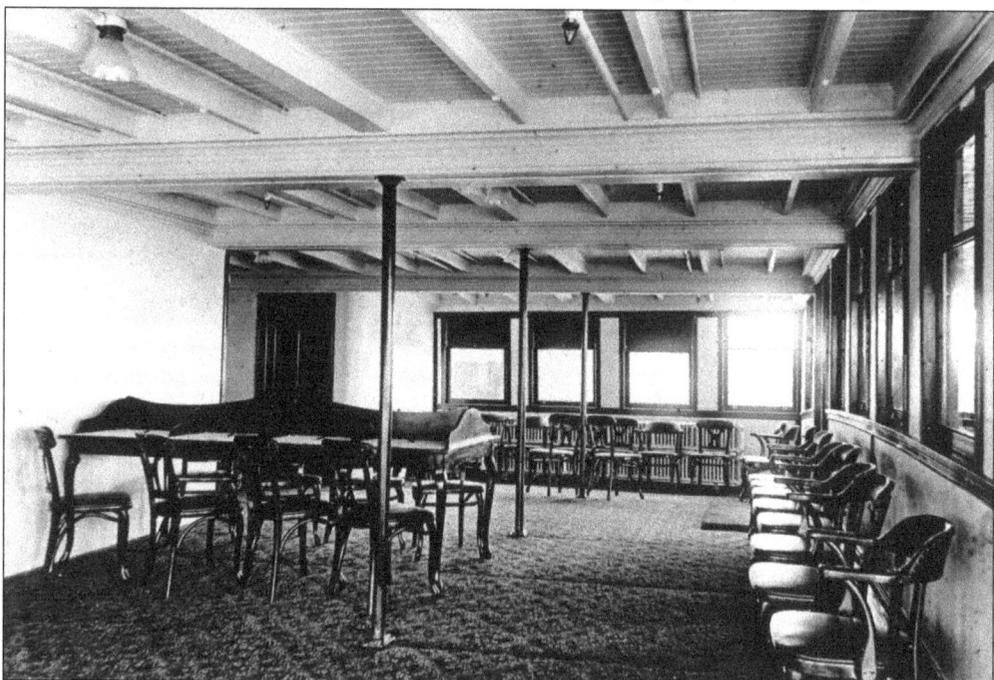

This is the writing room area at the forward end of the saloon deck on the new *Islander*. Writing paper with the company's logo was supplied, as well as ink and pens. This view is looking toward the port side of the steamer.

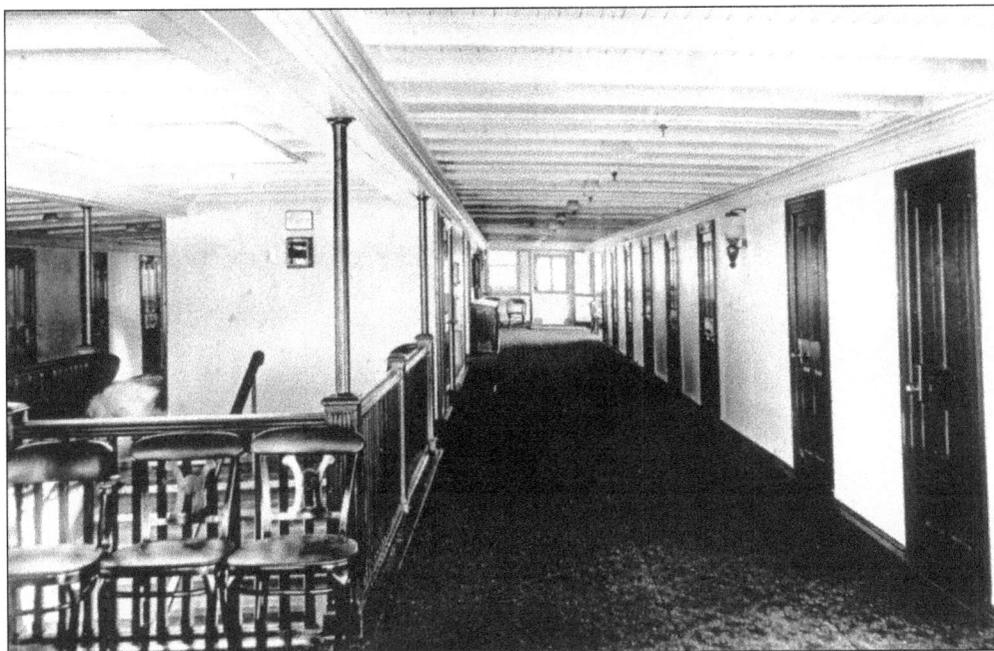

Here is another interior view of the saloon deck on the *Islander*; the photograph was taken looking forward. The doors down either side were day staterooms that could be rented for the duration of the voyage. They were popular with families that wanted some privacy and to avoid the crowds on deck. The stairway leads down to the main deck where passengers came aboard.

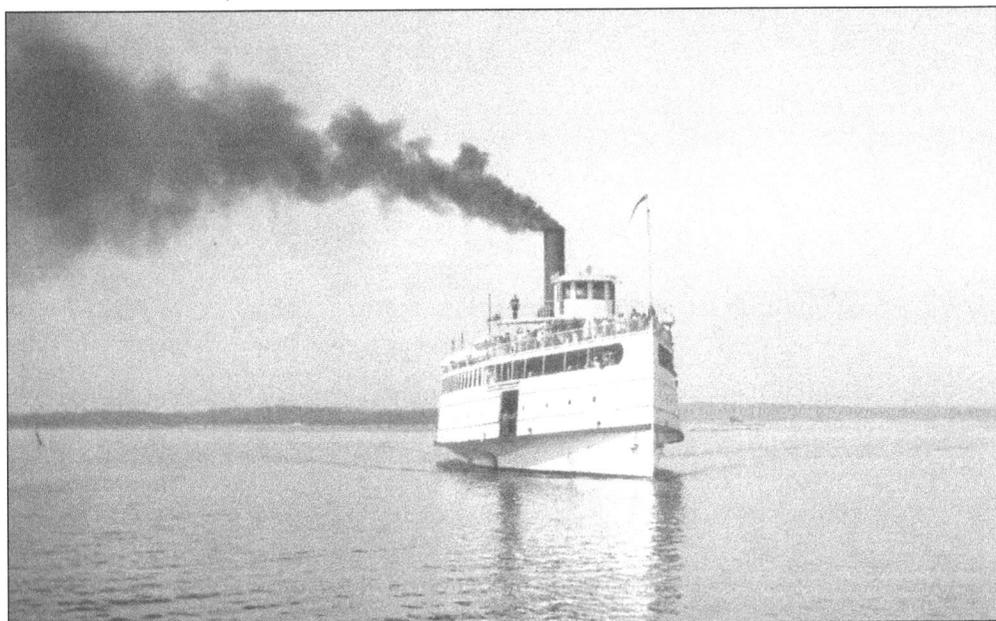

In 1928, the *Islander* was renamed *Martha's Vineyard*. In this view, she is seen approaching the wharf at Woods Hole with soft coal smoke pouring from her stack. The fireman must not have been paying attention, as these steamers normally did not smoke like this. In 1934, the White Fleet steamers were all converted to oil burners. (Photograph by Dan Streeter; courtesy of Rosemary Bottum.)

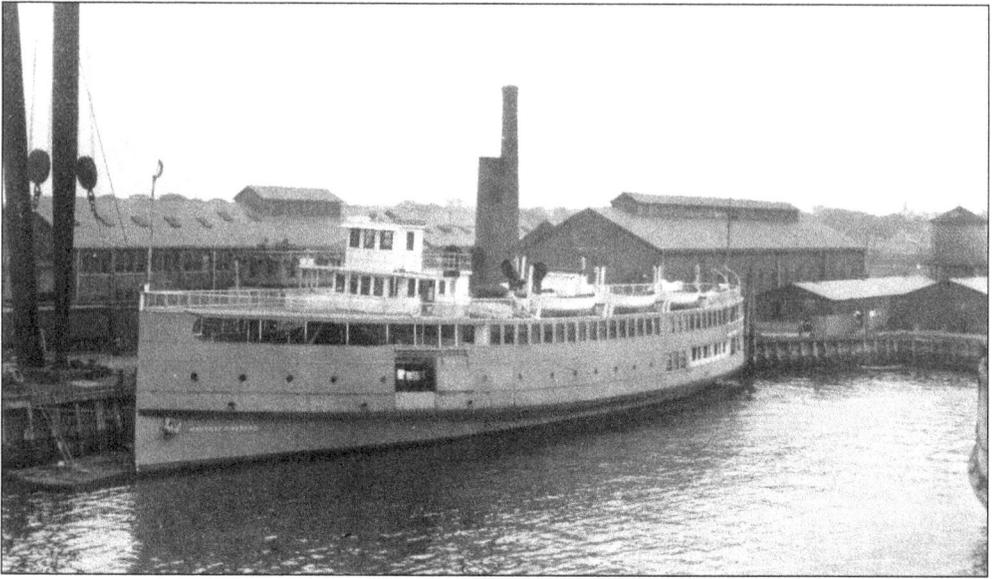

In 1930, to save money, the steamers were painted gray. This enabled the company to cut back on painting to cover rust and dirt. After howls of protest from islanders and critical articles in the newspapers, the ships were repainted white the following year. In this view, a gray-painted *Martha's Vineyard* is tied to a wharf at the Long Wharf complex in Newport. (Photograph by William K. Covell; author's collection.)

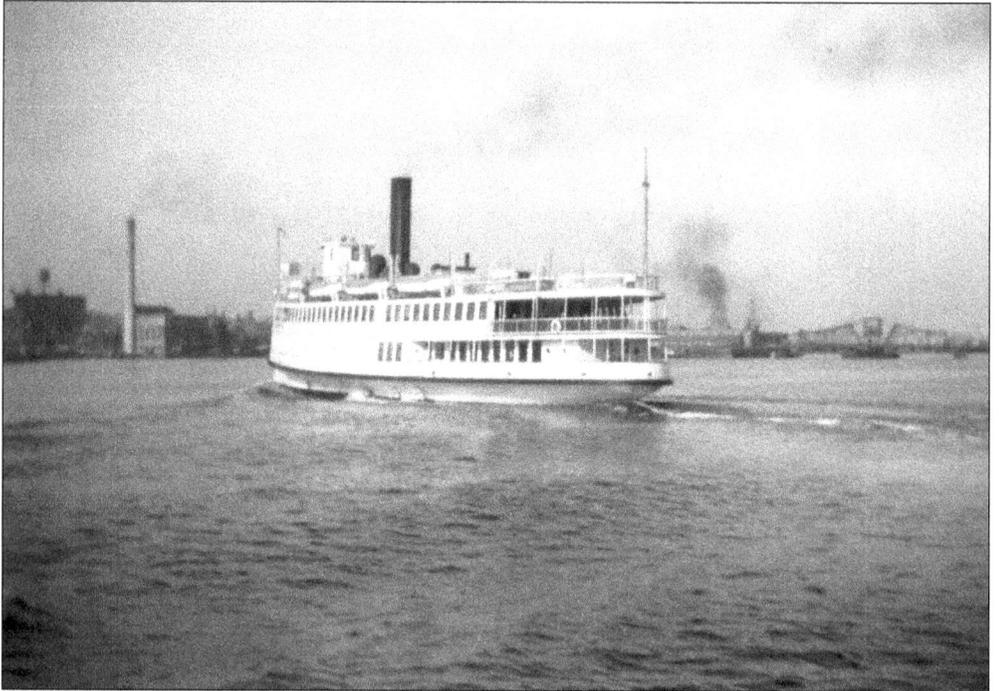

In this late afternoon view, the *Martha's Vineyard* is in the harbor at New Bedford and heading for her wharf. Repainted in gleaming white, her appearance is greatly improved over the drab gray that she and her fleet mates endured for a year. (Photograph by Dan Streeter; courtesy of Rosemary Bottum.)

In the steamboat era, visitors to the islands would say that their vacation began when they boarded the ship. Dan Streeter, who took some of the photographs in this book, is clearly in vacation mode aboard the *Martha's Vineyard*. (Courtesy of Rosemary Bottum.)

The *Martha's Vineyard* is seen here at Long Wharf in Newport. Visible is the NE logo that was added to the smokestacks of the first three of the White Fleet steamers in 1934. In the background is the famous Fall River Line steamer *Priscilla*. The Fall River Line, another of the New Haven's New England Steamship Company lines, operated large side-wheel night boats between Fall River, Newport, and New York. (Photograph by William K. Covell; author's collection.)

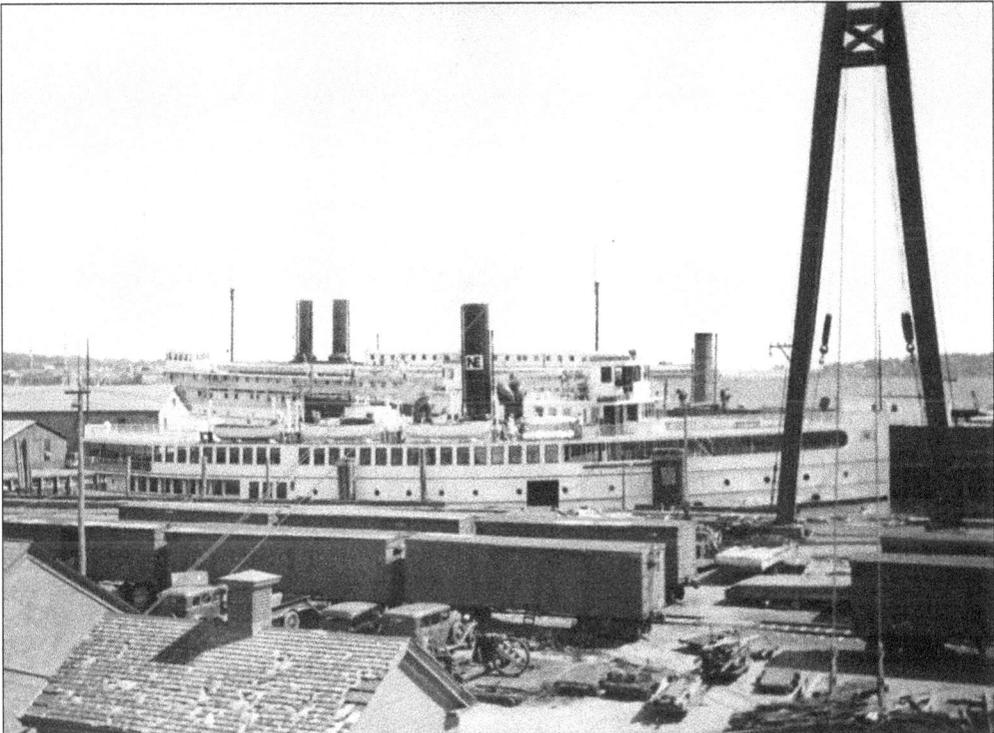

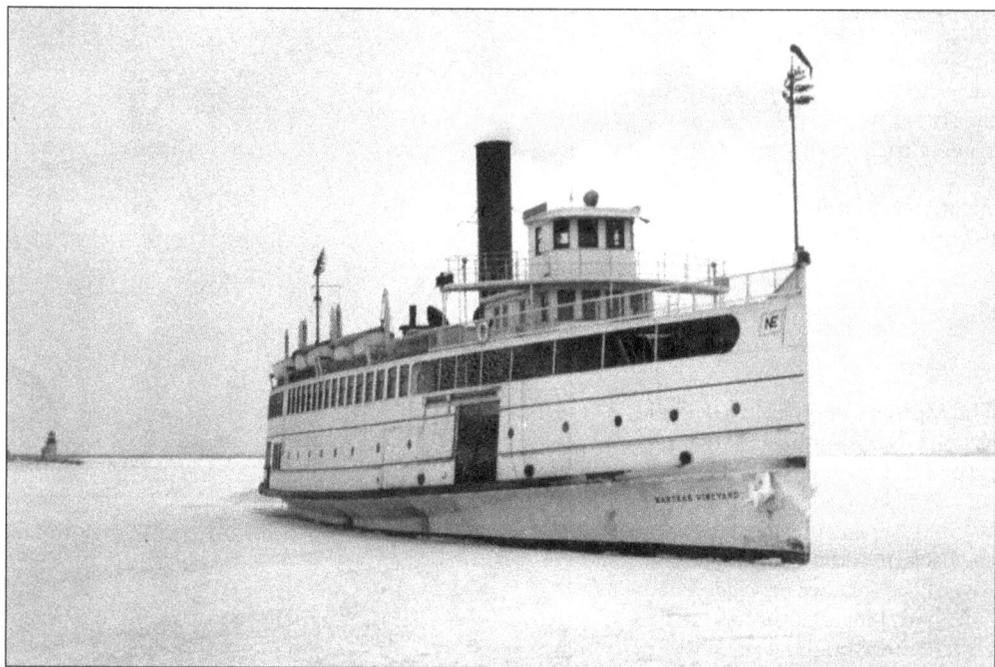

It is a cold, gray day on Nantucket as the *Martha's Vineyard* approaches the wharf through the frozen harbor. This must have been during the Holiday season, as she sports Christmas trees at both mastheads. In the background is the Brant Point lighthouse. (Courtesy of Mark Snider.)

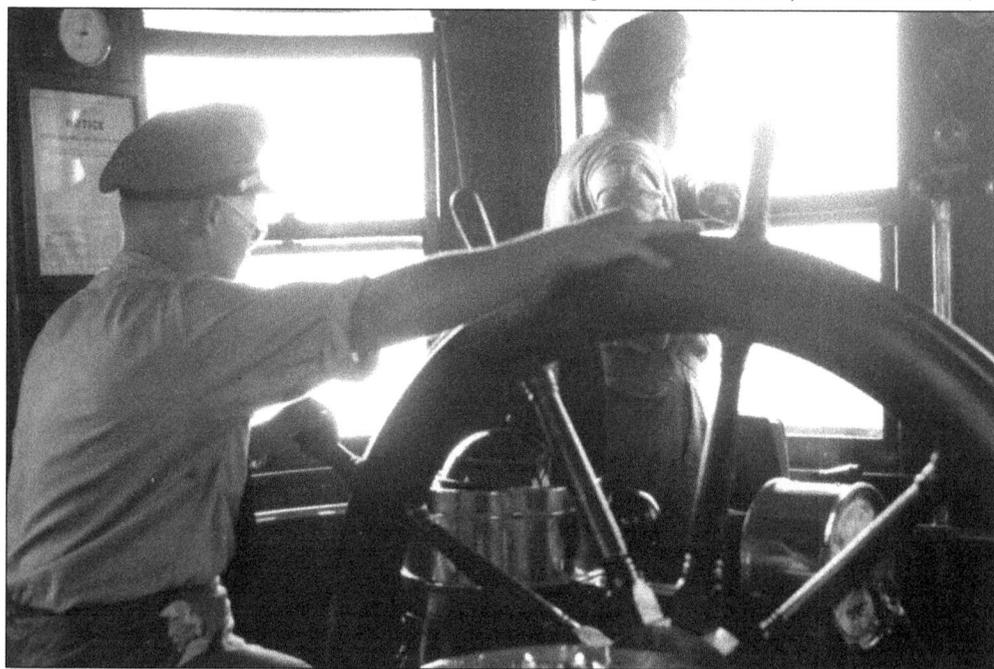

In this interior view of the *Martha's Vineyard's* pilothouse, the quartermaster, at the wheel, is studying the binnacle, and the captain or pilot is looking forward out the window. Note the large spaces between the windows. To improve visibility, this was changed on the *Nobska*, the next steamer in the fleet.

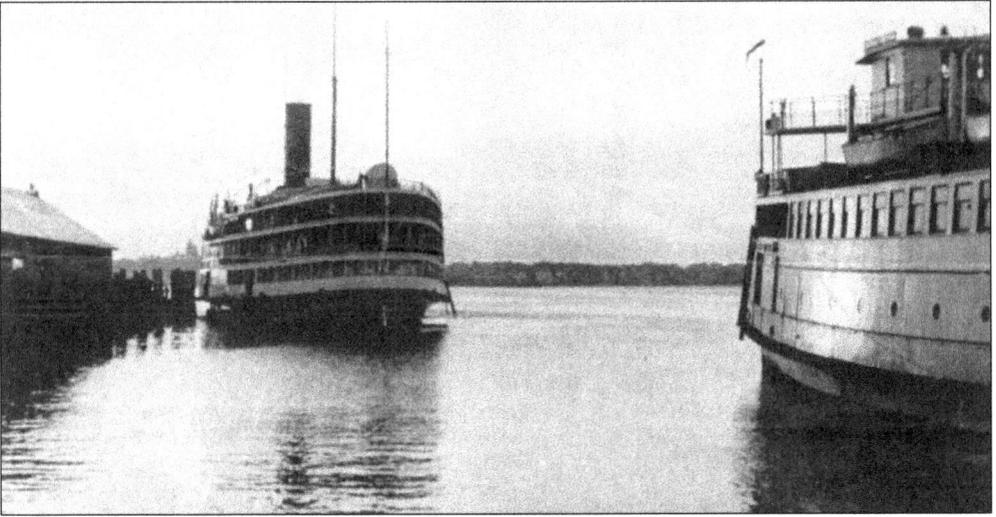

As mentioned earlier, New Bedford was a very active steamboat port. In this early-morning view, the sun is rising over Fairhaven as the New Bedford Line steamer *Plymouth*, just arrived from New York, is backing into her slip. On the right, the *Martha's Vineyard* will soon be making her first trip of the day to the islands. On board will be passengers from the *Plymouth*.

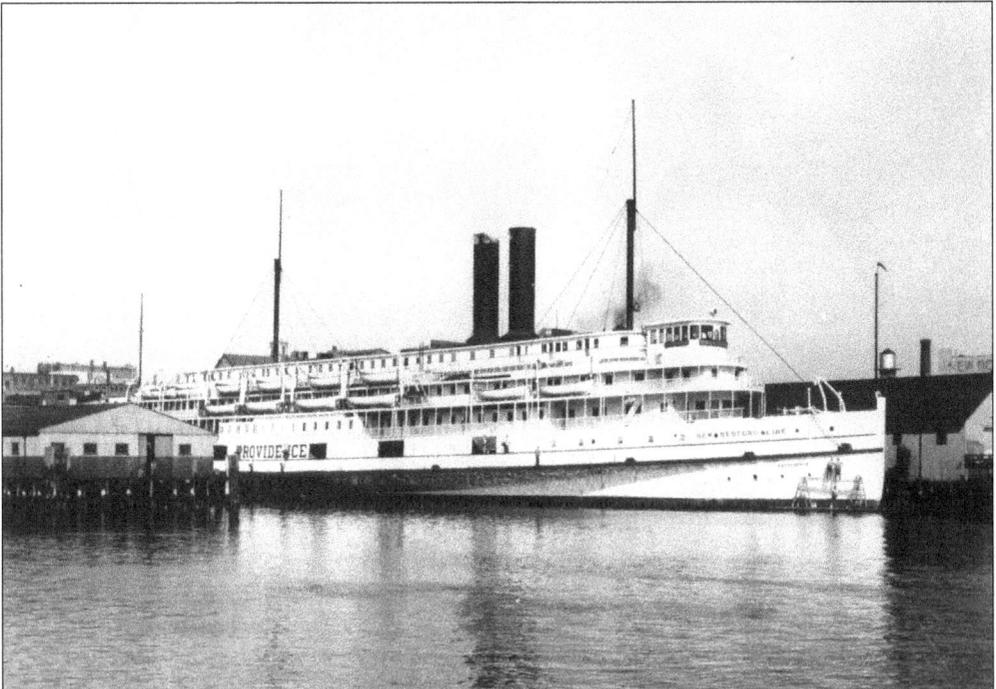

The *Providence* was another of the big side-wheel night boats of the New England Steamship Company that ran on the New Bedford Line. Like the *Plymouth*, she often served as a winter boat on the Fall River Line. Here, she is at New Bedford between trips. On the left is the island steamboat wharf, and directly behind her after mast is the cupola of the Whaling Museum. (Photograph by William K. Covell; author's collection.)

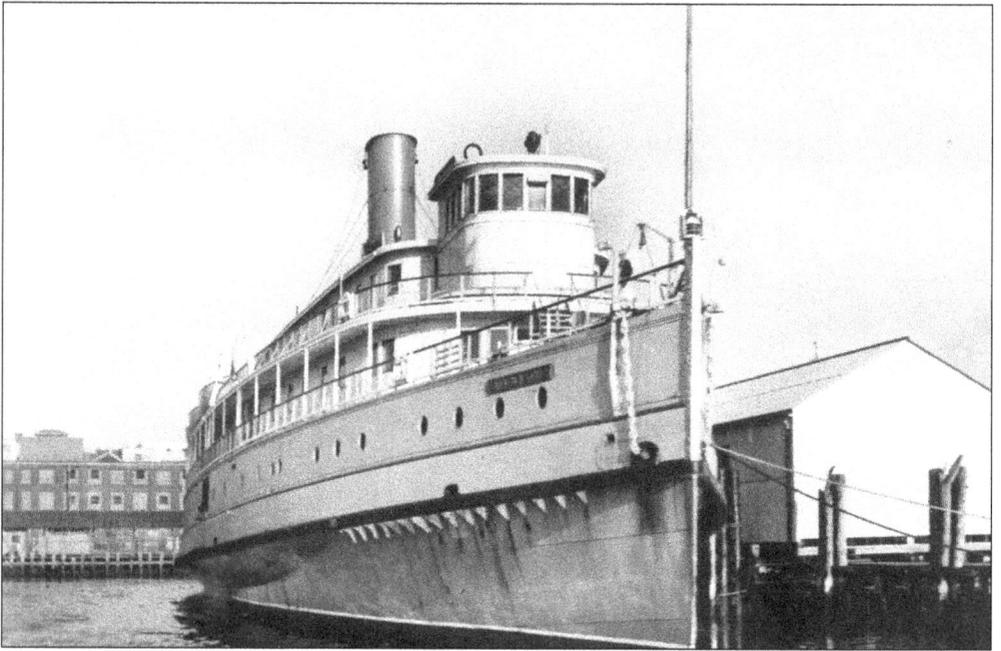

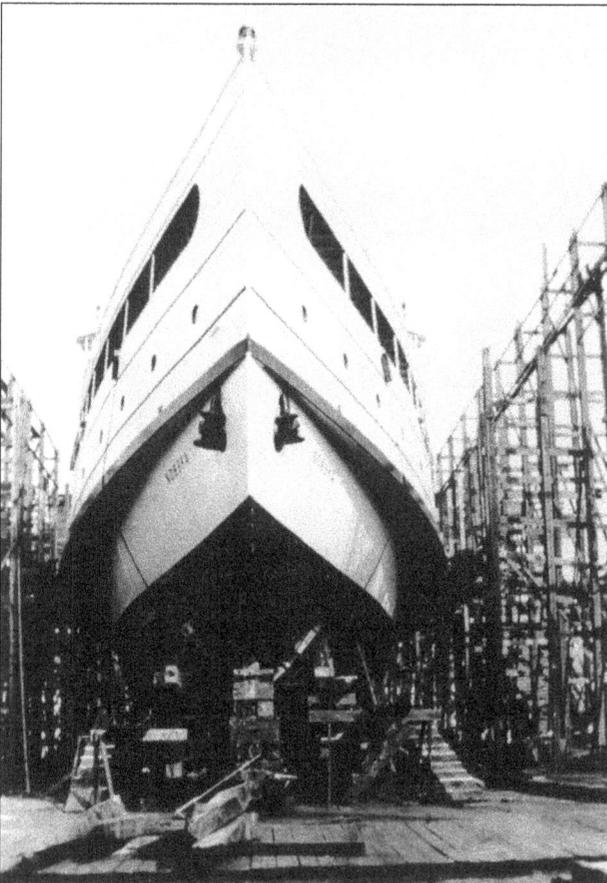

After the New England Steamship Company closed down its night lines in 1937, their Providence Line steamer *Chester W. Chapin* was purchased by the Colonial Line. Refurbished and renamed *Meteor*, she was placed in overnight service between New Bedford and New York. She is seen here at her New Bedford wharf. The line was the last to operate regular passenger service between the two cities, connecting with the island steamers. (Photograph by R. Loren Graham; author's collection.)

With the loss of the *Sankaty*, the island line quickly needed another modern steamer. The *Islander* was so successful that the same plans were used, with minor changes, for the new steamer to be named *Nobska*. In this view, her bow looms over the building ways at the Bath Iron Works in Maine. She was launched without fanfare, and with steam up, on March 24, 1925. (Photograph by Richard Berry; author's collection.)

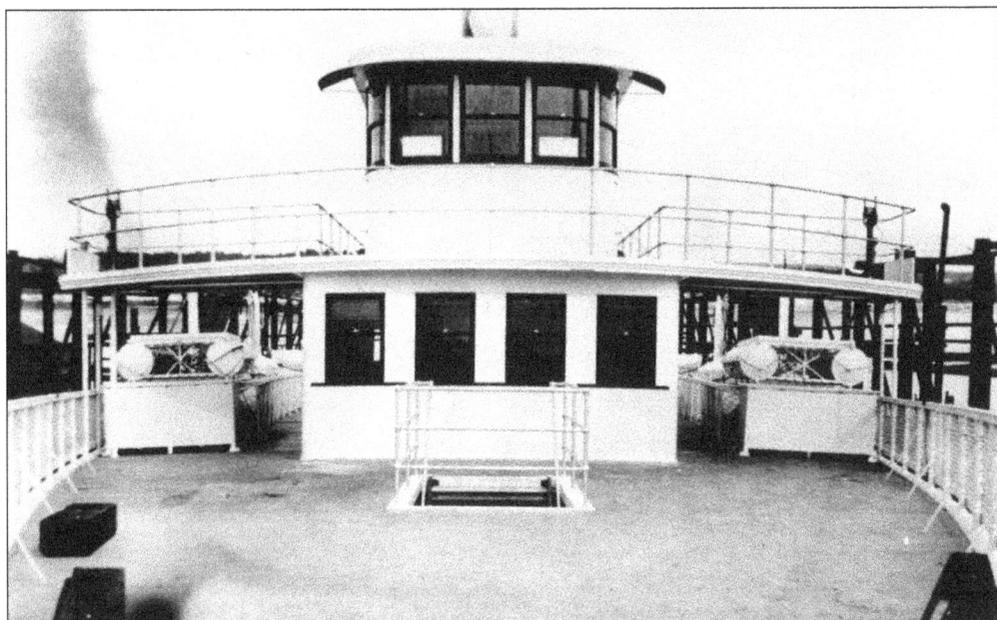

This view of the *Nobska's* pilothouse, taken before launching at Bath, clearly shows the absence of the large spaces between the windows like the *Islander* had. This is the easiest way to tell the two steamers apart at a glance. After launching, the *Nobska* steamed to Newport for finishing touches and provisioning. She made her maiden voyage on April 9, 1925. (Photograph by Richard Berry; author's collection.)

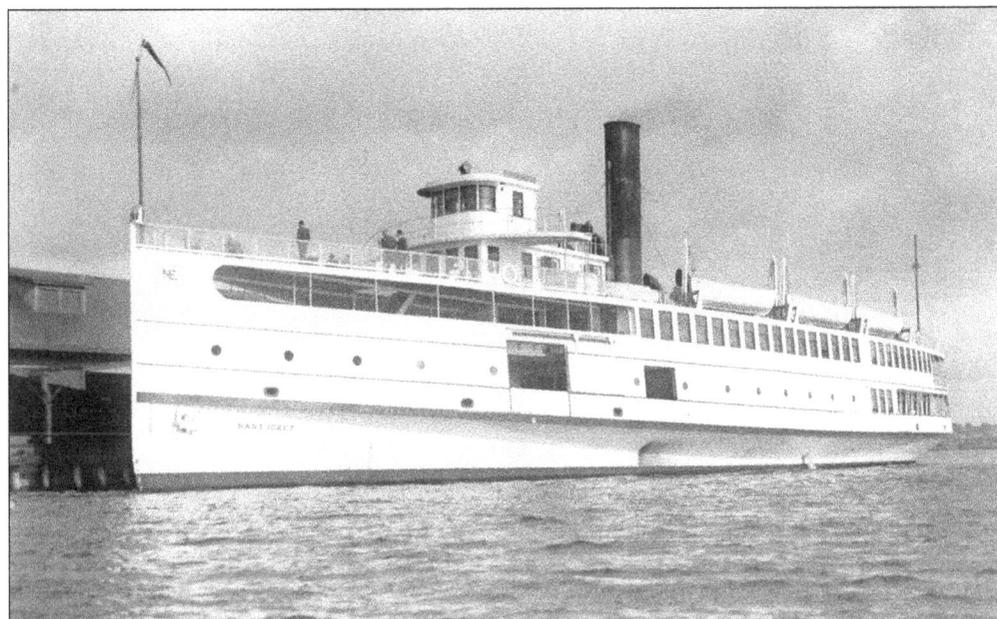

In 1928, at the same time the *Islander* was renamed *Martha's Vineyard*, the *Nobska* was renamed *Nantucket*. She is seen here tied up at the end of Long Wharf in Newport. She has the NE on her smokestack in raised letters, but there is no white background behind the letters. Perhaps her stack was recently painted, and the white was still to be added. (Photograph by William K. Covell; author's collection.)

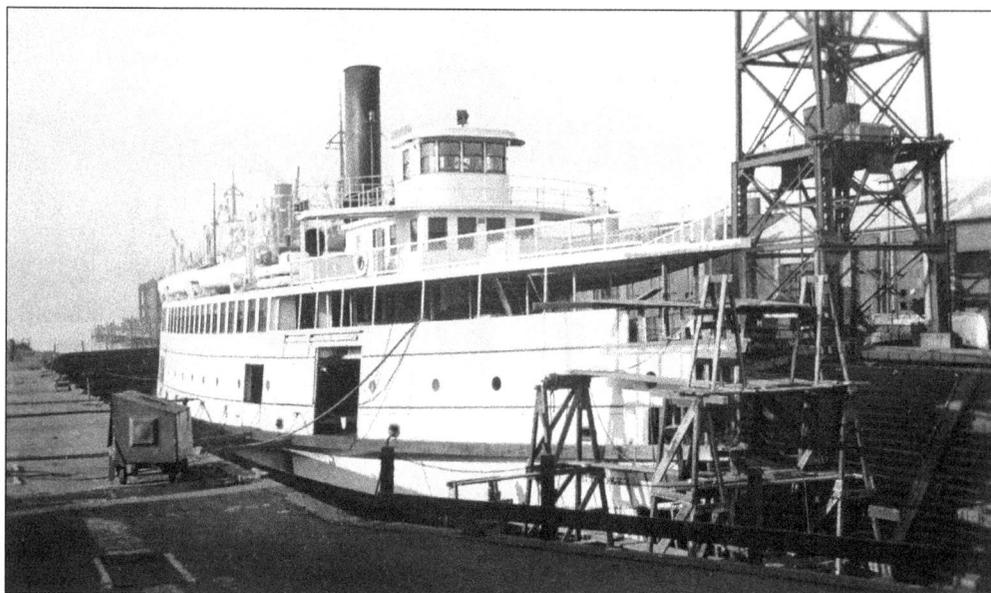

On August 6, 1932, the *Nantucket* rammed the *Martha's Vineyard* in a thick fog. Both vessels were able to proceed to Martha's Vineyard under their own power. With temporary repairs, the *Martha* was able to return to service. The *Nantucket*, however, had to go into dry dock in East Boston, as seen here, to have her bow rebuilt. This incident finally prompted the company to install wireless on the steamers. (Photograph by R. Loren Graham; author's collection.)

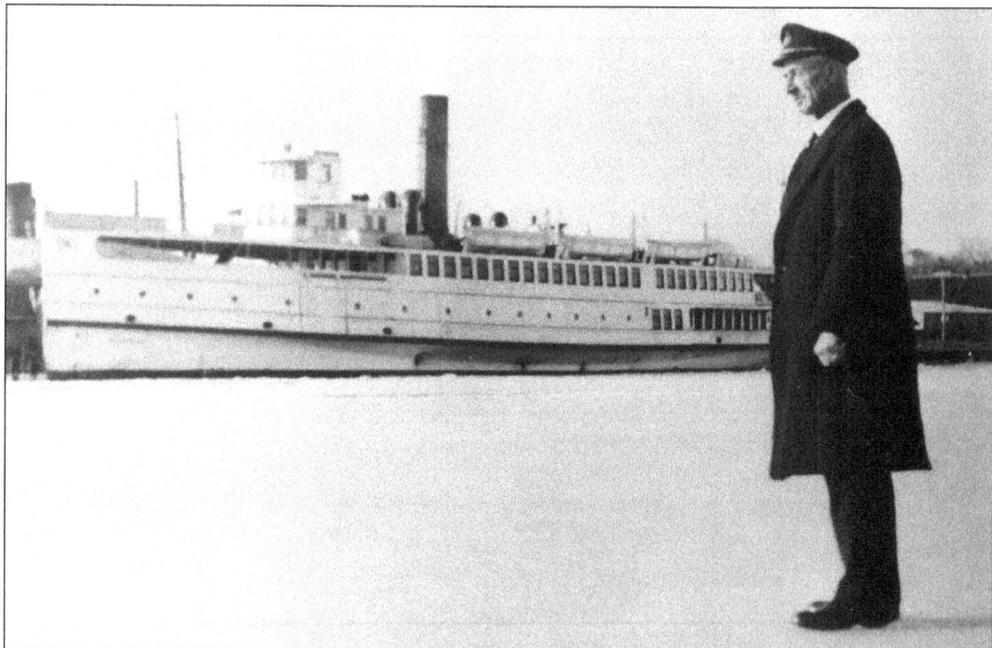

1934 must have been a cold winter. In this February view, the *Nantucket* is frozen in at Vineyard Haven. Standing in the foreground is Capt. James Negus, who had walked out on the ice to take some photographs of his own. The smokestack in the background probably belongs to one of the large coastwise tugs that would often put into Vineyard Haven to wait out bad weather. (Photograph by Ed Gavitt; courtesy of the New England Steamship Foundation.)

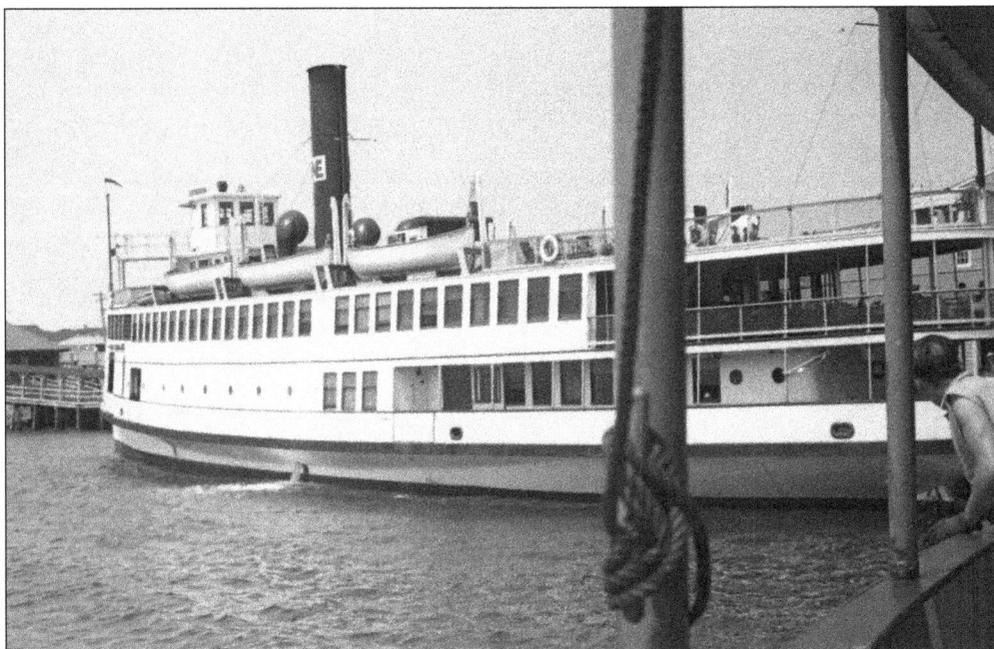

In this interesting view, the *Nantucket* is at the south side of the wharf at Oak Bluffs. She was photographed from the *Naushon* as she was making the approach to tie up at the end of the pier. A deckhand is looking forward, getting ready to handle the lines. (Photograph by William Ewen Sr.; author's collection.)

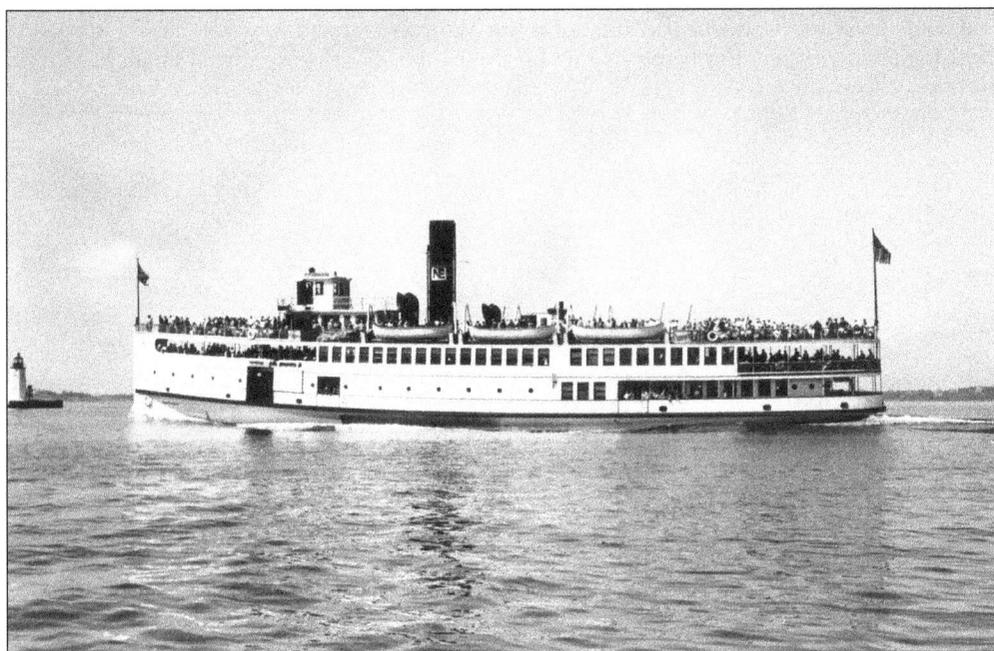

The *Nantucket* is seen here entering the harbor at Newport, Rhode Island, with a large crowd of passengers on board. The photograph is not dated, but it could have been taken during the time of an America's Cup competition. The lighthouse in the background is on the north end of Goat Island. (Photograph by William K. Covell; author's collection.)

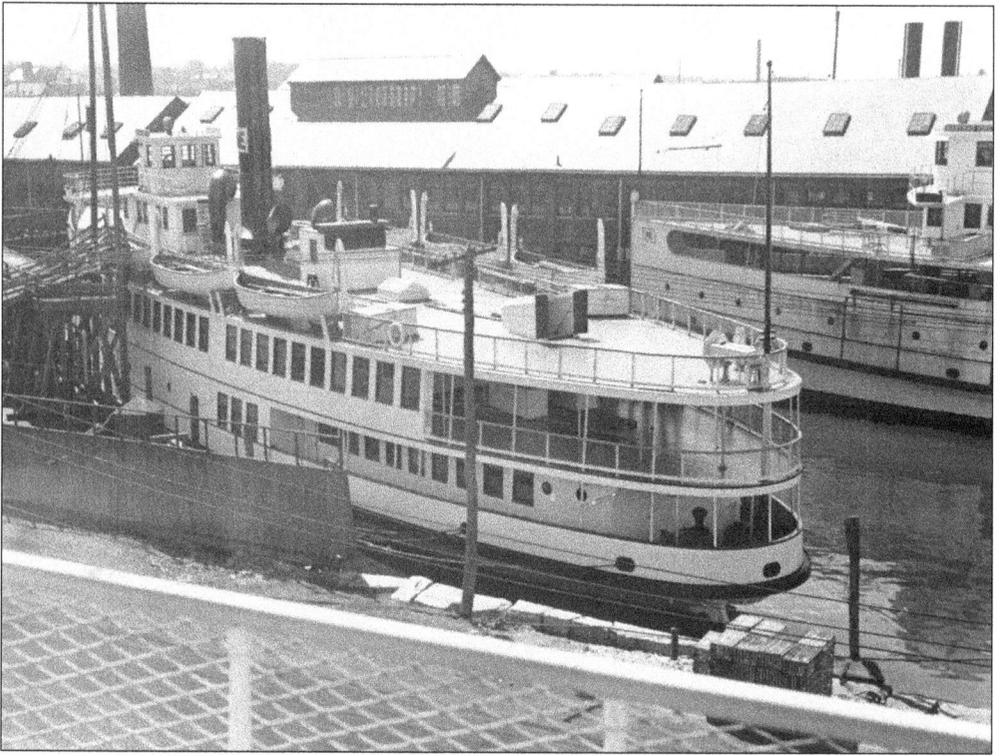

In another view at Newport, the *Nantucket* is in a slip at Long Wharf. She looks freshly painted and ready to return to service. Behind her is the *Martha's Vineyard*, which is clearly in need of cleaning and painting after being tied up for the winter. (Photograph by William K. Covell; author's collection.)

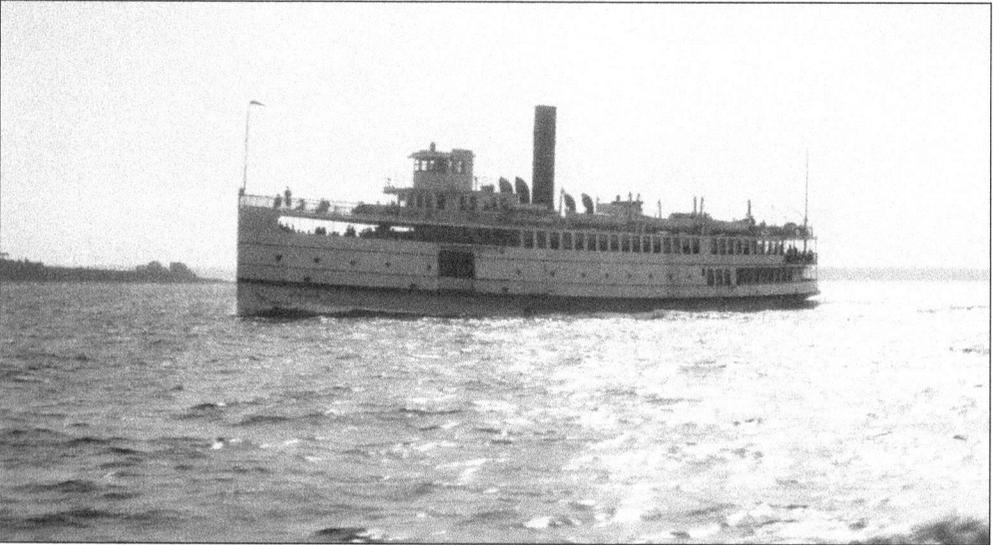

The late-afternoon sun silhouettes the *Nantucket* as she heads into Woods Hole on a return trip from Nantucket and Martha's Vineyard. Though not fancy, the *Nantucket* and her fleet mates were graceful and nicely proportioned vessels. They were also good sea boats. (Photograph by Dan Streeter; courtesy of Rosemary Bottum.)

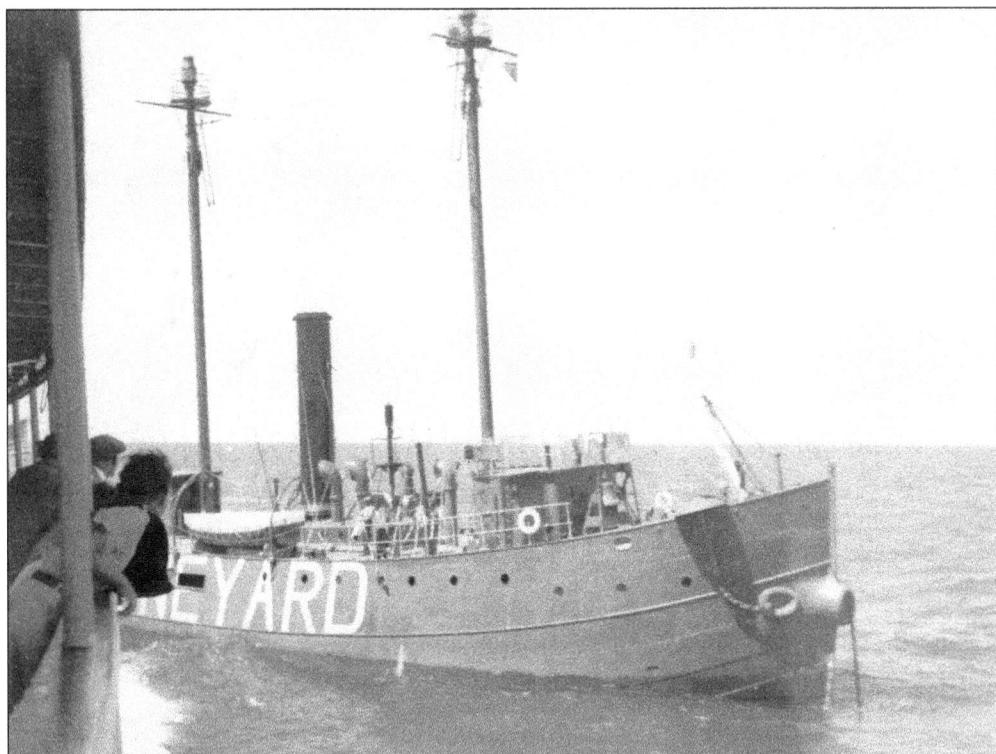

Up until 1936, when the Coast Guard banned the practice, the steamers would often run in close to the lightships, and rolled-up newspapers and magazines would be thrown to the crews of the lightships. This rare view was taken from the *Nantucket* as she passed close to the *Vineyard* lightship. (Photograph by William K. Covell; author's collection.)

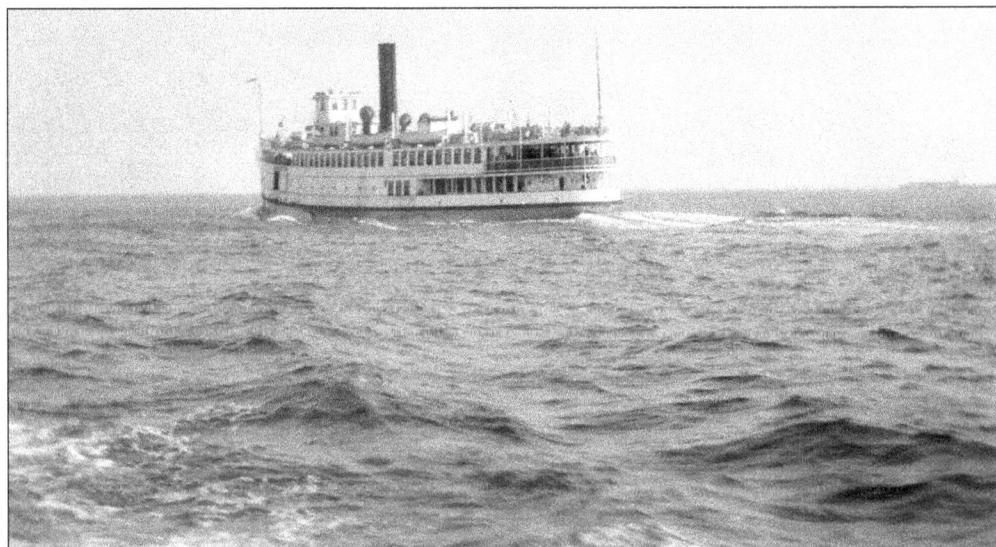

In this image, the *Nantucket* is off Oak Bluffs, running at full ahead. She will change course and head for the Oak Bluffs wharf on the right in the distance. The steamer that the photographer was on is just crossing the waves from the *Nantucket's* wake. (Photograph by Dan Streeter; courtesy of Rosemary Bottum.)

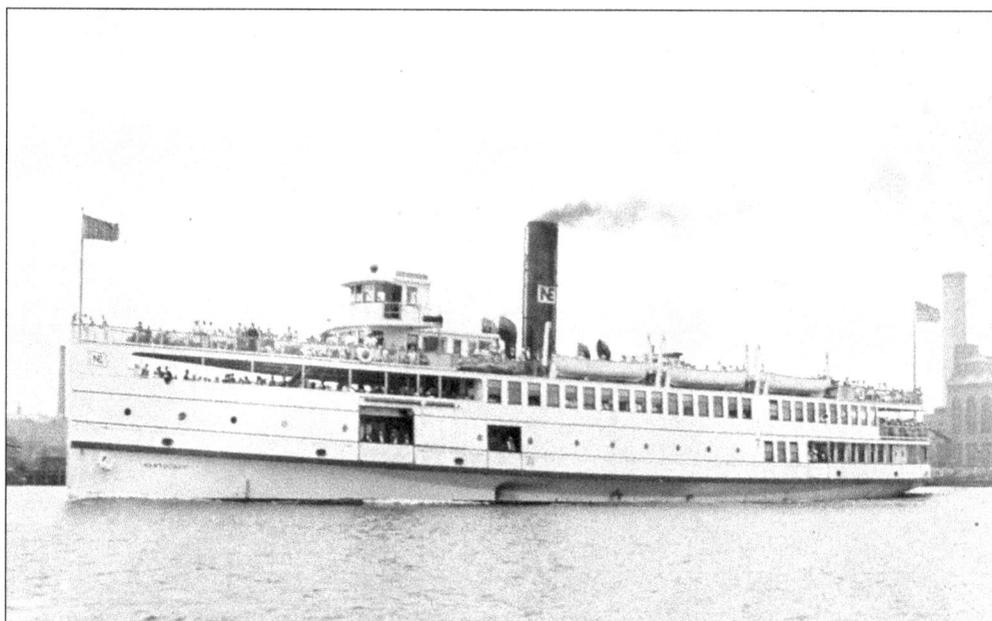

With traffic down during the Depression, not all of the steamers were needed for the regular island service. From 1933 until 1936, the *Nantucket* was based in Providence, running day trips to Oak Bluffs. Although a long trip, it gave people in Southern New England easier access to the island. Here, she has just left her Fox Point wharf and is headed down the Providence River. (Photograph by R. Loren Graham; author's collection.)

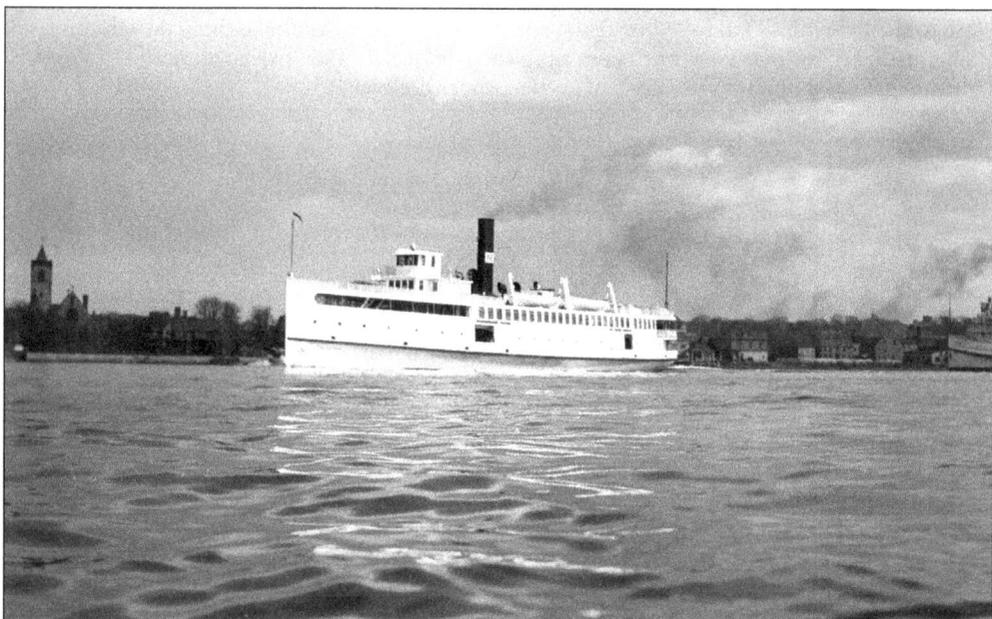

The year 1928 saw the addition of the third of the White Fleet steamers. She was the *New Bedford*, launched on May 5 of that year. She went into service on May 26. Unlike the *Islander* and *Nobska*, which were built in Bath, Maine, she was built at the Fore River Shipyard in Quincy, Massachusetts. This dramatic photograph shows her underway at Newport, Rhode Island. (Photograph by William K. Covell; author's collection.)

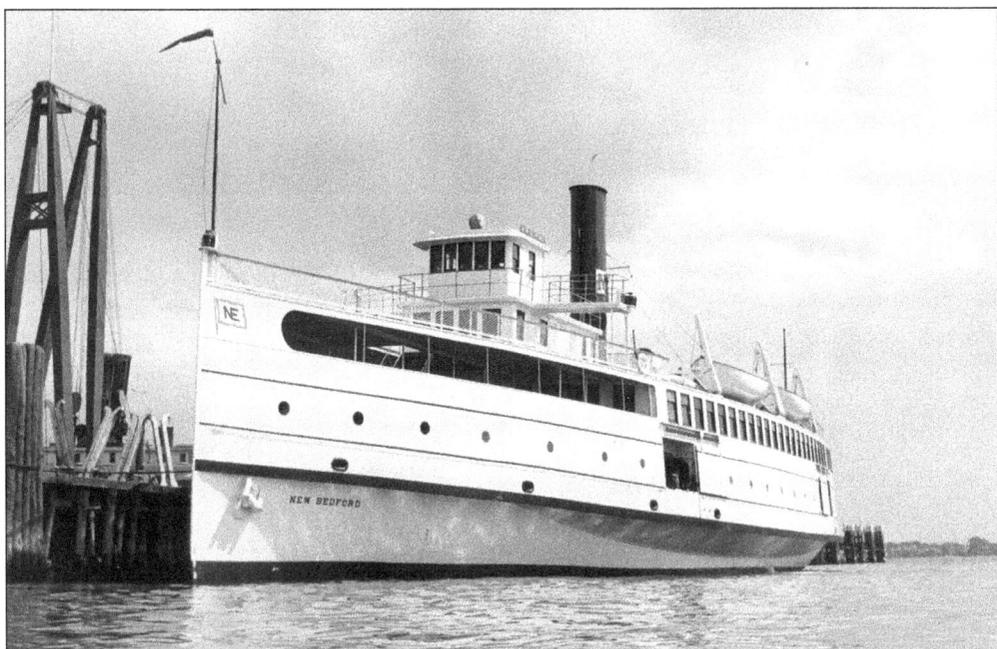

Although the same basic plans were used, the *New Bedford* differed from the *Islander* and *Nobska* in several ways. One visible difference can be seen in this view of her at Long Wharf in Newport. Her pilothouse was much squarer than those on the other two steamers. (Photograph by William K. Covell; author's collection.)

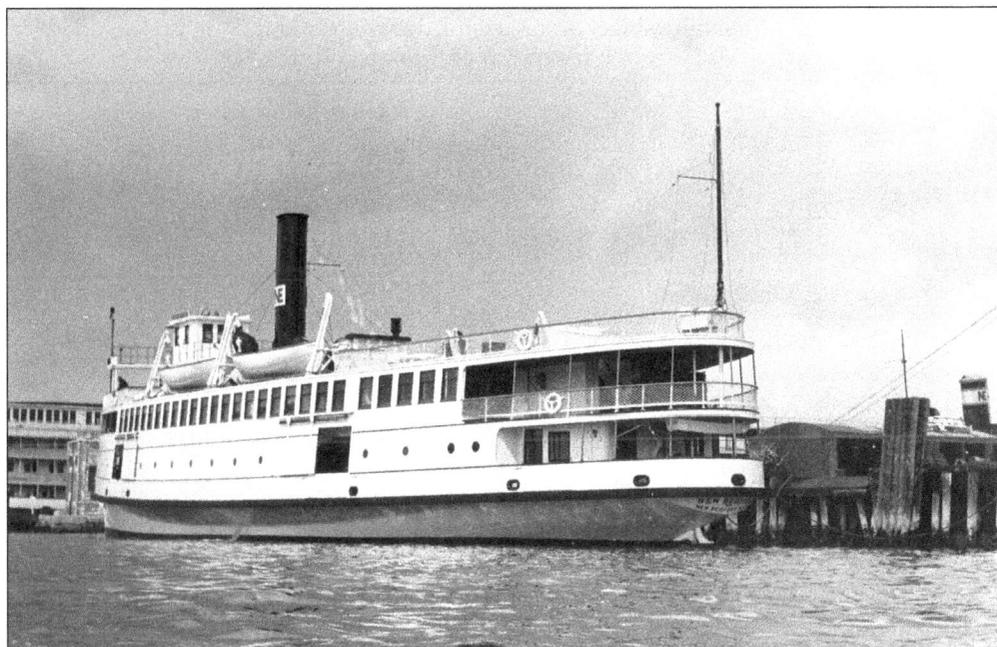

On the *New Bedford*, the lunch counter and purser's office were moved from the main deck to the second deck. This enabled the freight space on the main deck to be increased, allowing for more automobiles. As can be seen in this stern quarter view, the enclosed part of her main deck extends farther aft than on her predecessors. (Photograph by William K. Covell; author's collection.)

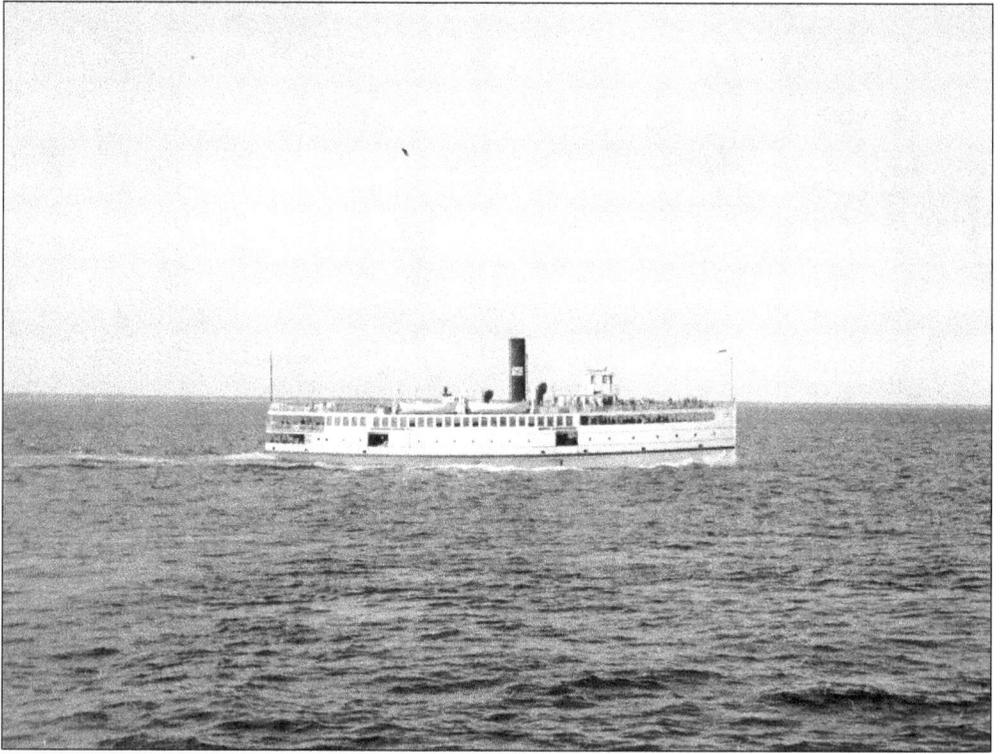

In this broadside view, the *New Bedford* is underway to the islands. It is late afternoon, and the steamer that the photograph was taken from is most likely inbound to Woods Hole and New Bedford. (Photograph by Dan Streeter; courtesy of Rosemary Bottum.)

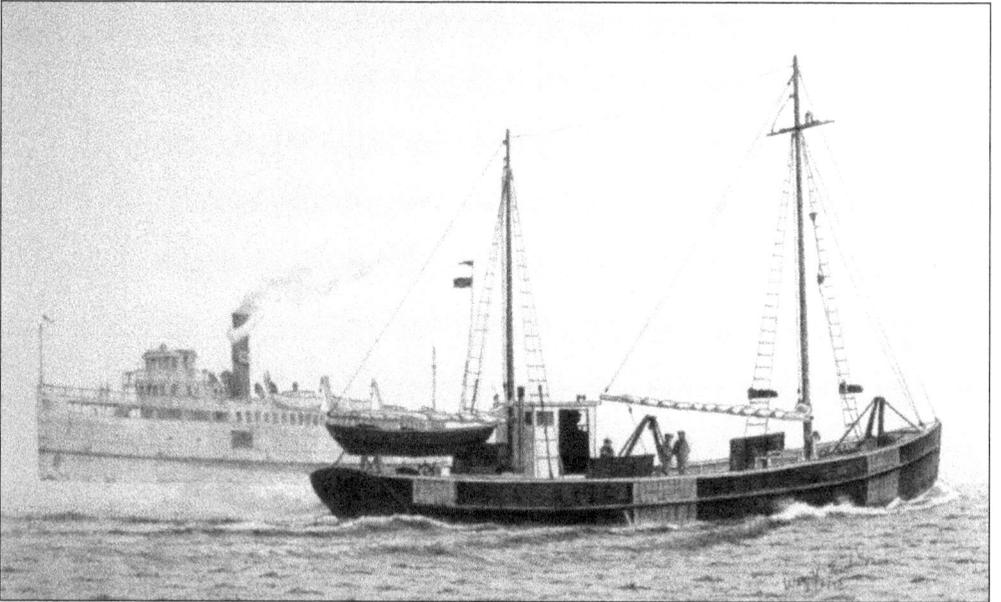

In this drawing by the author, an Eastern Rig–type dragger from New Bedford is heading out into the fog on Buzzard's Bay. In the background, proceeding cautiously, with her whistle blowing, the *New Bedford* is inbound to her namesake city. (Courtesy of George Fisher.)

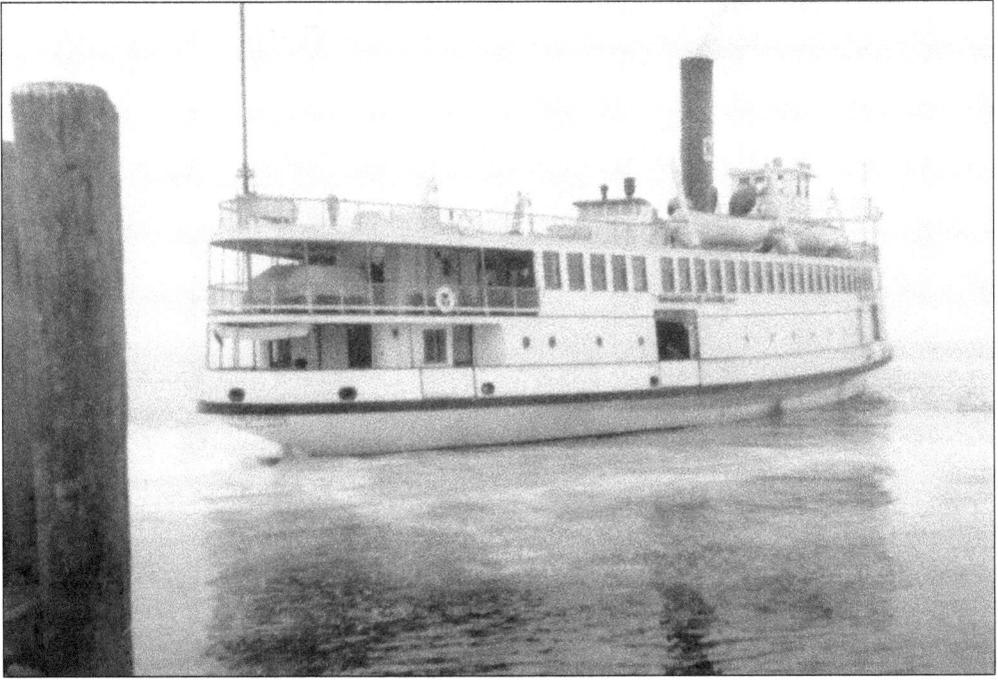

In this image, taken on a foggy April 4, 1938, it appears that *New Bedford* has just backed around from the end of the wharf at Woods Hole. The steamers would often tie up at the head of the wharf here to unload and load. To depart, they would have to back around the corner on a spring line, to the south side of the wharf, before heading out. (Photograph by Joseph Allen; author's collection.)

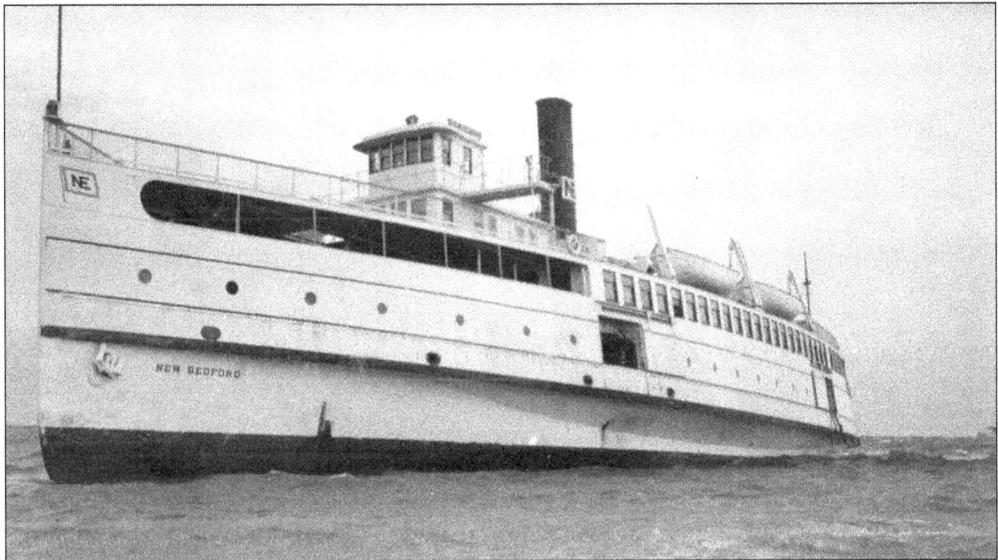

On the evening of September 30, 1934, the *New Bedford* hit Weepecket Rock at the narrow entrance to the Woods Hole channel. With several plates ruptured, she had to be beached on Uncatena Island to prevent her from sinking in deep water. After being refloated and having temporary repairs made, she went to Boston to have the damaged plates replaced. (Courtesy of Mark Snider.)

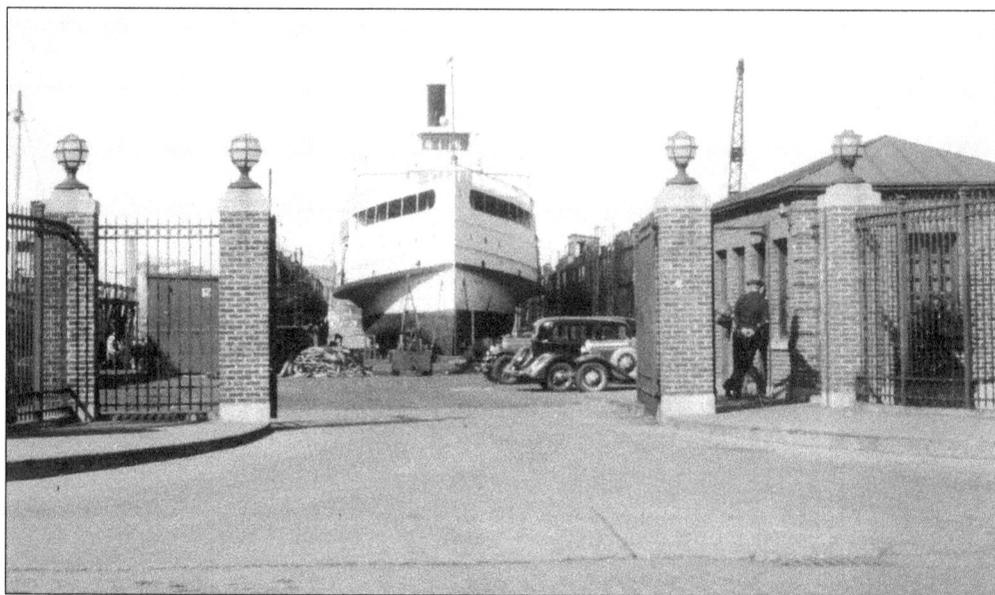

This photograph was taken in October 1934 and shows the *New Bedford* in dry dock at the Atlantic Works in East Boston. She was in the process of having permanent repairs made to her hull after the mishap on September 30. (Photograph by William K. Covell; author's collection.)

In this winter view taken from the Fall River Line steamer *Commonwealth*, the *New Bedford* is seen laid up at Newport. Behind her, also in layup, is the larger *Naushon*. The buildings in the background were all part of the New England Steamship Company's Long Wharf facilities. The roadway on the pier in the foreground now crosses a causeway to Goat Island. (Photograph by William K. Covell; author's collection.)

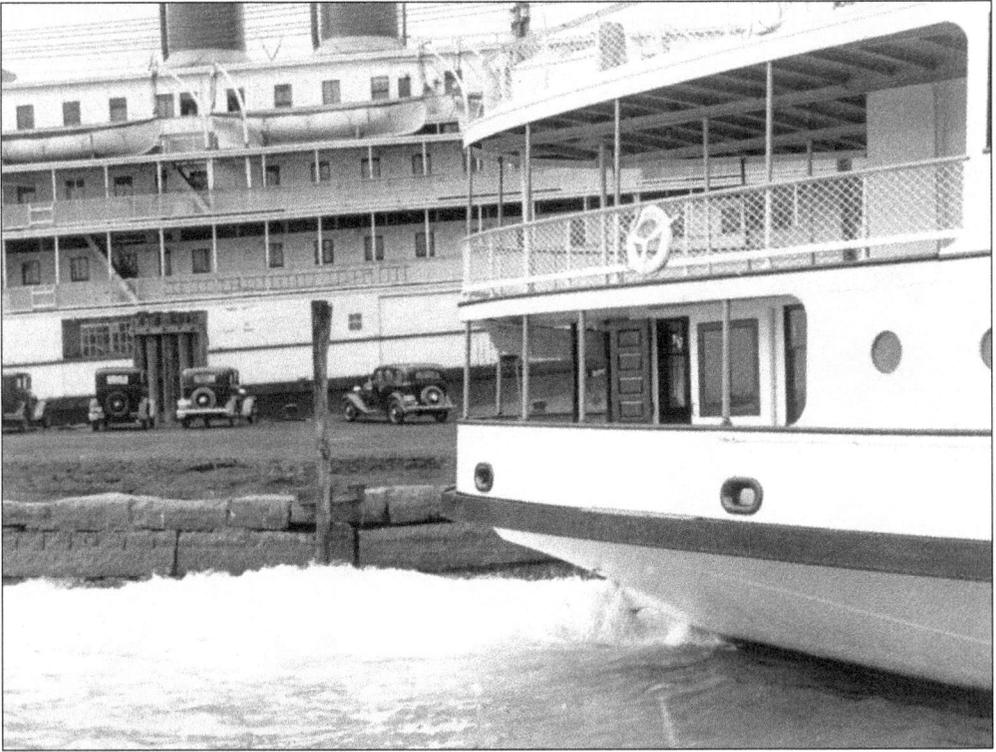

This is a close-up view of the *New Bedford's* stern. She is in the same location at Long Wharf as in the previous image, and the *Commonwealth* is visible behind her. It is spring, and she has been freshly painted. While tied to the wharf, her engine is being tested before she reenters service. (Photograph by William K. Covell; author's collection.)

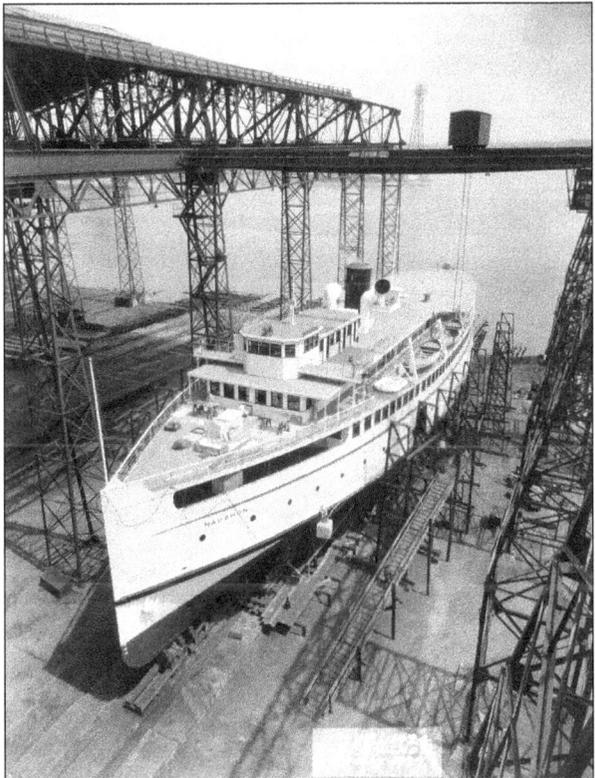

The *Naushon*, the last and largest of the White Fleet, joined the company in 1929. She is seen here on the building ways at the Fore River Shipyard in Quincy, Massachusetts. At 250 feet in overall length, she was the largest steamer to serve the islands. She was also the first to have twin screws. (Courtesy of the New Bedford Whaling Museum.)

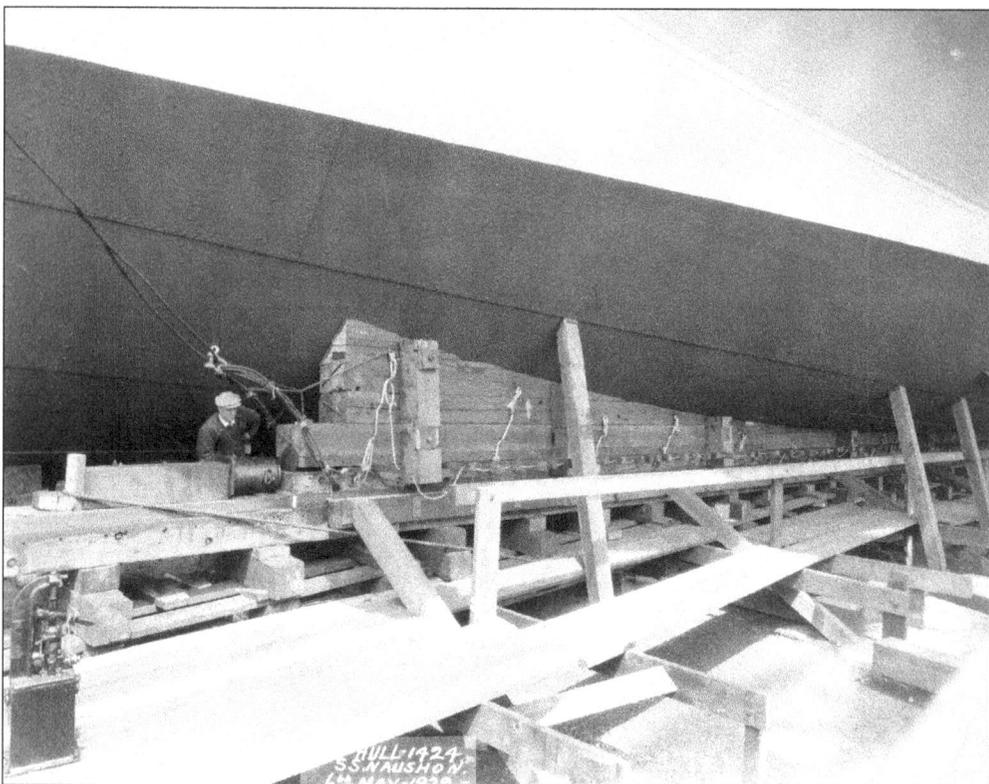

In this unusual view, a shipyard worker stands next to one of the launching rams that will be used to start the *Naushon* down the ways. She was launched on May 7, 1929, and was built at a cost of $650,000.

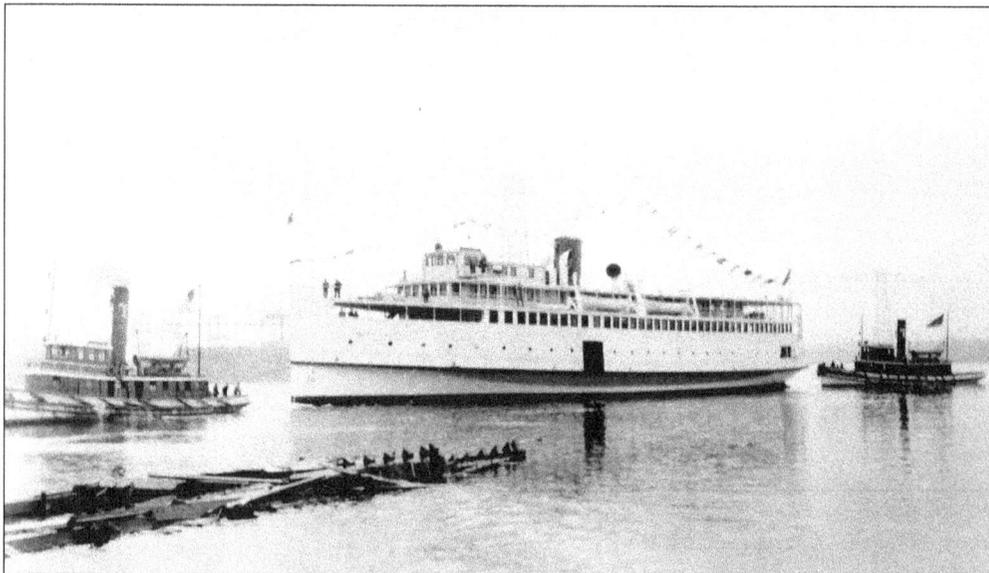

The *Naushon* has just been launched and is taken in tow by two T-Wharf Towboat Company tugs from Boston. They will move her into a fitting-out pier. Her smokestack ultimately had to be increased in height to keep fumes off the top deck.

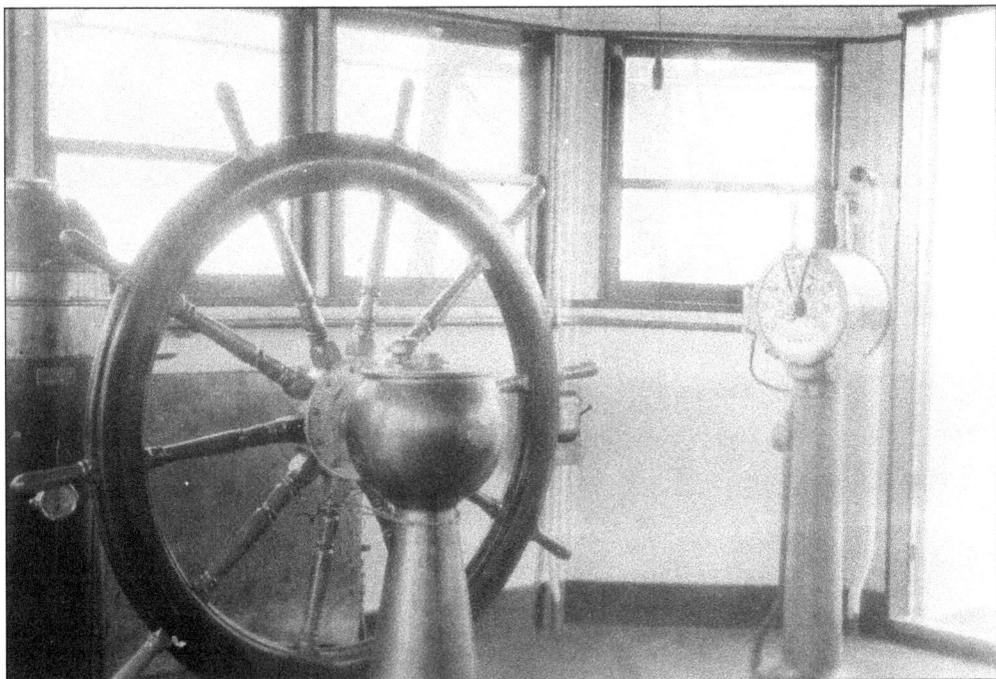

The interior of the *Naushon's* pilothouse is quite uncluttered, as seen in this photograph taken shortly after she was launched. Some furniture would be added, but there would be no radar, GPS, or any other electronics in 1929. (Photograph by William K. Covell; author's collection.)

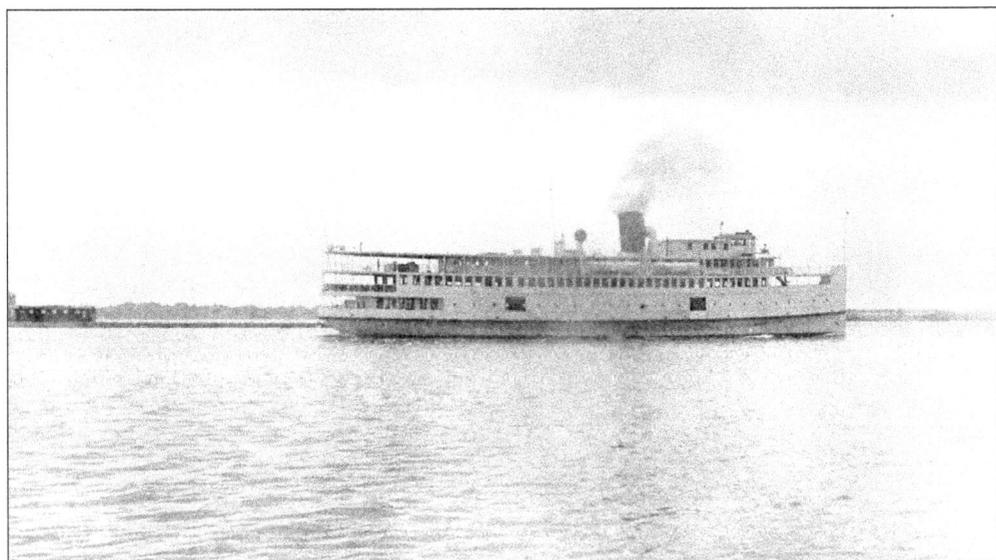

From the shipyard, the *Naushon* steamed to Newport for finishing touches and fitting out. On June 4, she sailed to Woods Hole and Oak Bluffs. From there, with dignitaries aboard, she went on to Nantucket. This view, taken at Newport in 1929, very likely shows her departing on that first trip. She still has the shorter stack at this time. (Photograph by William K. Covell; author's collection.)

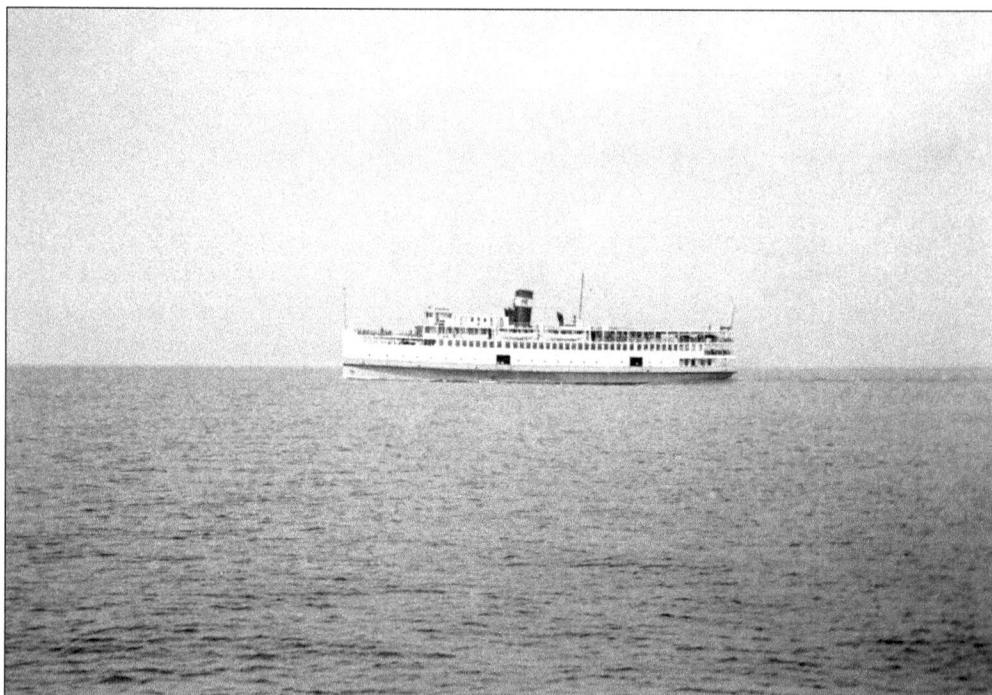

The *Naushon* is seen under way somewhere between Martha's Vineyard and Nantucket. Unlike her smaller fleet mates, she had been painted light-gray from her hull to the rail on her main deck. She also received the NE on her stack several years earlier than the others did. To those who knew the *Naushon* in service and for many years after, she was always considered the Queen of the Fleet. (Photograph by Dan Streeter; courtesy of Rosemary Bottum.)

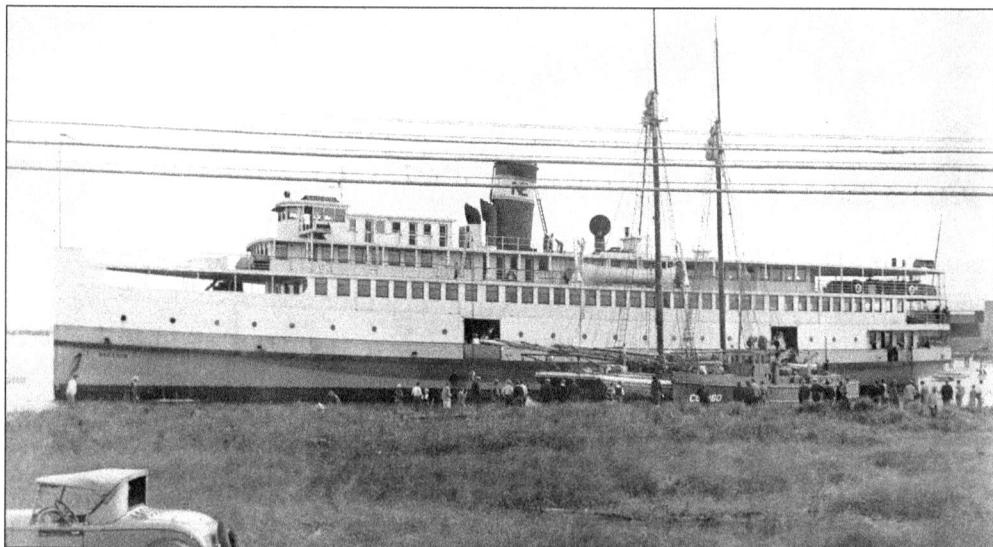

On August 24, 1931, the *Naushon* was approaching the wharf at Vineyard Haven in gale-force winds. Without warning, a Coast Guard vessel pulled out in front of her, and she had to swing away. While maneuvering for another approach, she was caught by the wind and pushed toward shore, taking the schooner *Alice S. Wentworth* and other craft with her. She is seen here where she came to rest. (Courtesy of Mark Snider.)

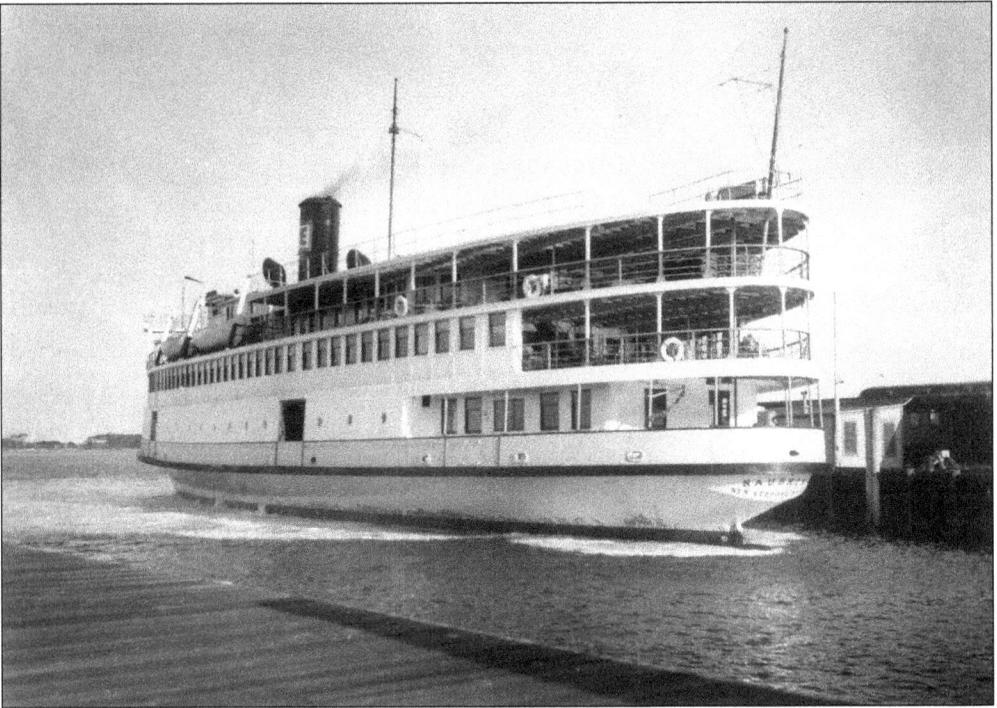

The *Naushon* is backing into the slip at Woods Hole. Because of her size, she was too large to tie up at the end of the wharf, as the other steamers did. Her bow and stern would have blocked access to the slips on either side. (Photograph by R. Loren Graham; author's collection.)

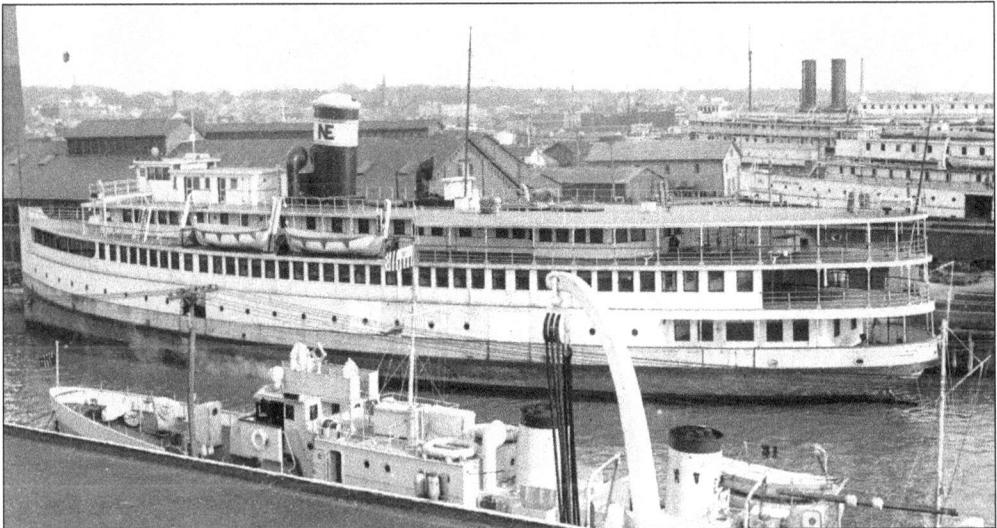

The *Naushon* had a total of 32 staterooms on two decks. The original plan was for her to fill in as a night boat in the New York service during the winter. While she did this at least once, the Depression put an end to that, and she spent most winters at Newport, as seen here. In the background are the steamers *City of Lowell* and *Priscilla*. (Photograph by Ralph Arnold; author's collection.)

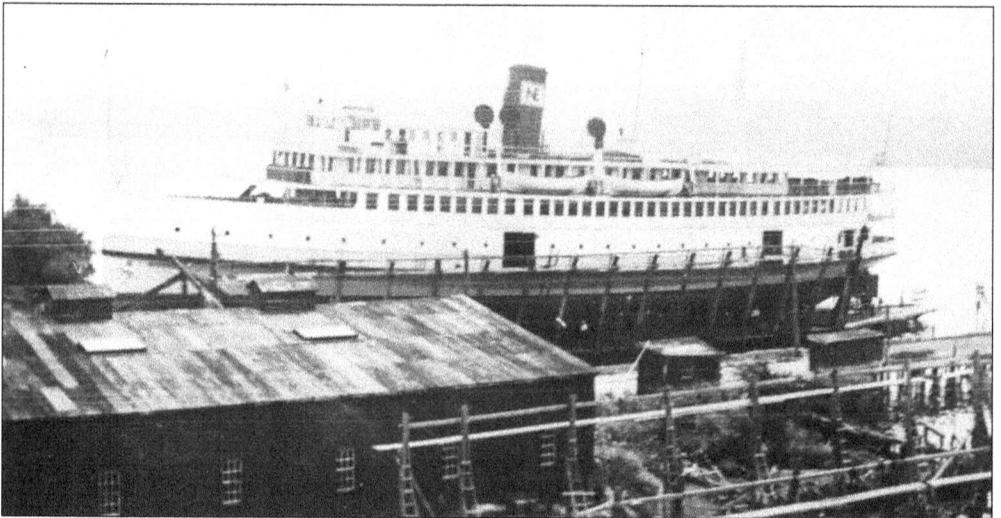

While the island steamers usually had shipyard work done in Boston or New York, they occasionally used other yards. In this view, the *Naushon* is on the marine railway at the Crowninshield Shipyard in Somerset, Massachusetts. She was in to have some work done on her propellers. This is the location of the present Gladding Hearn Shipyard. (Photograph by Ed Gavitt; courtesy of the New England Steamship Foundation.)

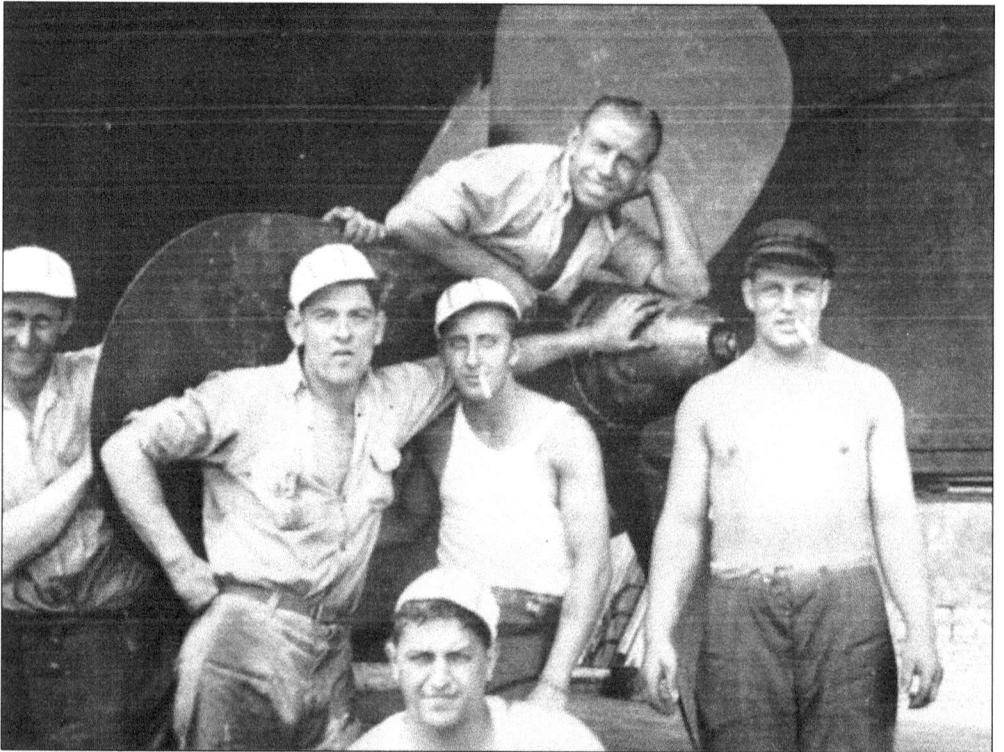

Several of the *Naushon's* crew pose by one of her propellers while at the Crowninshield Shipyard. Lying on the shaft is the boatswain, Tony Peters. Standing are, from left to right, unidentified, "Frenchy," Leo Quillette, and John Nemeth. Kneeling is ? Souza. (Photograph by Ed Gavitt; courtesy of the New England Steamship Foundation.)

The *Naushon* is seen here in the unpopular gray paint scheme of 1930. She is at the Long Wharf facilities in Newport and appears to be out of service. Possibly, she is being made ready for off-season layup. There is a ladder leaning on her smokestack, which might be used for placing a cover over the top of the stack. (Photograph by William K. Covell; author's collection.)

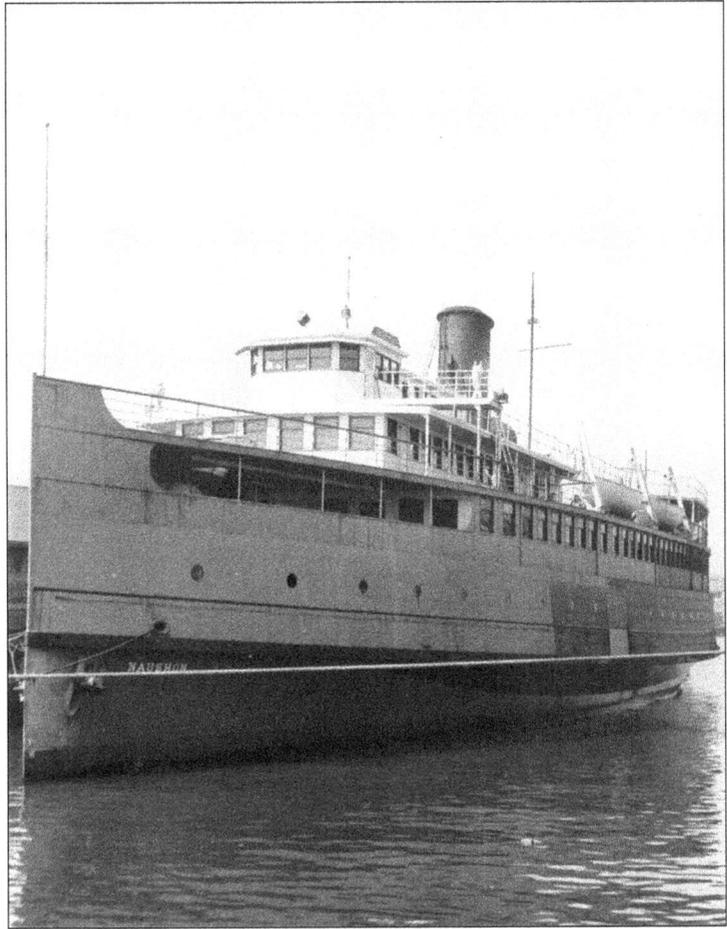

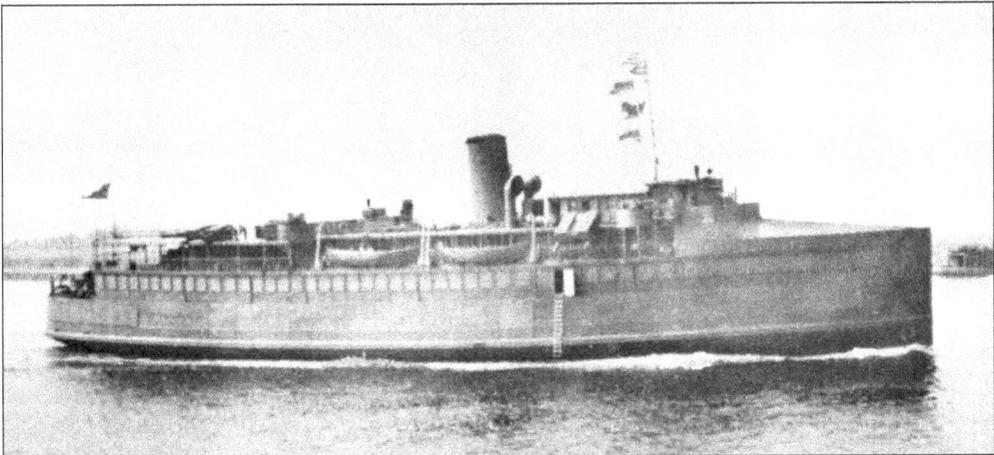

World War II had a long-lasting impact on the island line. In 1942, the War Shipping Administration requisitioned the two newest steamers in the fleet. The *Naushon* was taken first, on July 9. Both vessels were modified to cross the Atlantic and turned over to the British Ministry of Transport. Seen here is the HMS *Naushon* passing through the Cape Cod Canal on her way to join Convoy RB-1.

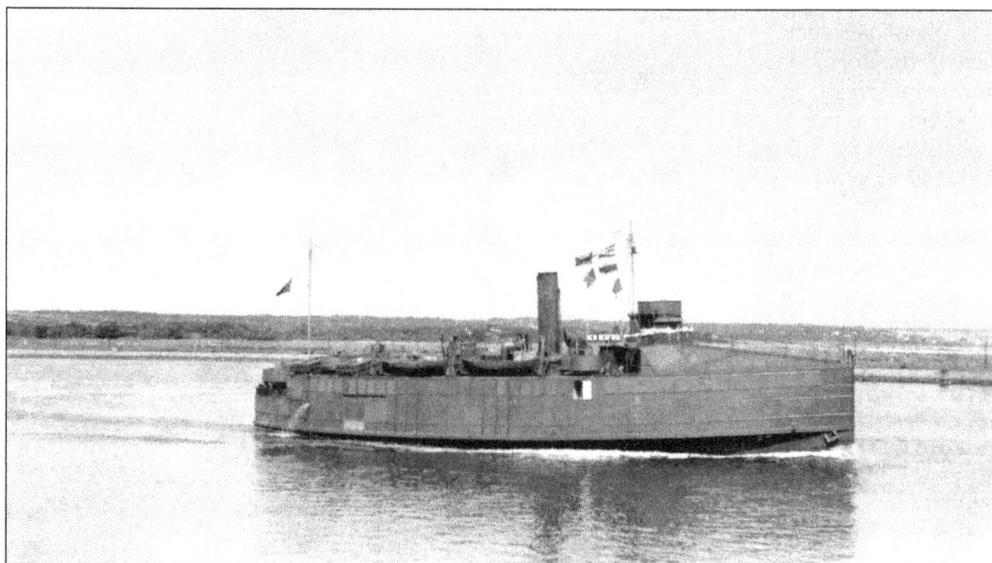

The *New Bedford* was taken next, on August 4. Both steamers sailed from Newfoundland on September 21 for the United Kingdom, in a convoy made up of eight coastal steamers escorted by two destroyers. The group was nicknamed the Honeymoon Fleet. German U-boats sank three of the vessels, but the *Naushon* and *New Bedford* made it to Scotland to begin their wartime service.

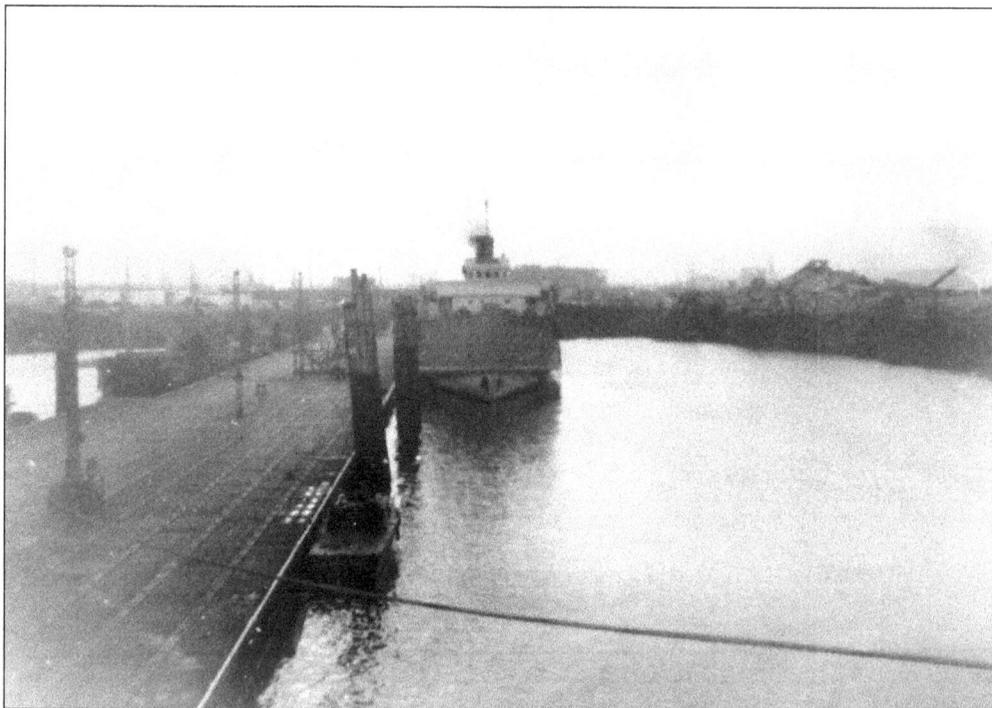

While not the best quality, this is a rare image of the *Naushon* in Europe. The camera is looking into the sun but the steamer can plainly be seen in this bow view at a wharf in France. A written notation on the back of the photograph says that it is probably in Brest. (Courtesy of the Vineyard Gazette.)

Five

AFTER THE WAR, MASSACHUSETTS STEAMSHIP LINES, AND THE STEAMSHIP AUTHORITY

During the war, the *Naushon* and *New Bedford* served as hospital ships, and both were at Normandy bringing the first wounded back to England. The *Naushon* had been renamed *Hospital Ship 49*. Both steamers also served as transports. Running between Southampton and Le Havre, they carried over 40,000 American troops across the English Chanel. After being laid up in Le Havre for a time, they returned to the United States under their own power, but they never returned to island service.

In 1937, the New England Steamship Company had abandoned all of its steamship operations except the island line. During the war, the *Martha's Vineyard* and *Nantucket* had been left to carry on. After the war, in December 1945, the New Haven Railroad sold the island line to a private corporation, Massachusetts Steamship Lines. This ended all operations of the New England Steamship Company.

In need of additional capacity, the company purchased the former Pennsylvania Railroad ferry *Hackensack* in 1946. Although not overly attractive, she was a sign of things to come. She was the first double-ender to serve the islands—a true ferryboat—where vehicles drove on one end and off the other. It is a mistake to refer to the earlier steamers as ferries.

After just a few somewhat turbulent years of Massachusetts Steamship lines ownership, which included strikes, unsatisfactory service, and not enough capital, a state commission was formed to look into steamboat service to the islands. It was concluded that a private company could not provide adequate and profitable year-round service. As a result, a state authority was established on June 11, 1948, to purchase and operate the steamboat line. On April 8, 1949, a bill was signed authorizing the takeover of the island line by the New Bedford, Woods Hole, Martha's Vineyard, and Nantucket Steamship Authority. Minus New Bedford in its name, the Authority still operates the ferries to the islands.

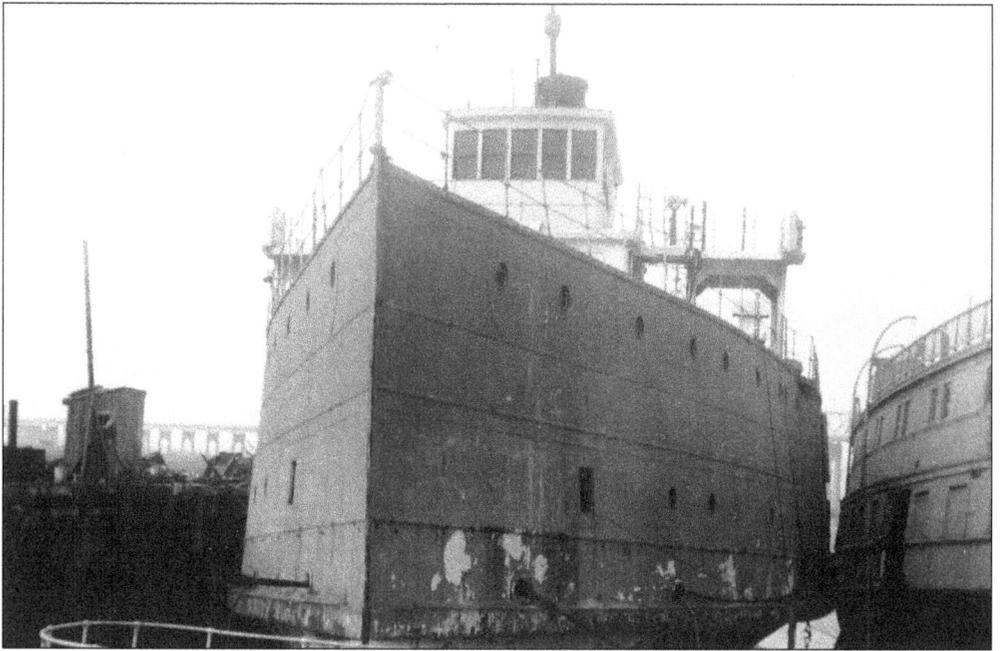

After returning from Europe, the *New Bedford* and *Naushon* were laid up in the James River Reserve Fleet. In March 1947, the Sound Steamship Lines purchased the *New Bedford* for service between Providence, Rhode Island, and Block Island. This view of her was probably taken after the new owners had taken possession; however, the main and saloon decks are still enclosed with steel.

This close-up of the *New Bedford's* starboard stern quarter gives an idea of the condition of the steamers after the hard use of wartime service. In addition, both had been greatly reconfigured, and the island line felt that it would be too costly to rebuild them to the condition required for the company's needs. Neither ever returned to Martha's Vineyard or Nantucket.

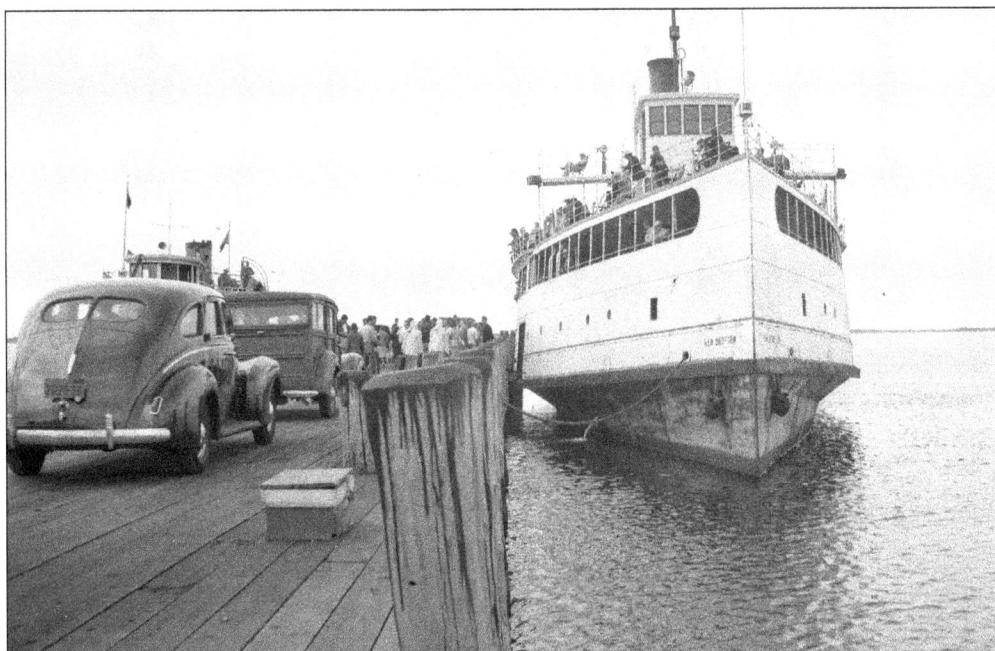

In this view, the *New Bedford* is at Payne's Dock at New Harbor on Block Island. This was not an easy place to load automobiles. They had to drive out on the narrow pier, as seen here, and make a sharp turn to go up the gangplank onto the steamer. Note the captain taking it easy in a deck chair up on the bridge wing, waiting for departure time.

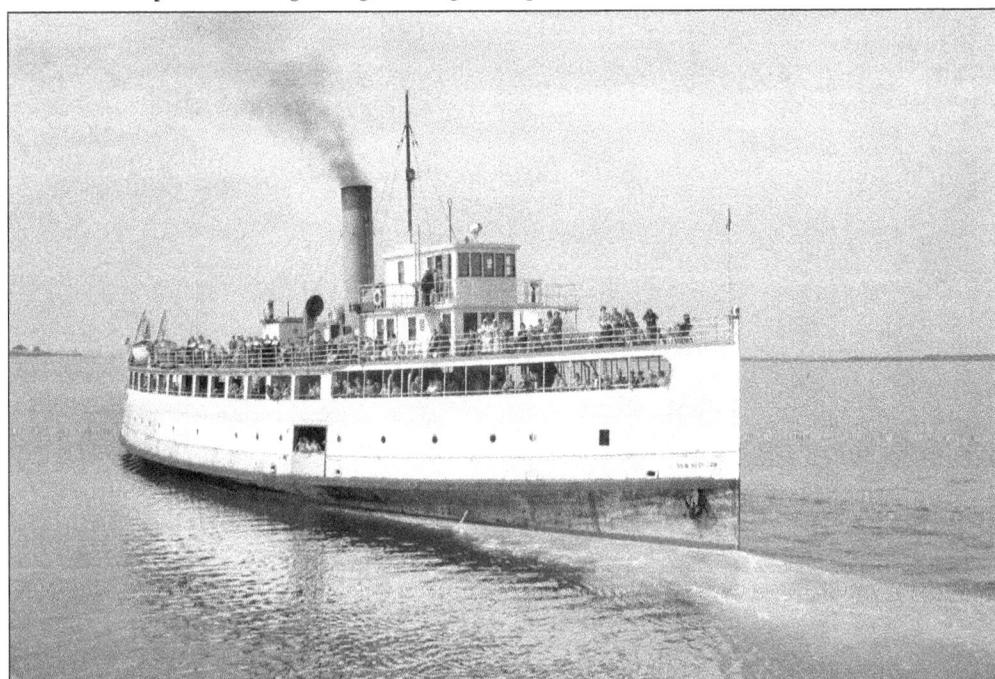

The *New Bedford* is seen backing away from her Block Island wharf for the return trip to Newport and Providence. As rebuilt after the war, she was certainly not as attractive or well maintained as she had been in service to Martha's Vineyard and Nantucket.

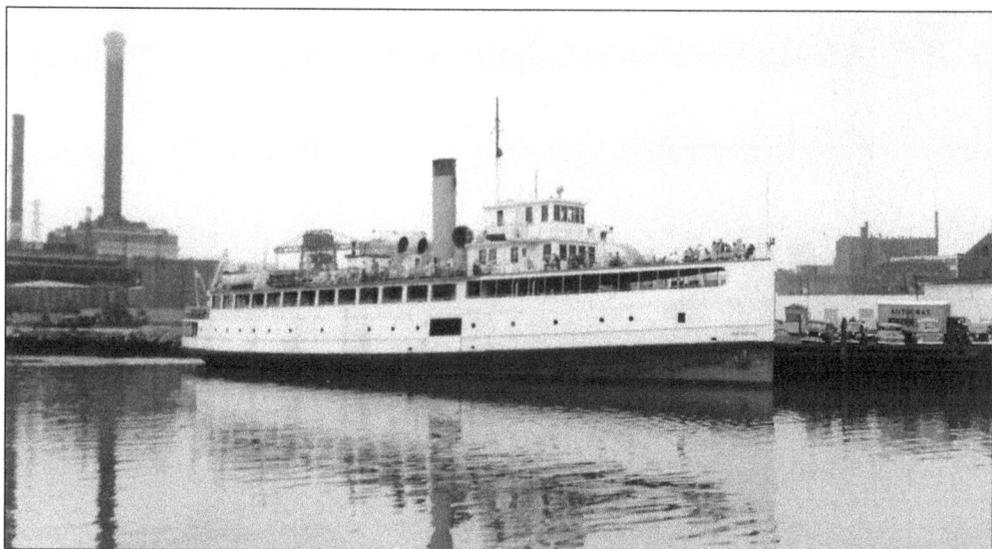

At her Fox Point Wharf in Providence, the *New Bedford* is boarding passengers for the sail down the bay to Newport and on to Block Island. This location had been the New England Steamship Company's terminus for the night boats of the Providence Line. The *New Bedford* ran summers between Providence and Block Island from 1949 through 1955. (Photograph by John Lochhead; author's collection.)

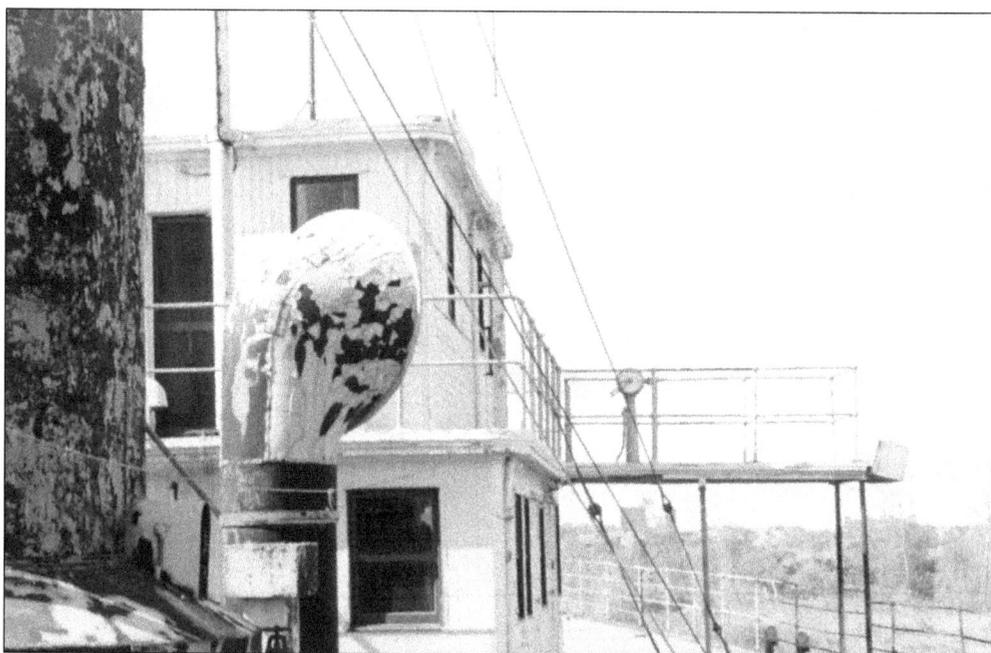

At the end of the 1955 season, the *New Bedford* was laid up at Perth Amboy, New Jersey, and never ran again. This photograph was taken on board in 1964, and the lack of care and maintenance is clearly evident. The view is looking forward on the boat deck. (Photograph by John Dawber; author's collection.)

In 1967, the *New Bedford* was bought for salvage by Witte Marine of Staten Island, New York, and was removed from documentation in 1969. Along with many other historic vessels at the yard, she has deteriorated over the years. Since this photograph was taken, her superstructure has collapsed, and there is no paint left. A sad end for a veteran of D-Day and thousands of miles traveled to summer islands. (Photograph by Steve Dininio; author's collection.)

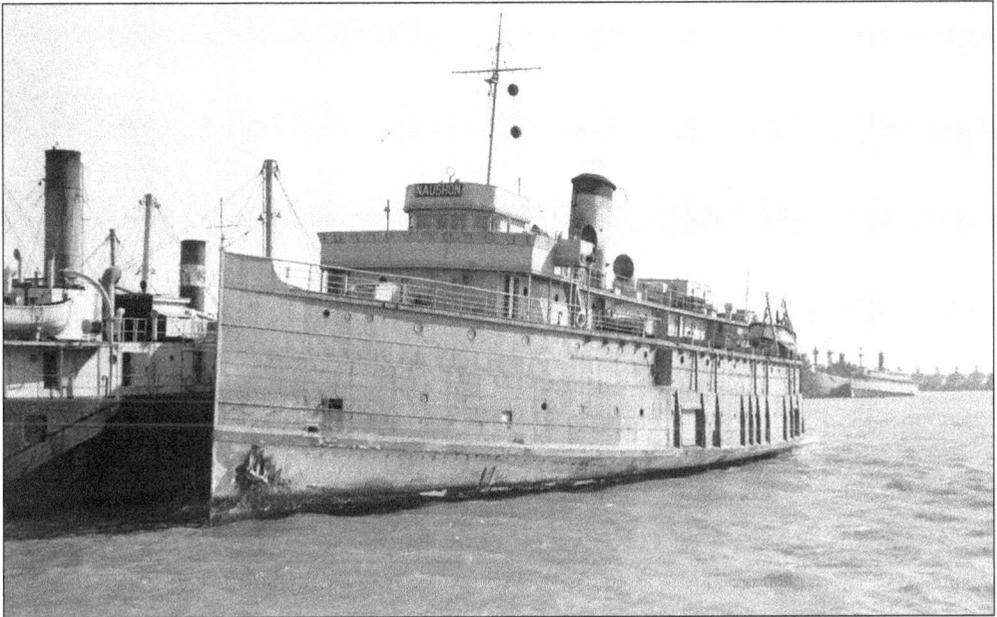

The *Naushon* is seen here in the James River Reserve Fleet in 1946. Her once open decks are still enclosed in steel, and she is looking quite drab. In spite of this appearance, her pleasing lines are still evident. Travelers to Martha's Vineyard and Nantucket, as well as residents, were very disappointed that their favorite steamer did not return. (Photograph by William K. Covell; author's collection.)

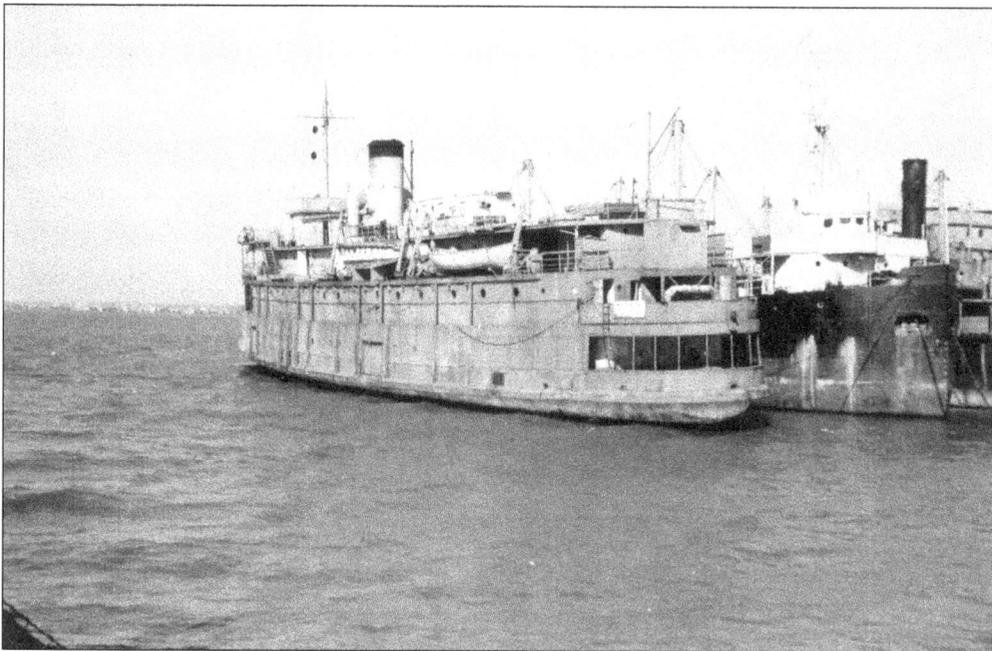

Several stern decks of both steamers were cut back for the installation of gun emplacements, as can be seen in this view of the *Naushon* in the Reserve Fleet. In January 1947, the she was sold to the Meseck Steamboat Company for conversion to a New York excursion boat. (Photograph by William K. Covell; author's collection.)

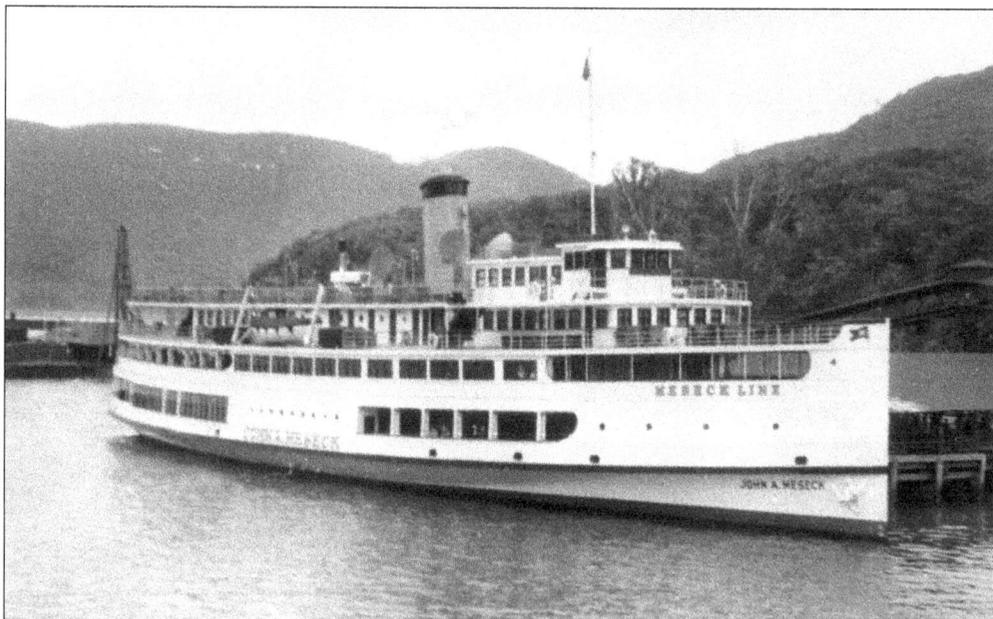

The Meseck Steamboat Company rebuilt the *Naushon* as an excursion boat, renamed *John A. Meseck*. The company ran her from New York to Playland Park, on Long Island Sound, and then on to Bridgeport, Connecticut. Although quite altered, she was still a nice-looking steamer. Her conversion was better thought out than that of the *New Bedford*. In this image, she is at Bear Mountain Park on the Hudson River. (Photograph by the author.)

This view is looking up at the *John A. Meseck's* smokestack. Her flat-topped whistle looks identical to those on the other White Fleet steamers, so it is likely the whistle she had in island service as the *Naushon*. At some point, while owned by the Meseck Line, she was given a crown-topped whistle from the Hudson River steamer *Benjamin B. Odell*. (Photograph by William K. Covell; author's collection.)

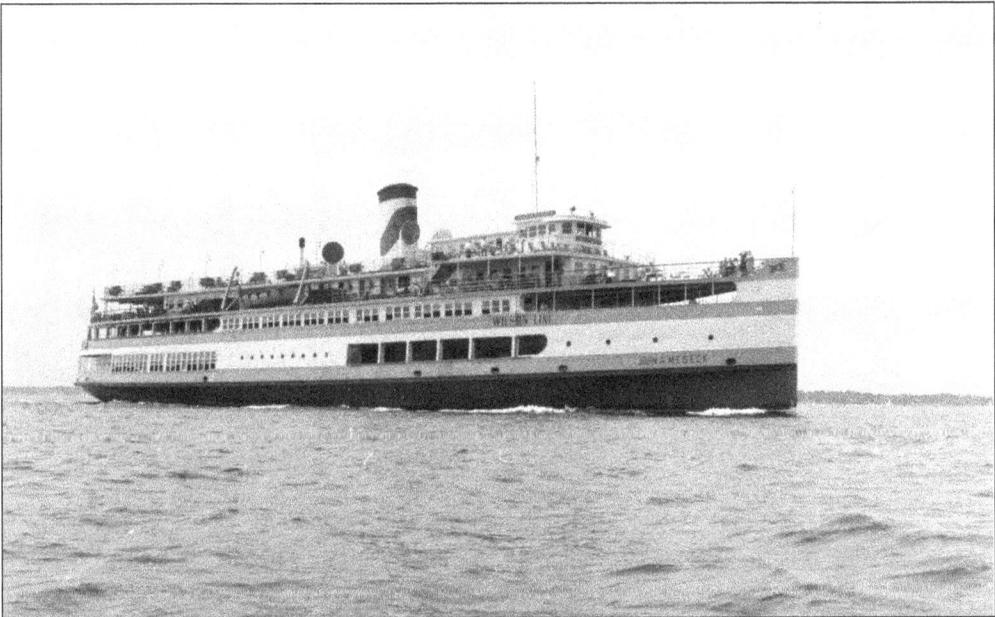

The *John A. Meseck* was the last steamer in the Meseck fleet and was sold to the Wilson Line in 1957. Wilson operated her until 1961, when she was laid up. She was purchased by the International Seafarers Union for a training center and was finally scrapped in 1974. In this image, she is underway on Long Island Sound, painted in the somewhat unflattering Wilson colors of black and yellow. (Photograph by the author.)

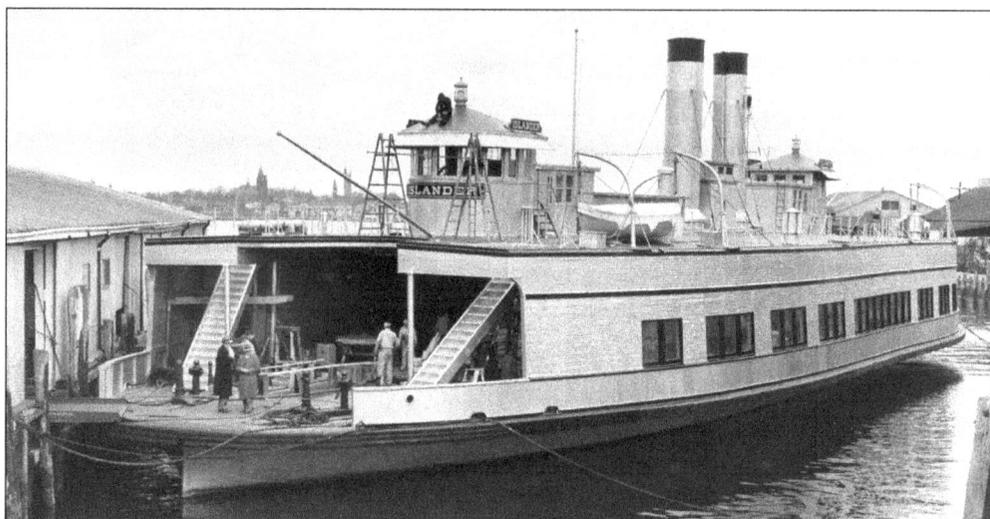

With the *New Bedford* and *Naushon* gone, the Massachusetts Steamship Lines needed another vessel. The company purchased the former Pennsylvania Railroad ferryboat *Hackensack* and renamed her *Islander*. She had been built in 1906 as the *Hempstead* and was used at New York crossing the Hudson River. She is seen here in New Bedford being upgraded. For some reason, she was painted with aluminum paint in her first year. (Courtesy of Mark Snider.)

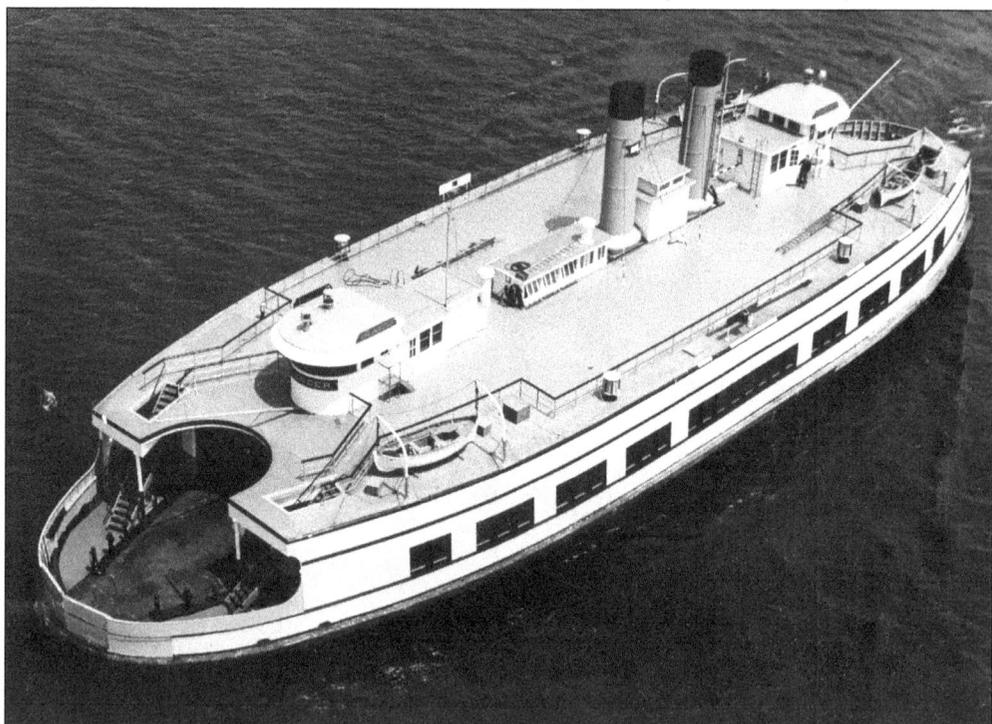

As seen in this aerial view, the *Islander* was a true double-ended ferryboat. Ferry slips and transfer bridges had to be constructed for her at Woods Hole and Vineyard Haven. Her first trip on the line was April 15, 1946. By the time this photograph was taken, she had been painted white with buff smokestacks. Massachusetts Steamship Lines changed the stack color of all the steamers from black to buff. (Photograph by Shell Oil Company; courtesy of Mark Snider.)

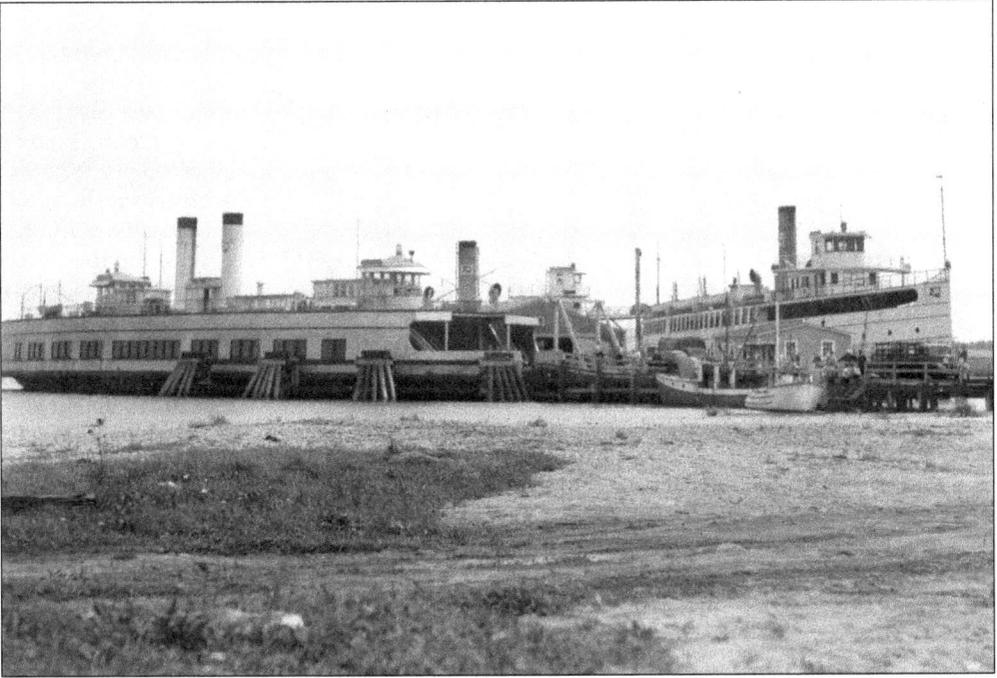

From September 9 until September 12, 1946, the steamers were tied up by a strike against the Massachusetts Steamship Lines. Seen here laid up at Vineyard Haven are, from left to right, the *Islander*, *Martha's Vineyard*, and *Nantucket*. (Courtesy of Mark Snider.)

When the New Bedford, Woods Hole, Martha's Vineyard, and Nantucket Steamship Authority took over operation of the island line, it had a new diesel ferryboat built to replace the *Islander* and gave her the same name. The older *Islander* was sold in 1950 to the Whaling City Dredge Company of New London, Connecticut, and the company cut her down for use as a barge. In this view, she is moored under the highway bridge at New London, awaiting conversion. (Photograph by William Ewen Sr.; author's collection.)

During Massachusetts Steamship Lines ownership of the steamers, the Shell Oil Company took a series of photographs. The machinery on the vessels was lubricated with Shell products, and the images were used for publicity. This photograph from the series shows a captain on the bridge wing of the *Martha's Vineyard* while docking. From this vantage, he could see the position of the steamer in relation to the wharf. (Photograph by the Shell Oil Company; courtesy of Mark Snider.)

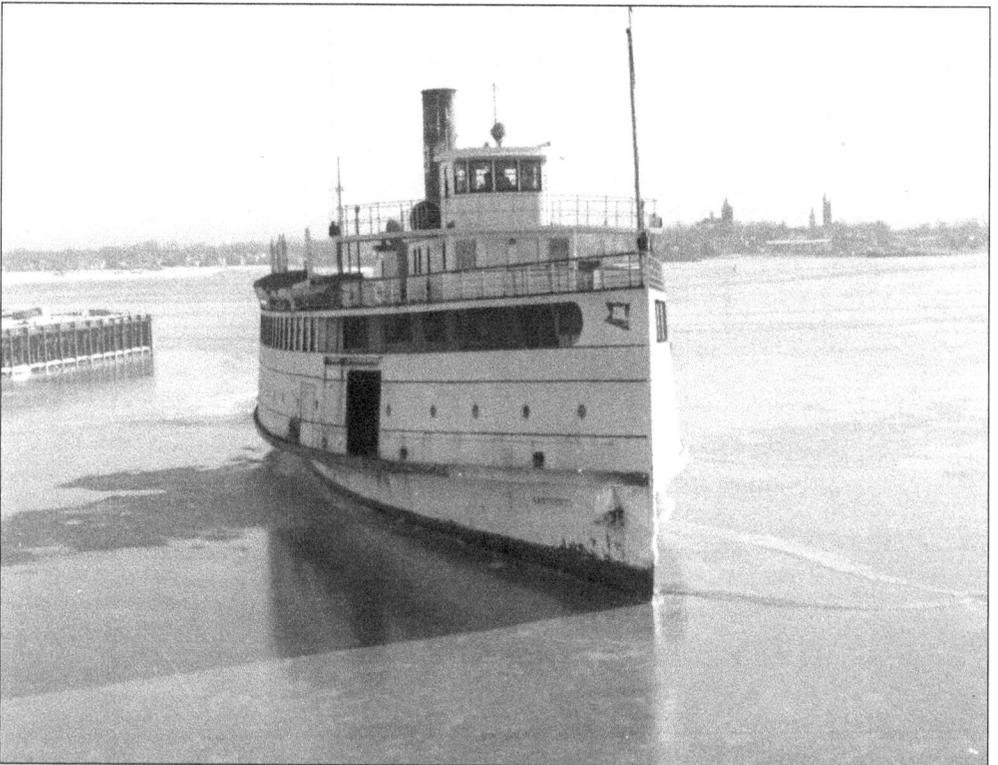

On a cold winter day in 1948, the *Nantucket* eases her way through harbor ice, approaching the New Bedford wharf. She has frozen spray on her anchors and guards, indicating that sea conditions on the way from the islands might have been a bit choppy. To the left is a corner of the State Pier, and in the background is the city of Fairhaven. (Courtesy of the New England Steamship Foundation; Winthrop Hodges collection.)

In May 1949, a month after the Steamship Authority took over, the senior captain of the line retired. Capt. James O. Sandsbury was a distinguished, respected, and very capable master. He began his career on the island steamers in 1909 as quartermaster on the side-wheeler *Nantucket*. As a captain, his commands included the *Gay Head*, *Uncatena*, *Sankaty*, *Martha's Vineyard*, *Nantucket*, *New Bedford*, and *Naushon*. (Photograph by the Shell Oil Company; courtesy of Mark Snider.)

In 1950, the Steamship Authority had the *Nantucket* rebuilt. This included moving the lunch counter and purser's office from the main deck to the saloon deck, the same configuration as the *New Bedford*; it also was done for the same reason—more room for automobiles. The *Nantucket* was also given a larger, squarer pilothouse, similar to that on the *Naushon*. As seen here, returning from the shipyard, she still retained her nice lines.

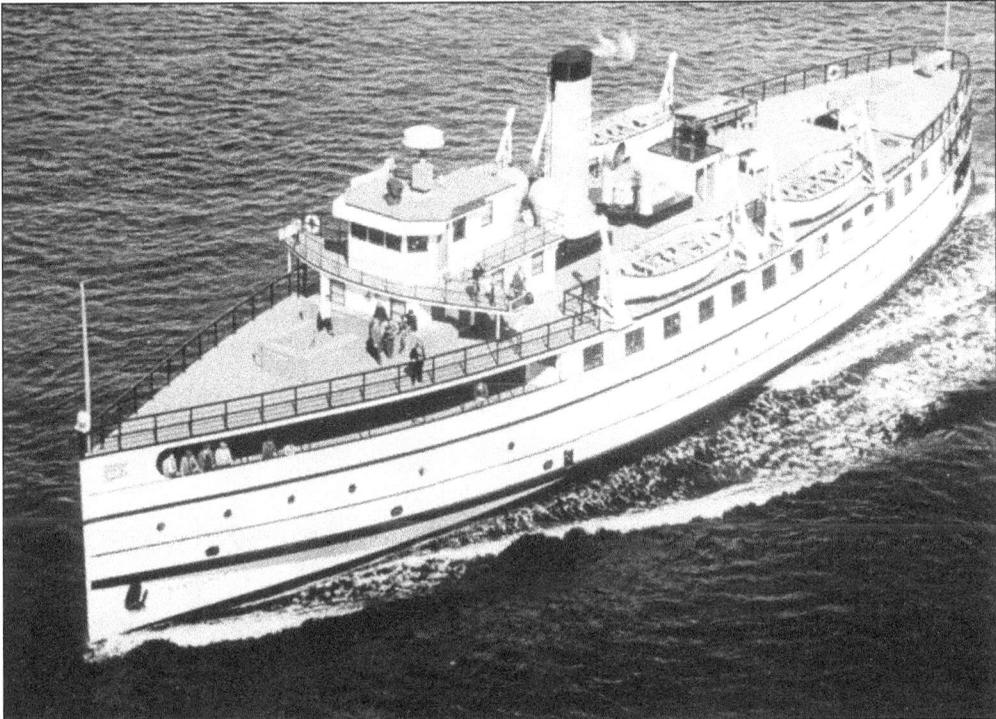

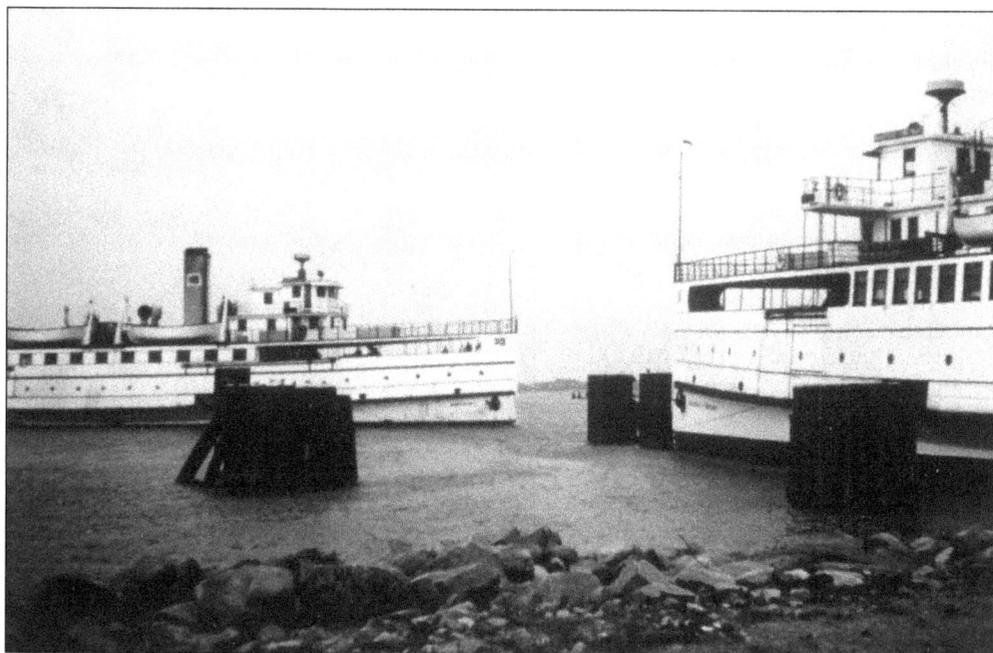

On a stormy day in August 1955, the *Nantucket* is easing up to the end of the wharf at Woods Hole, while the *Martha's Vineyard* is tied along the south side. By comparing the two steamers, changes in the *Nantucket* after being rebuilt are evident. Especially noticeable is the different style of windows along the saloon deck. (Photograph by and courtesy of Paul Huntington.)

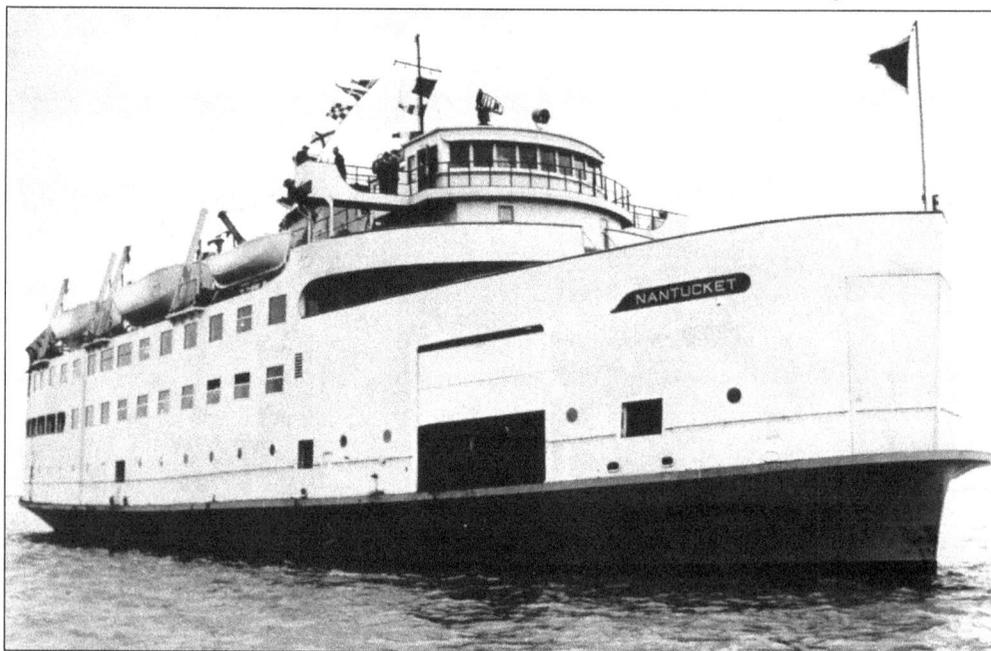

On March 23, 1956, a new steamer for the island line was launched at Camden, New Jersey, by the J.J. Mathais Company. She was named *Nantucket*, and she turned out to be the last steam-powered passenger ship built in America. She appears here as first built. To make the name available, the previous *Nantucket* was given back her original name of *Nobska*.

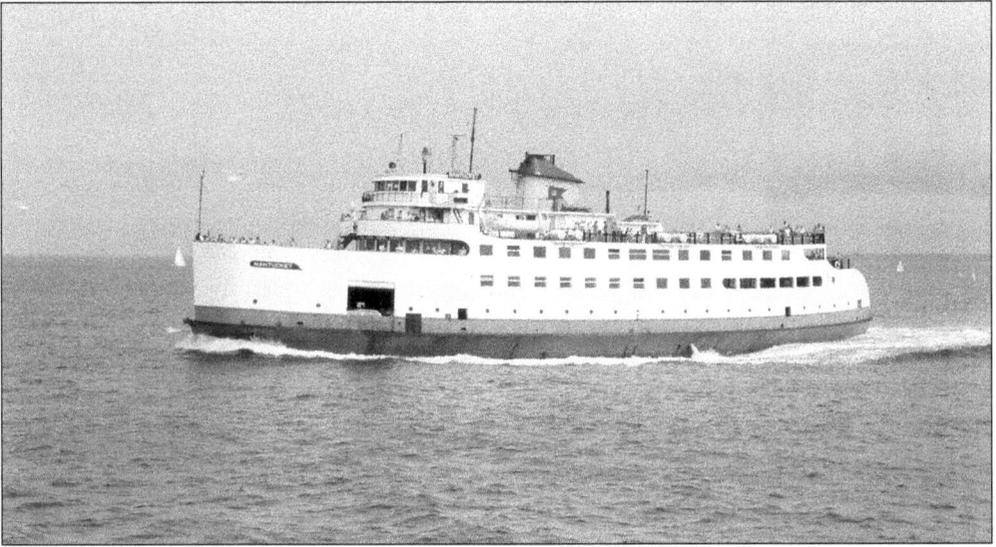

The *Nantucket* was a departure in design from the previous steamers of the line. She had a rounded bow, and her stern was sloped with a garage-style door. Still, she had enough sheer in her lines to give her a certain grace. In this view from 1968, the gray of her hull has been extended up to the main deck rail, and she now has two lifeboats instead of her original six. (Photograph by Steve Dininio; author's collection.)

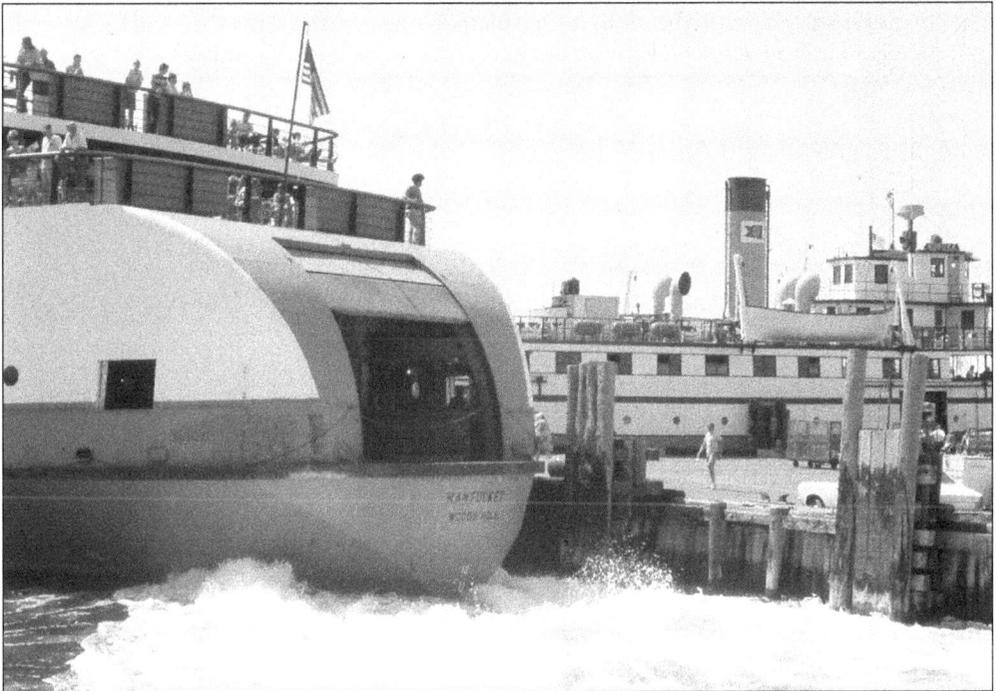

The *Nantucket's* powerful engines are kicking up a wake as she leaves Woods Hole. Her stern loading door is plainly visible. She was designed to load and unload from both bow and stern, but her bow was too high for the transfer bridges so the bow doors were eventually welded shut. In the background, the *Nobska* is at the end of the pier. (Photograph by Steve Dininio; author's collection.)

The *Nantucket* is easing up to the wharf at Oak Bluffs. Using her twin screws, she will back around into the slip to unload automobiles from her stern. (Photograph by the author.)

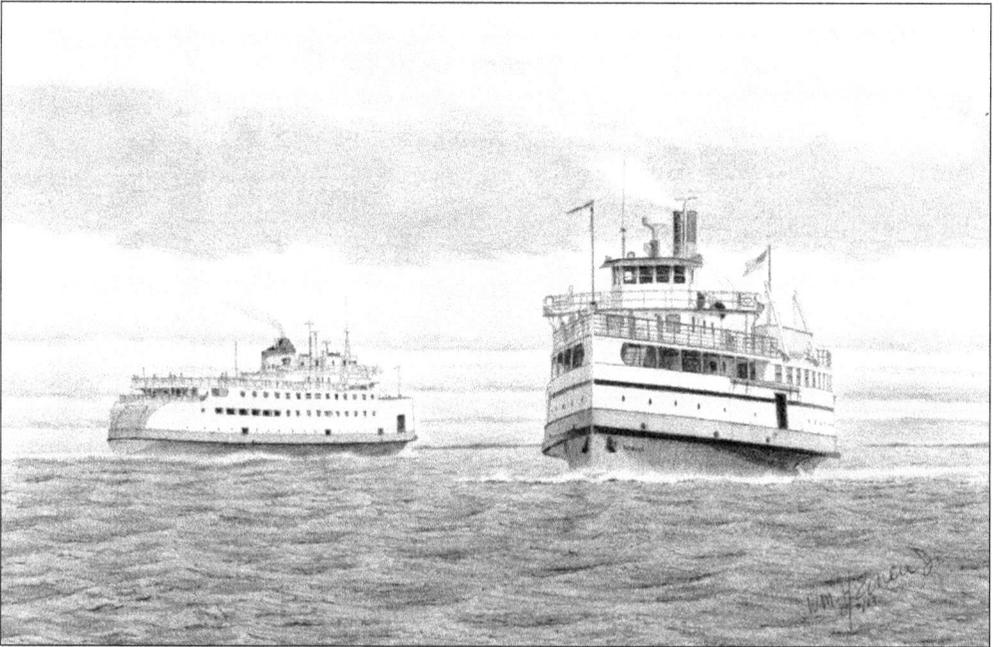

In this drawing by the author, "The Last Island Steamers," the *Nantucket* and *Nobska* are passing. During the time that both vessels were running, the island line was probably the last place in America where two large coastal passenger steamboats were operating in the same service. (Courtesy of George Fisher.)

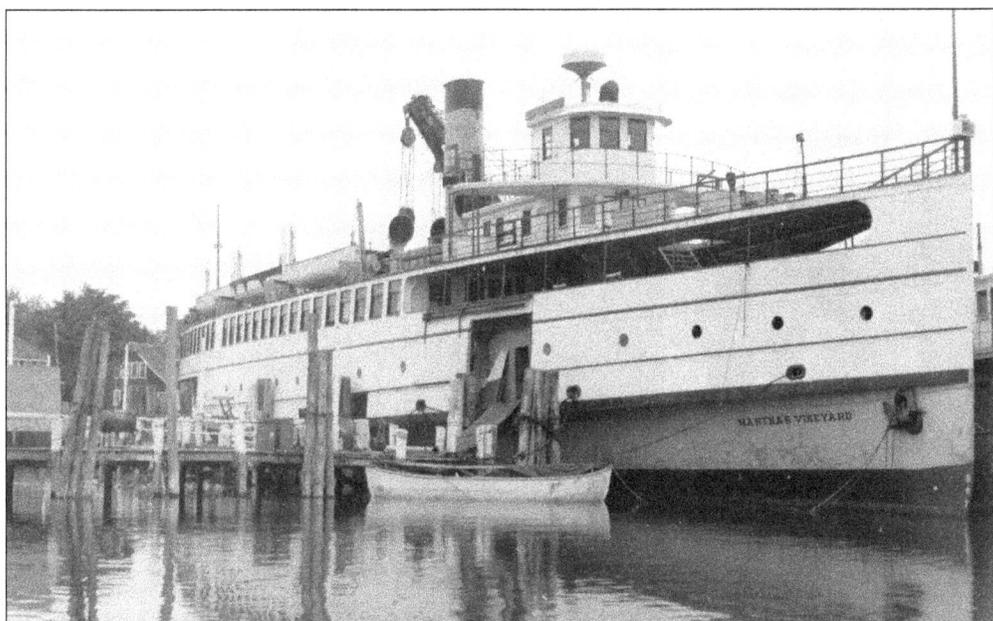

With the arrival of the *Nantucket*, the *Martha's Vineyard* was no longer needed, and she made her last scheduled trip on the line on October 4, 1956. She was laid up for several years but did come out as a replacement and to attend the 1958 America's Cup Races. She was sold to Capt. Joseph Gelinas, who dieselized her. She is seen here at Hyannis while having a new engine installed. (Photograph by John Dawber; author's collection.)

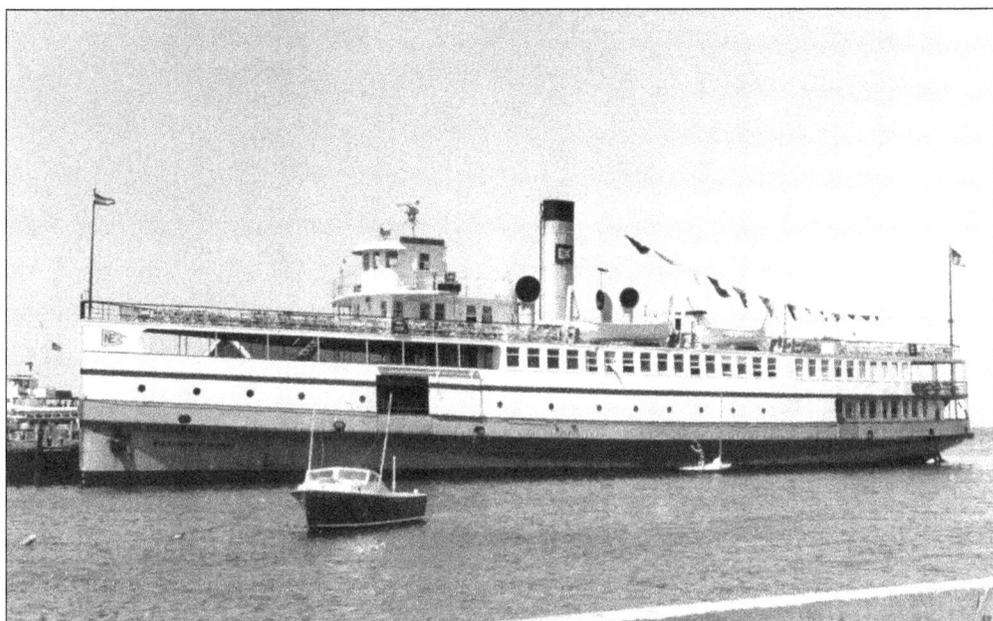

Captain Gelinas operated the *Martha's Vineyard* from Boston to Provincetown for a year. She then ran from Hyannis to Nantucket from 1962 to 1966. She is seen here at Nantucket during that period. Although she was the only one of the White Fleet to be dieselized, she retained her original outward appearance more than the others. She even retained her original chime whistle, which was blown with air. (Photograph by the author.)

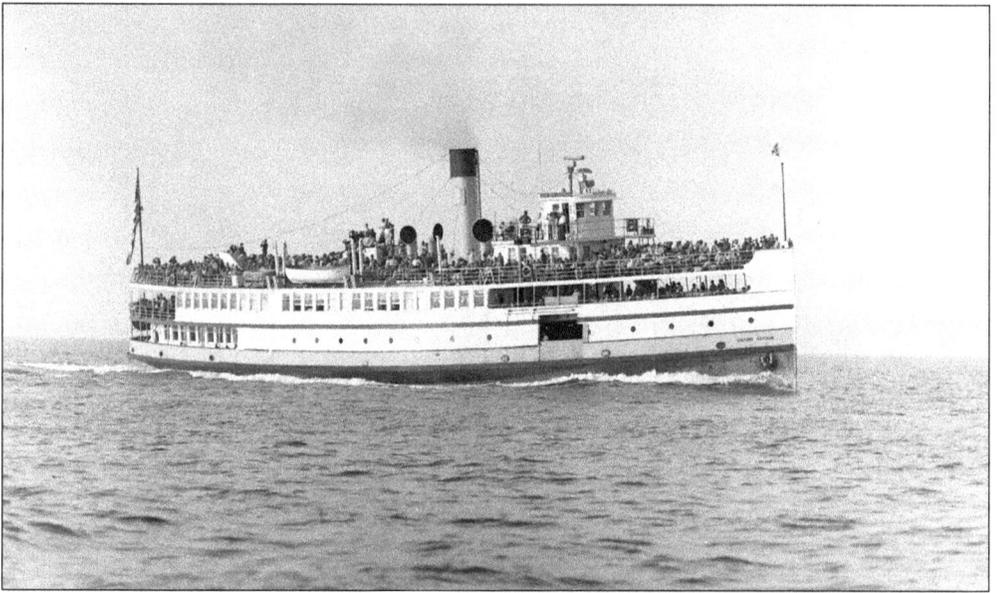

After running to Nantucket for five years, the Martha's Vineyard was sold to the Bridgeport–Port Jefferson Steamboat Company for service across Long Island Sound. In 1970, she was sent to Newport to take spectators out to the America's Cup races. In this view, she is in Rhode Island Sound returning from a race with a full complement of passengers. (Photograph by the author.)

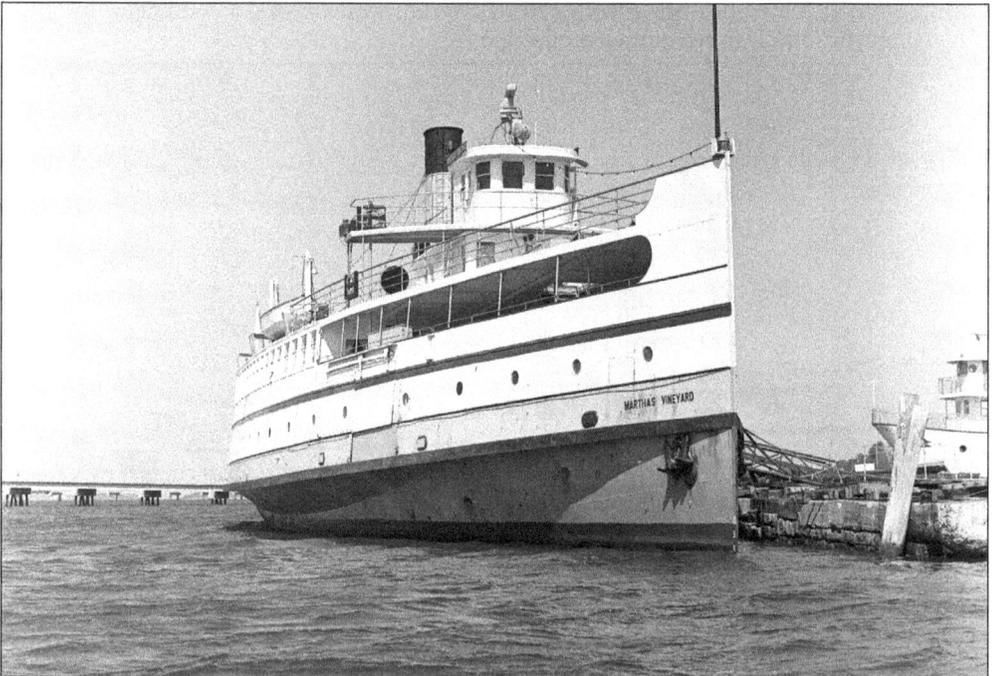

While in Newport, the Martha's Vineyard tied up at Long Wharf, the site of the former New England Steamship Company facilities. It was here that she had been designed and was maintained while under the company's ownership. At the time of this photograph, her hull was gray, the area from the main deck up to the rail was yellow, and the broad stripe was red. (Photograph by the author.)

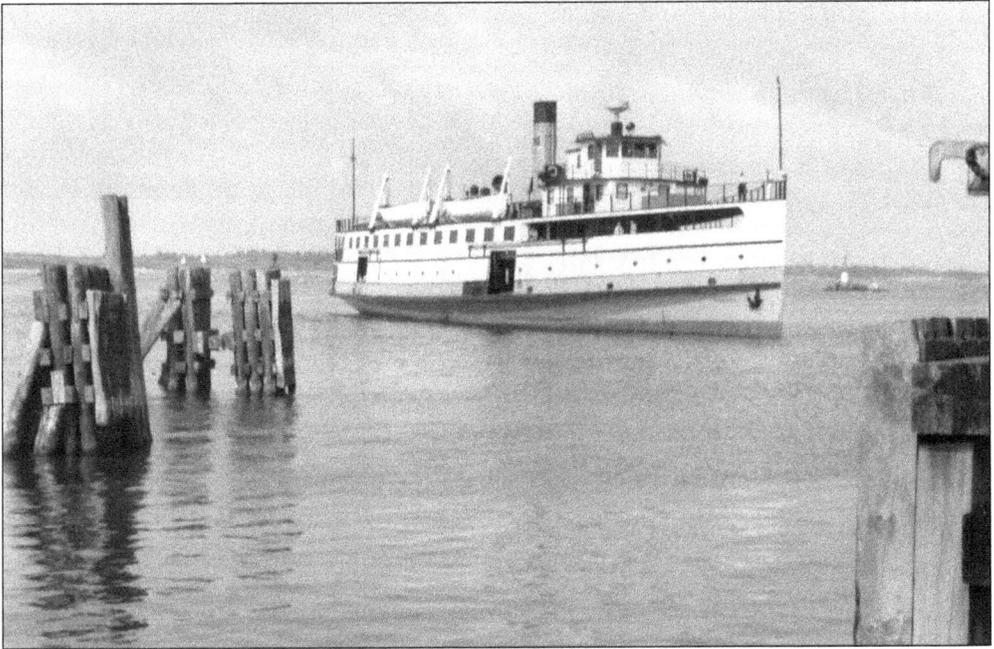

The *Nobska* was the last of the White Fleet still steam powered and the last still in island service. Gradually, she had more gray and black paint added to her hull and superstructure, as can be seen in this photograph at Woods Hole. (Photograph by John Dawber; author's collection.)

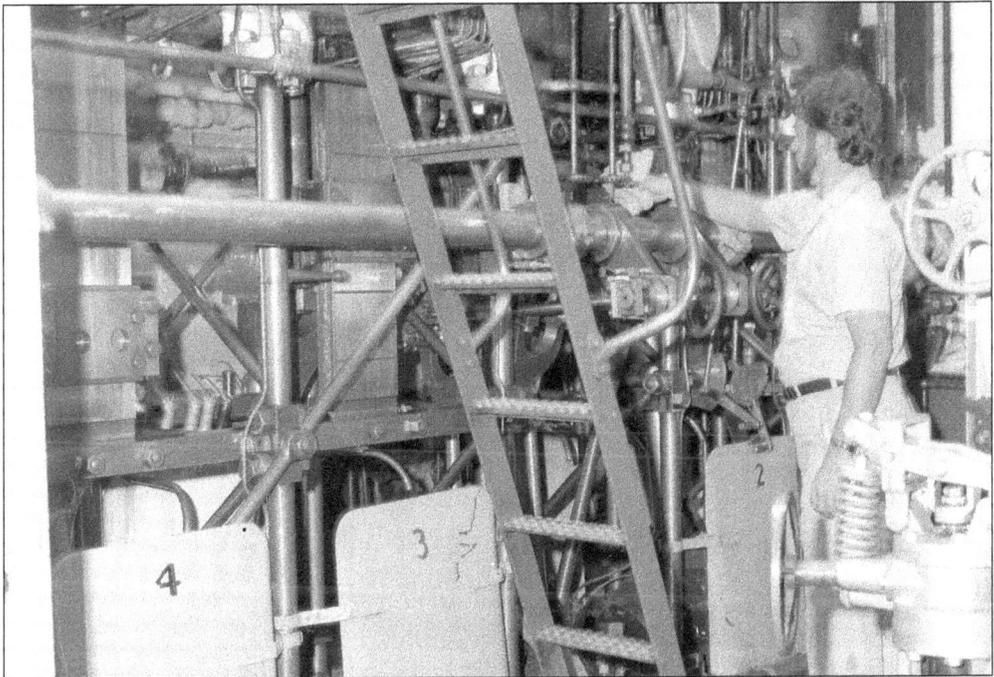

As steam-powered passenger vessels were becoming rare, the *Nobska*, with her beautiful four-cylinder, triple-expansion engine, became quite well known. People came to the area just to ride her. Many regular passengers also preferred her because of her quiet running and easy motion in a sea. (Photograph by the author.)

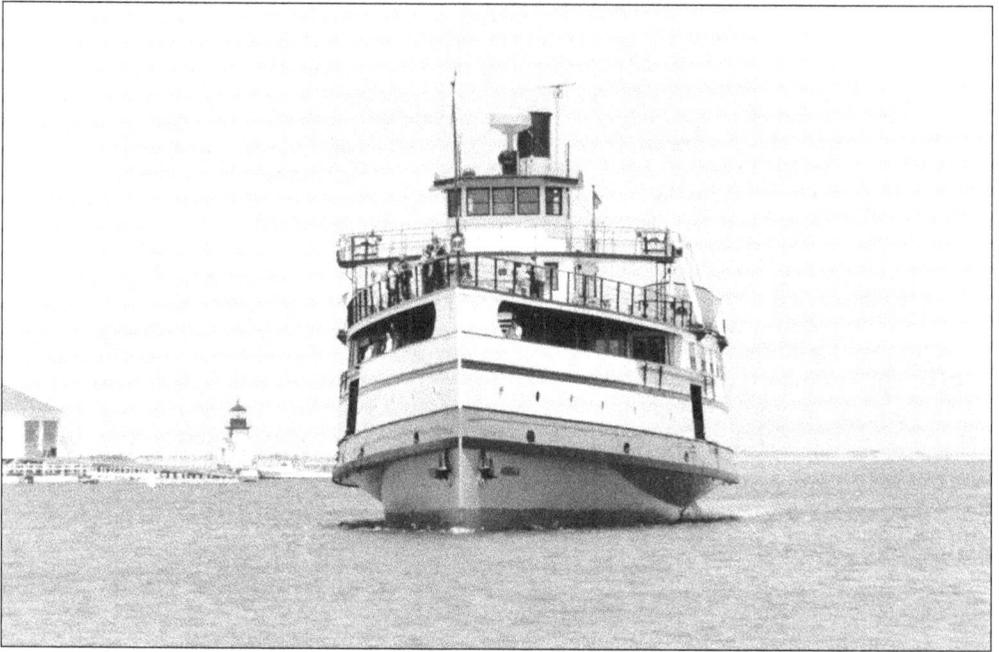

This is how many people still remember the *Nobska*—approaching the wharf at Nantucket. She would turn to port and pull up along the end of the pier and then back around on a spring line to the north side. The Brant Point Lighthouse is in the background. (Photograph by and courtesy of Ted Scull.)

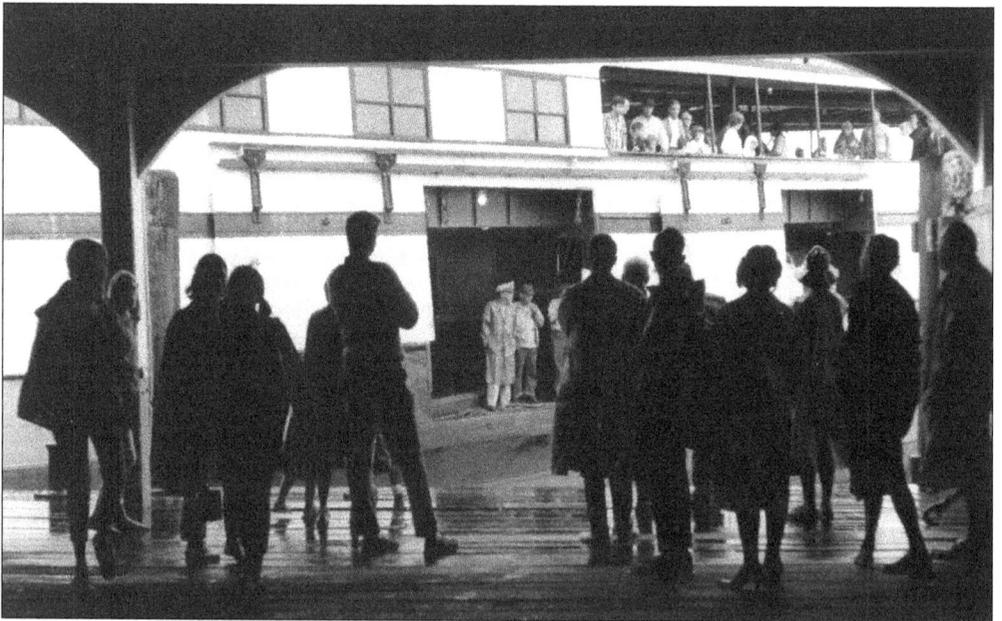

At the old Steamboat Wharf at Nantucket, people could stand under cover at the end of the pier and watch the vessels land. Here, the *Nobska* is starting to back around to the left. The officer standing in the gangway is the first mate, Jim Manchester, a longtime employee with the line. It is the late 1960s, and the officers still wore proper uniform caps, not baseball caps. (Photograph by the author.)

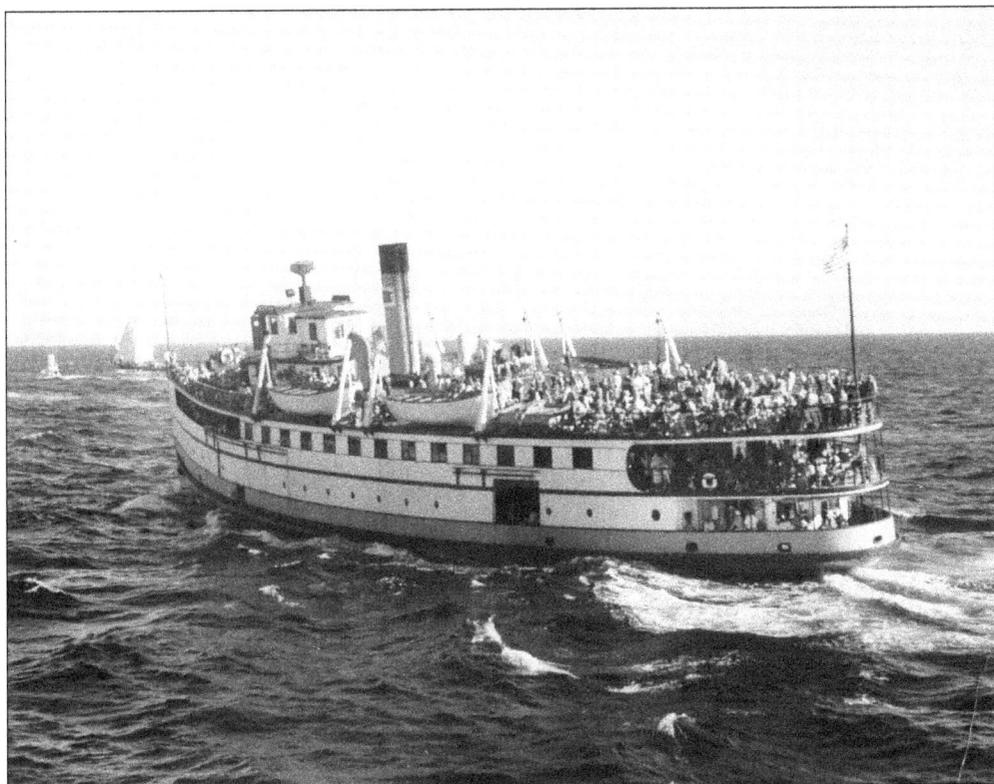

On September 15, 1962, the *Nobska* is off the coast of Rhode Island. She was in attendance as a spectator boat at the America's Cup. She appears to have a capacity crowd on board. (Photograph by R. Loren Graham; author's collection.)

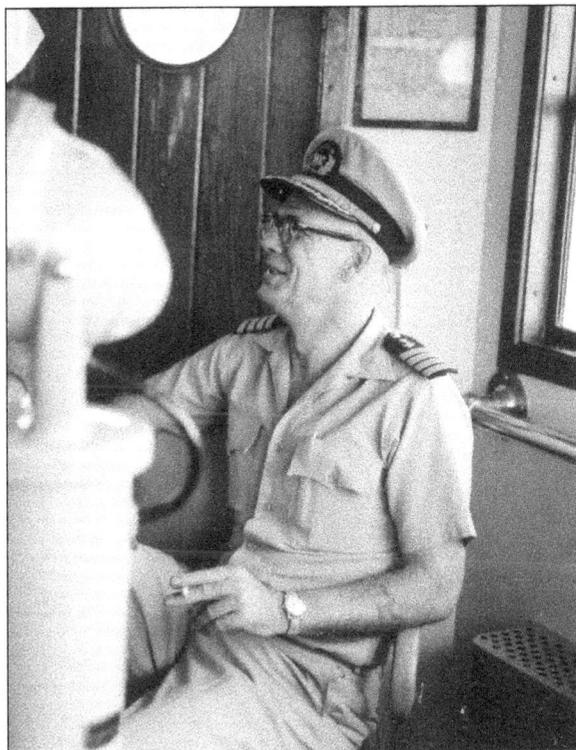

In this 1967 photograph, Capt. Alec Smith is seen in the pilothouse of the *Nobska*. When Captain James Sandsbury officially retired, he was on board the *Martha's Vineyard*. As she was leaving the breakwater at Nantucket, he turned the command over to Captain Smith. (Photograph by the author.)

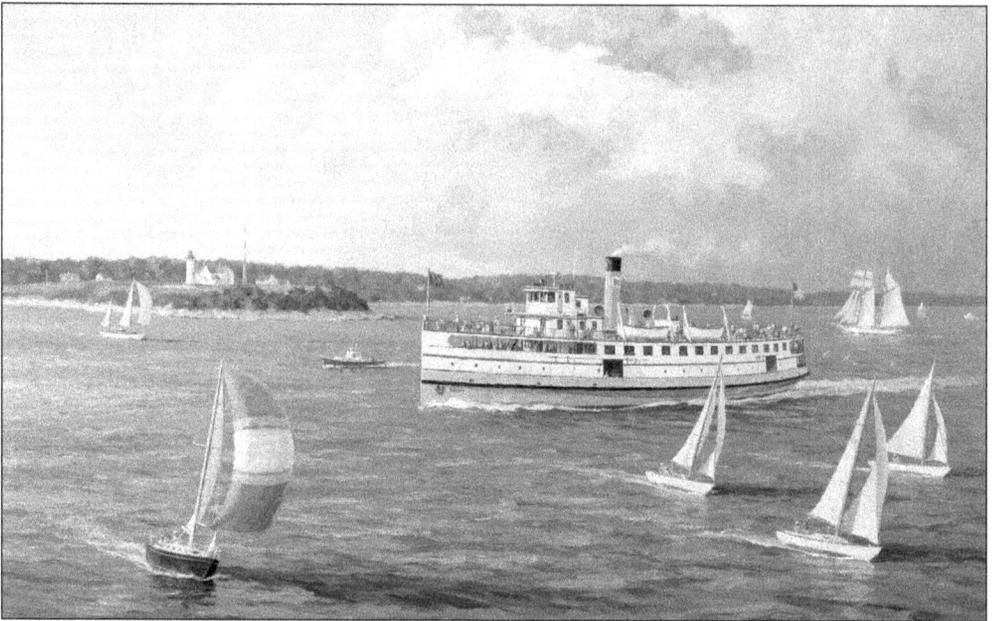

This fine oil painting by Bill Muller depicts the *Nobska*, late in her career, passing the lighthouse on Nobska Point. This prominent point was the source of the steamer's name. In the background is the schooner *Shenandoah*. (Painting by and courtesy of William G. Muller.)

While not uncomfortable, the *Nobska's* interior was a bit spartan after being rebuilt. She still had the day staterooms, but carpeting had been replaced with tiles, and the furniture was less than elegant. Compare this with the photographs of the interior of the *Islander* in chapter four. Besides cost and maintenance, another consideration was that later-day passengers were not always as careful about how they treated public property. (Photograph by the author.)

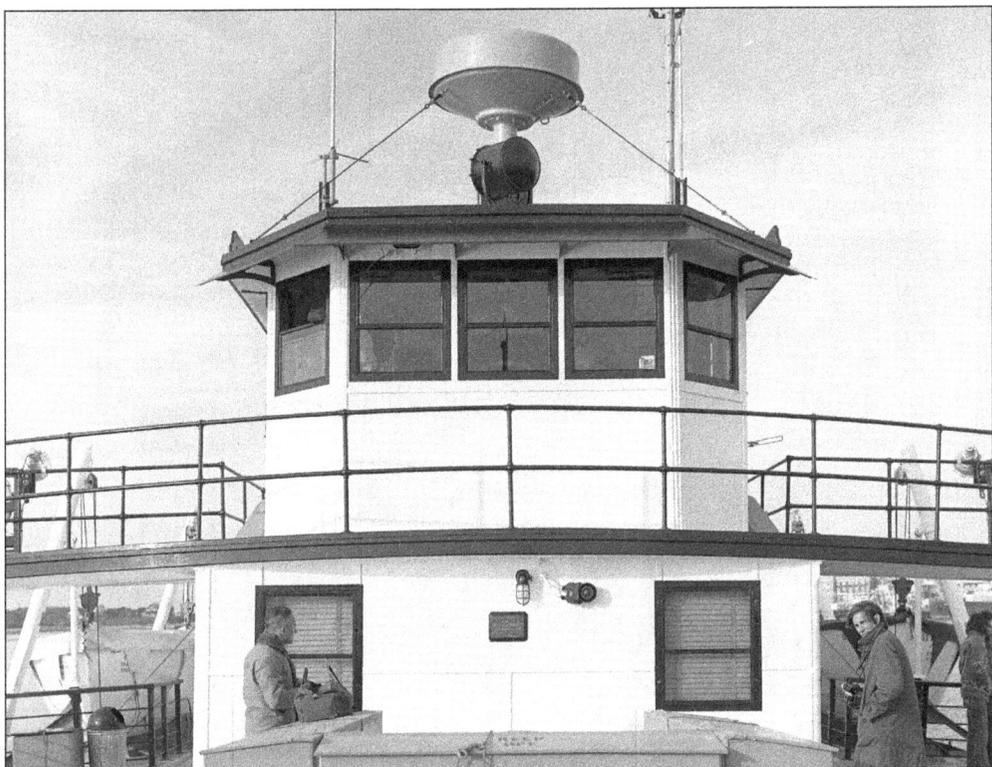

This view of the *Nobska's* pilothouse was taken on New Year's Day in 1972. She was on her way from Woods Hole to Vineyard Haven. Even in her last years, the historic steamer was well maintained. (Photograph by the author.)

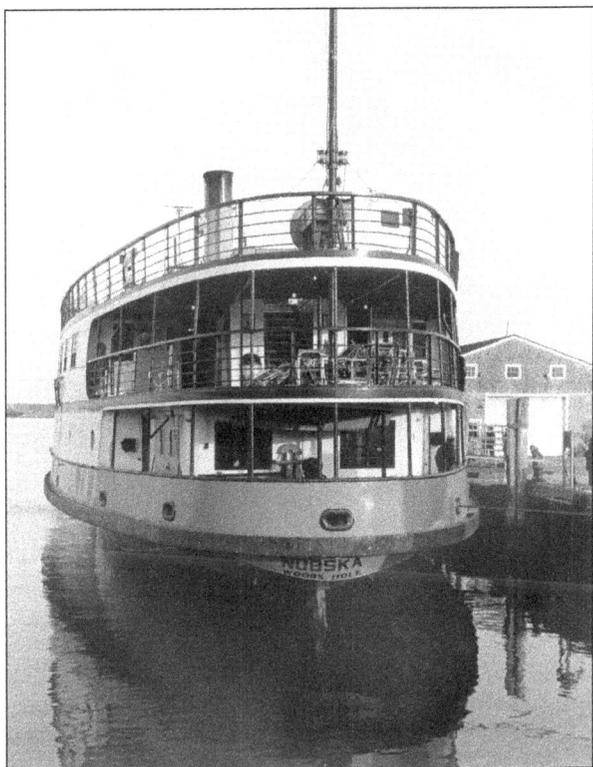

On January 1, 1972, the Nobska rests at Vineyard Haven between trips. She is backed in along the north side of the wharf, giving a close view of her classic rounded stern. (Photograph by the author.)

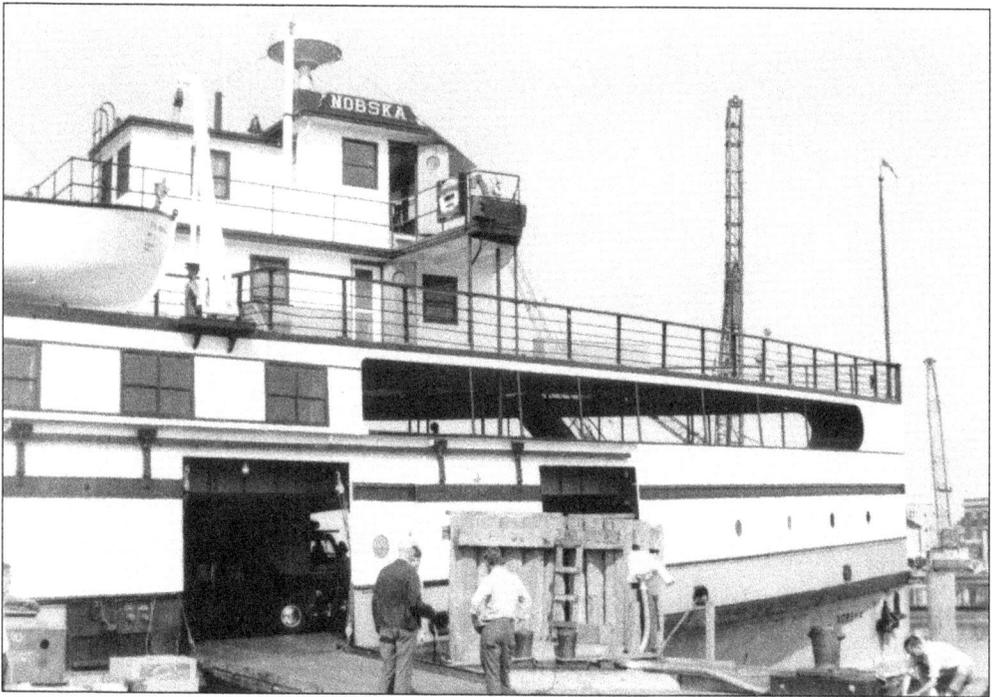

One of the deciding factors in the retirement of the *Nobska* was the fact that she was a side loader. It took longer to load vehicles than on a vessel that was an end loader. She is seen here at her berth at the end of the Woods Hole wharf. (Photograph by Steve Dininio; author's collection.)

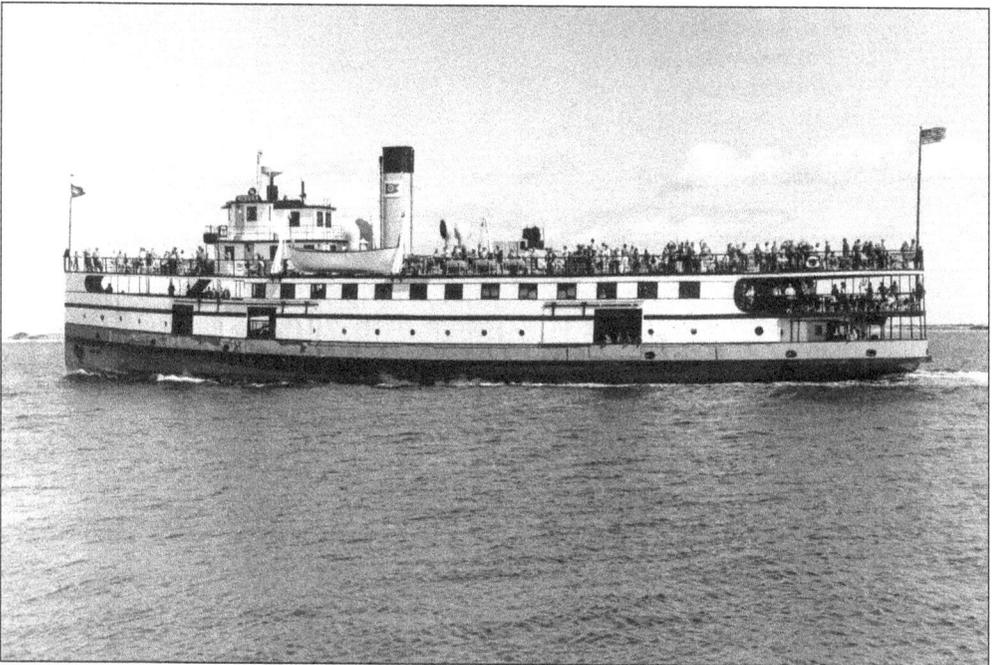

In her last year of service, two of her lifeboats had been replaced with inflatable life rafts in canisters. Over the years, she had gone from six lifeboats, to four, and finally down to two. (Photograph by the author.)

On September 18, 1973, the sun set on the 48-year career of the *Nobska*, in service to the islands of Martha's Vineyard and Nantucket. This appropriately moody photograph was taken on her top deck, looking aft, as she made her final trip from Nantucket back to Woods Hole. (Photograph by Steve Dininio; author's collection.)

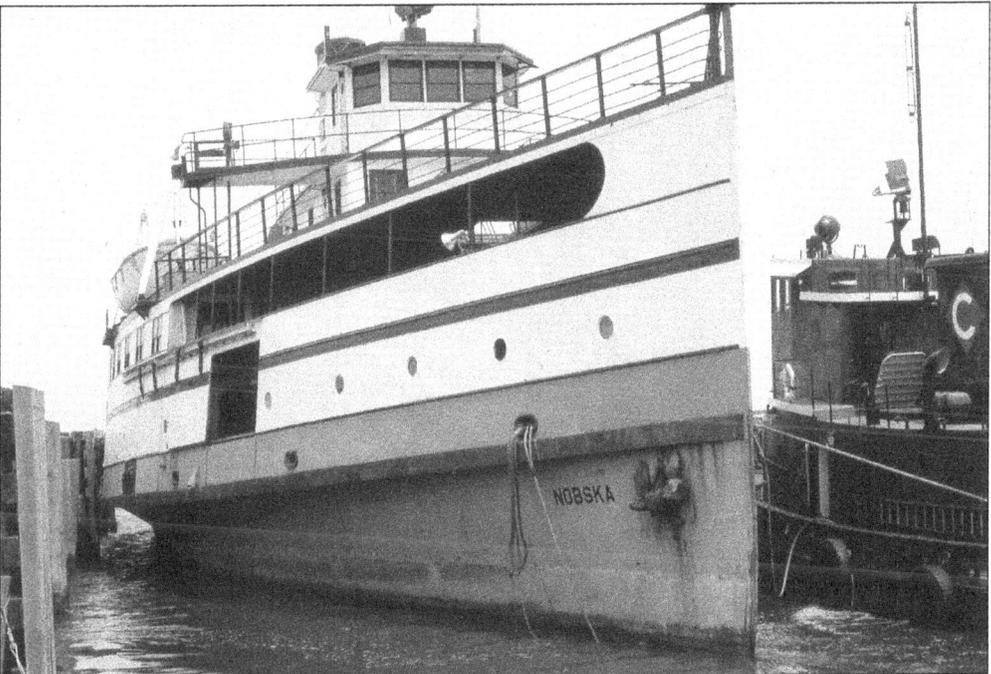

After being laid up since her last trip, the *Nobska* was sold and left Nantucket under tow, as seen here, on June 26, 1976. She first went to Fall River and was refurbished as a restaurant and then sold to the city of Baltimore. (Photograph by Steve Dininio; author's collection.)

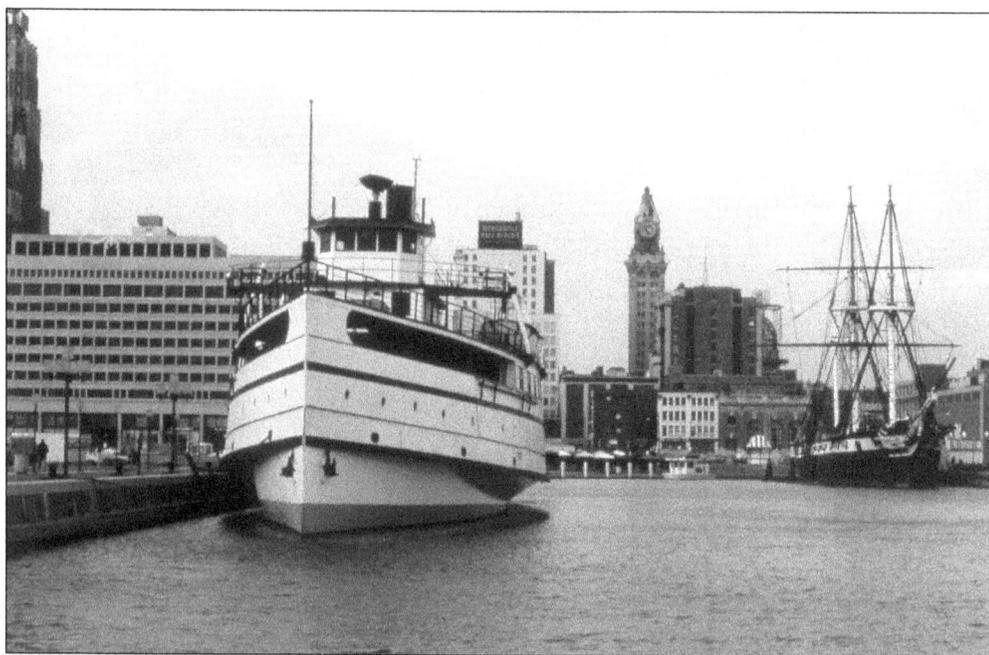

The *Nobska* is seen here in Baltimore where she was opened as a restaurant. Like so many floating restaurants, it was closed after only a few years. She was then sold to a private owner who gutted her interior and planned to reopen a restaurant on board. That never went any further, and she lay unused for years. (Photograph by Steve Dininio; author's collection.)

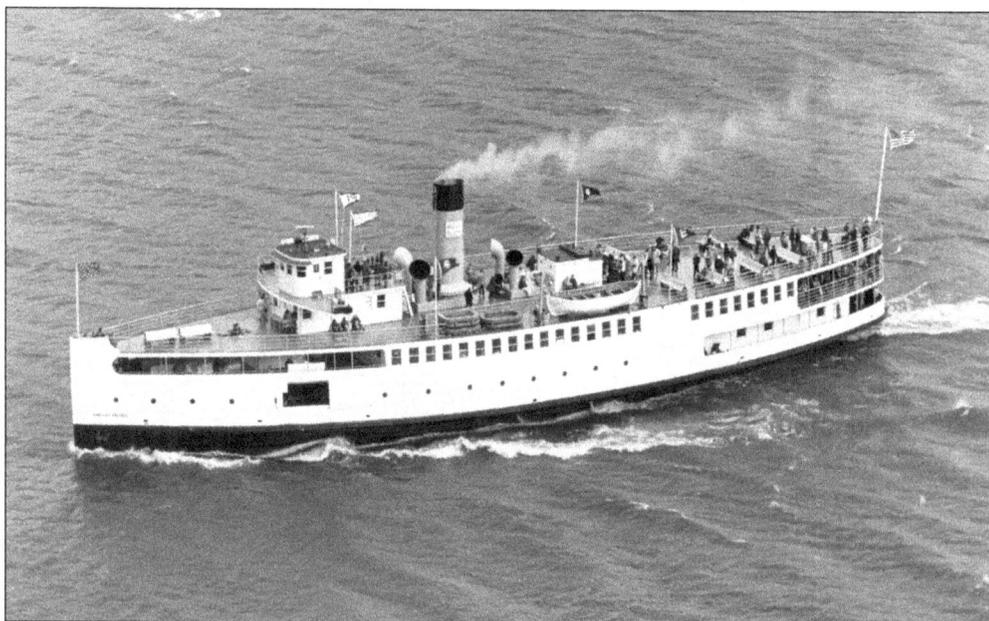

Meanwhile, the *Martha's Vineyard* was still in service on Long Island Sound. In October 1977, the New England Steamship Company of Massachusetts chartered her for a weekend trip from New York to Albany and return. She is seen here heading north on the river, in a photograph taken from Storm King Mountain. Several historians, including the author, had formed the company to operate historical trips once a year. (Photograph by Kay Stevens; author's collection.)

Although she had been altered a number of times, the *Martha's Vineyard* still had the look of a steamboat. In this view from the boat deck, she is heading south on the Hudson with Storm King Mountain on the right. This was the only time one of the White Fleet island vessels had ever traveled up the Hudson River above New York. (Photograph by the author.)

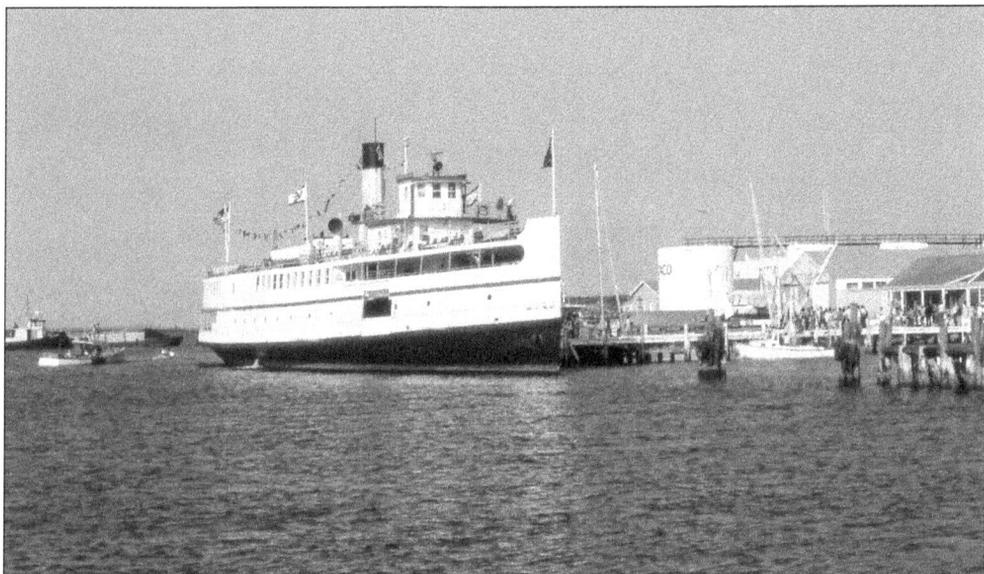

In 1984, the Friends of *Nobska*, a nonprofit preservation organization, chartered the *Martha's Vineyard* and returned her to her old home waters. Dinner cruises were operated from the two islands, raising awareness of the work to save the *Nobska*. She is seen here in Vineyard Haven for the first time in over 25 years. The crowd on the pier is waiting to board for the evening cruise. (Photograph by and courtesy of John Boardman.)

On the morning of August 29, the *Martha's Vineyard* left Nantucket and headed for New Bedford. She was the very last of the White Fleet of the 1920s to ever round Brant Point and cross Nantucket Sound. (Photograph by and courtesy of Joseph Morin.)

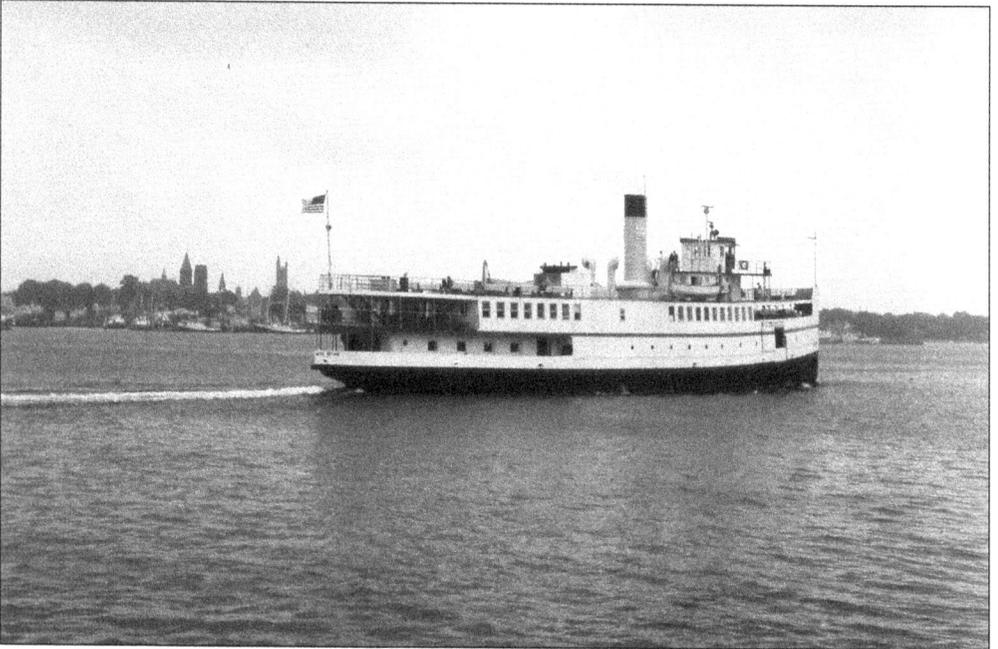

Later on the 29th, she arrived back in New Bedford. After unloading leftover supplies and volunteers, she departed her old homeport for the last time. The buildings of Fairhaven, in the background, had witnessed thousands of departures and arrivals of the *Martha's Vineyard*, her fleet mates, and generations of earlier steamboats. The distinctive church tower appears in many old photographs of the island steamers. (Photograph by Susan Ewen.)

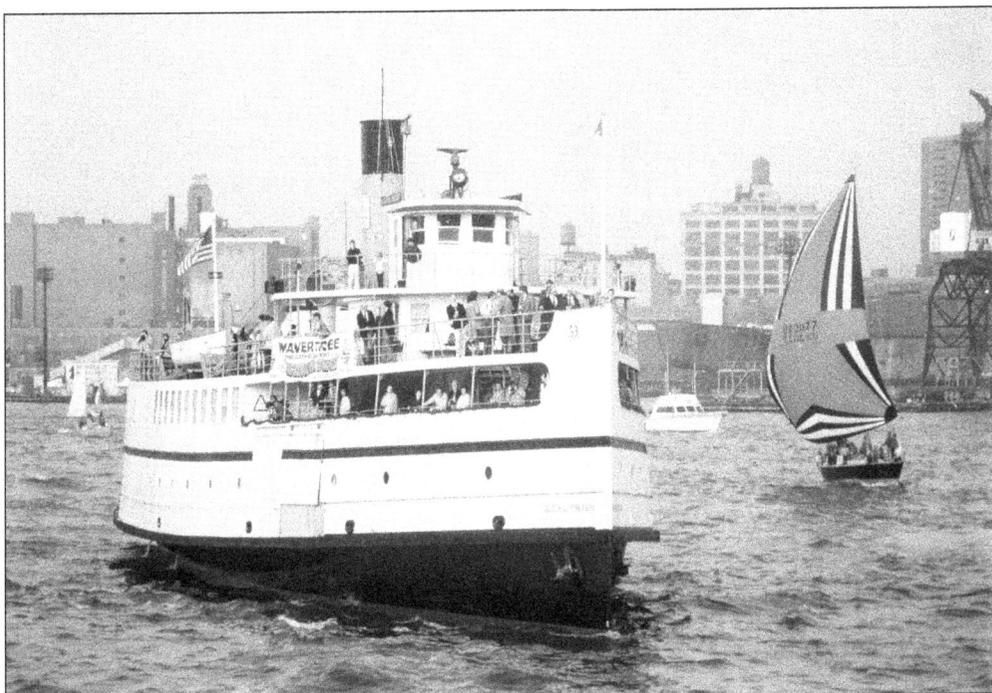

The *Martha's Vineyard* is seen here in the East River in 1983. She is in attendance at the Brooklyn Bridge Centennial celebration. Three years later, she was part of another spectator fleet, this time at the Statue of Liberty Centennial. That was the end of her career. She was sold to a tour boat company in Boston, who let her sink at a pier in Charlestown. (Photograph by and courtesy of Barry Eager.)

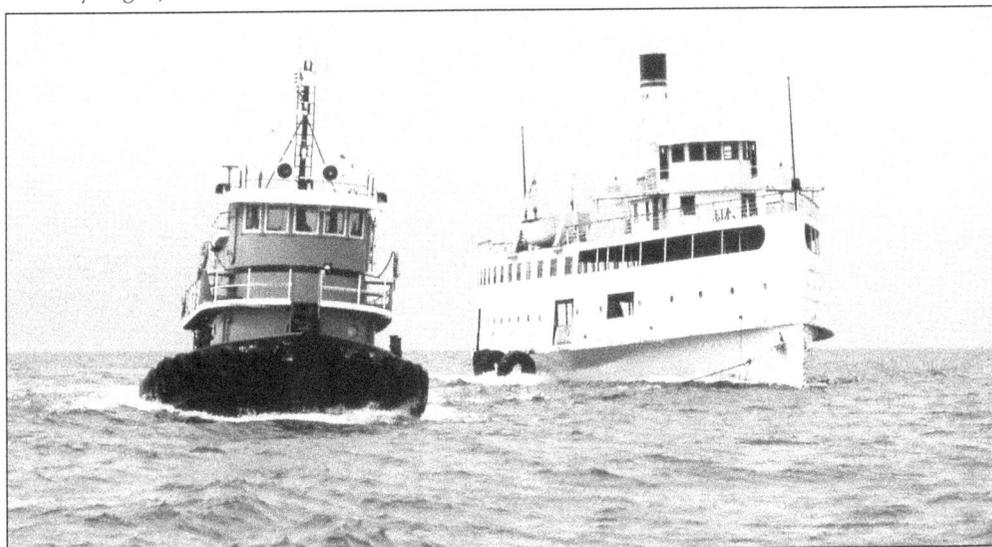

When the *Nobska* was sold by the Steamship Authority, the Friends of *Nobska*, later called the New England Steamship Foundation, was formed. This nonprofit organization had the goal of saving this last tall-stack island steamer. The city of Baltimore had allowed them to do preservation work on the engine, below decks. In 1988, the organization was able to buy the steamer and have her towed home, as shown here. (Photograph by the author.)

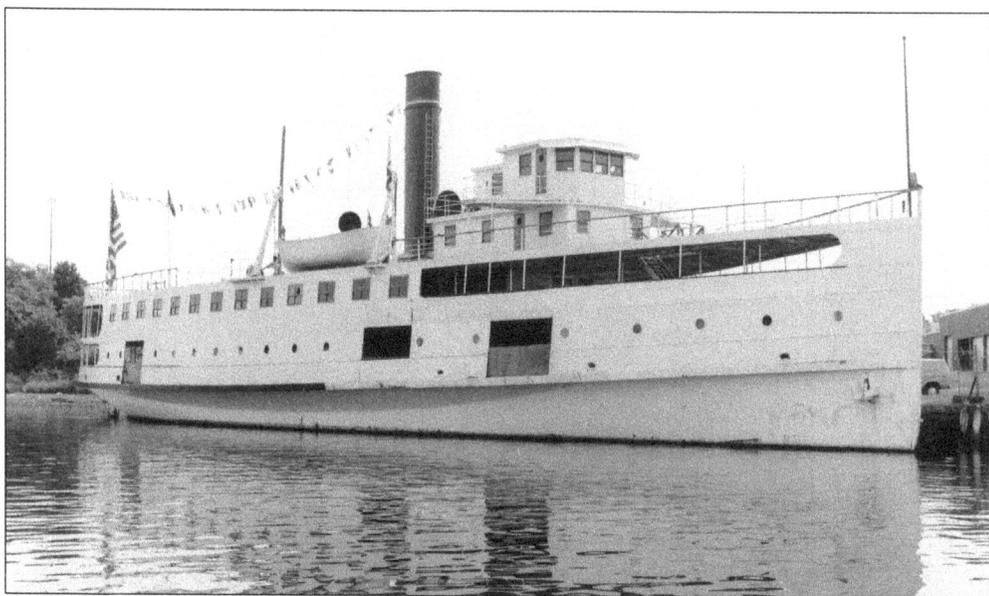

The *Nobska* was first moored in Fall River, where stabilization work and painting was ongoing. Many civic groups pitched in to lend a hand wherever possible. All the while, efforts were continuing to raise the money needed for major restoration work. Unfortunately, the pier became unavailable in 1991, and she needed a new home. (Photograph by the author.)

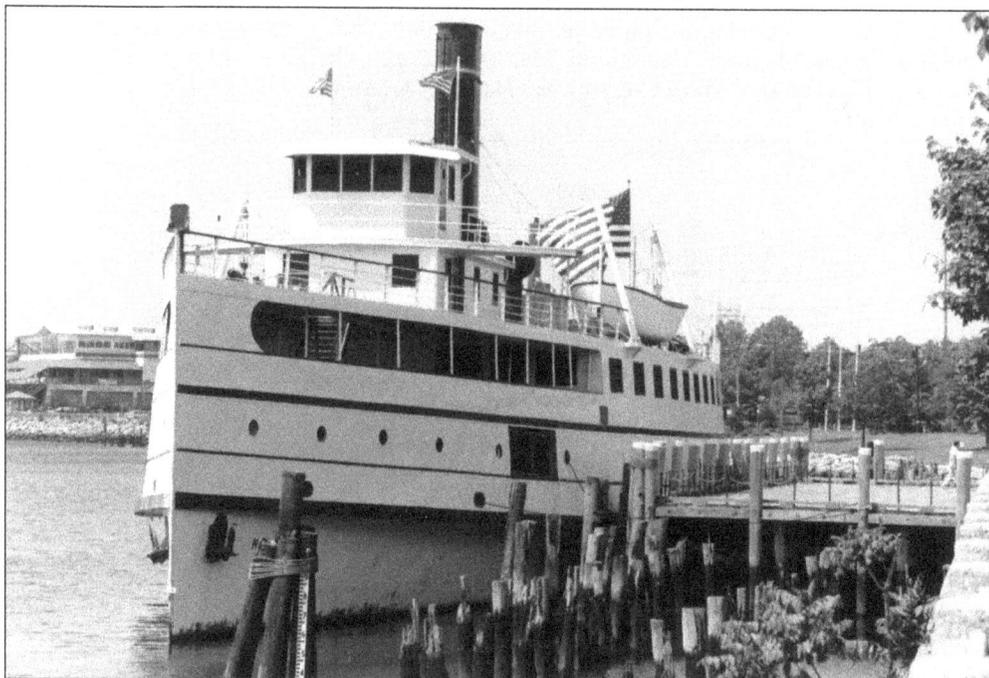

The mayor of the City of Providence offered the use of the wharf at India Point Park. While there, *Nobska* was open to the public during a number of festivals. As maintenance work continued, other groups reached out to help. The Girl Scouts of Rhode Island even created a *Nobska* Preservation badge, and an Eagle Scout candidate organized a work party as part of his civic project. (Photograph by the author.)

After a stay in New Bedford, and with a $3 million grant, *Nobska* was moved into the historic dry dock at the Charlestown Navy Yard National Park in 1996. Her hull was almost completely rebuilt, with just the last plates tack-welded in position. There were high hopes for the future of this National Historic Landmark and her ultimate return to operation. (Photograph by the author.)

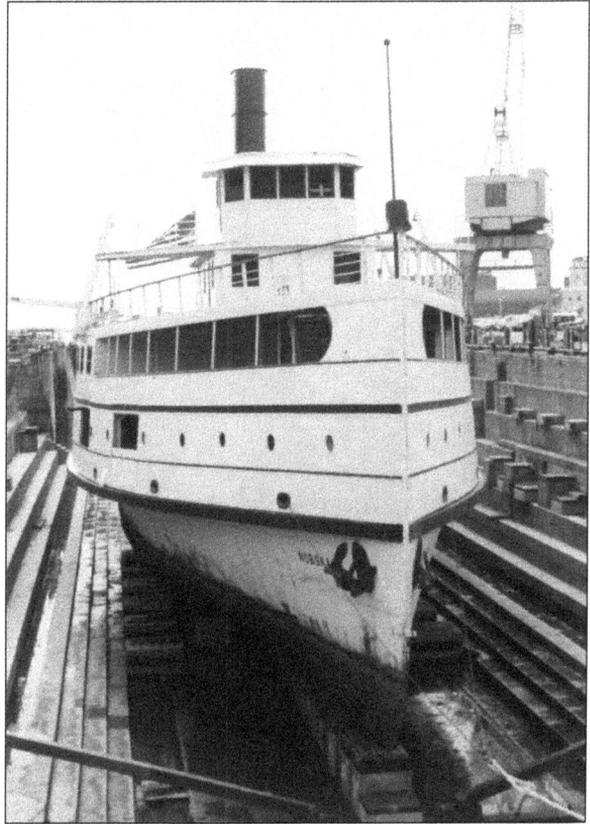

Looking forward, some of the many new frames and hull plates can be seen. Sadly, funds ran out. After 10 years, the park wanted the dry dock available and cut the *Nobska* up. There were those who felt it would have been less expensive to finish the welding and float her out. The foundation still has her engine, in case someday someone will want to build a replica. (Photograph by the author.)

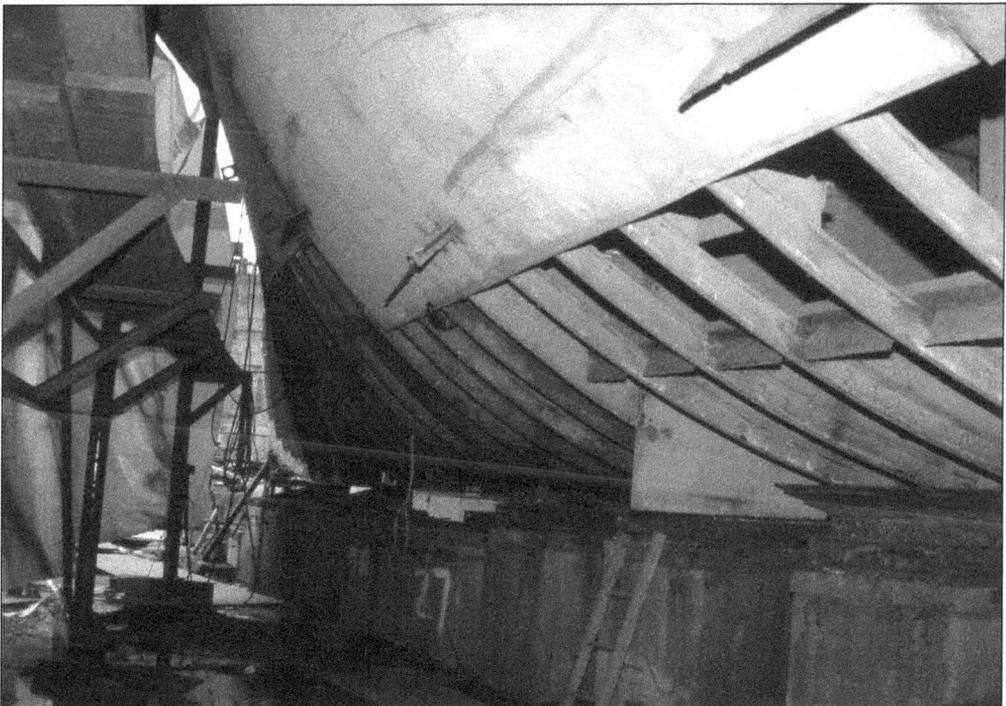

A new diesel vessel named *Nantucket* had replaced the *Nobska*, and the steamer *Nantucket* was renamed *Naushon*. With the *Nobska* gone, the *Naushon* became the country's last operating coastal passenger steamer. She had two Skinner Uniflow reciprocating engines. Standing in her engine room is chief engineer Lee Rand. Seated with their hands on the controls for each engine are Oiler Bill Wylie (left) and first assistant engineer Matt Flaherty (right). (Photograph by the author.)

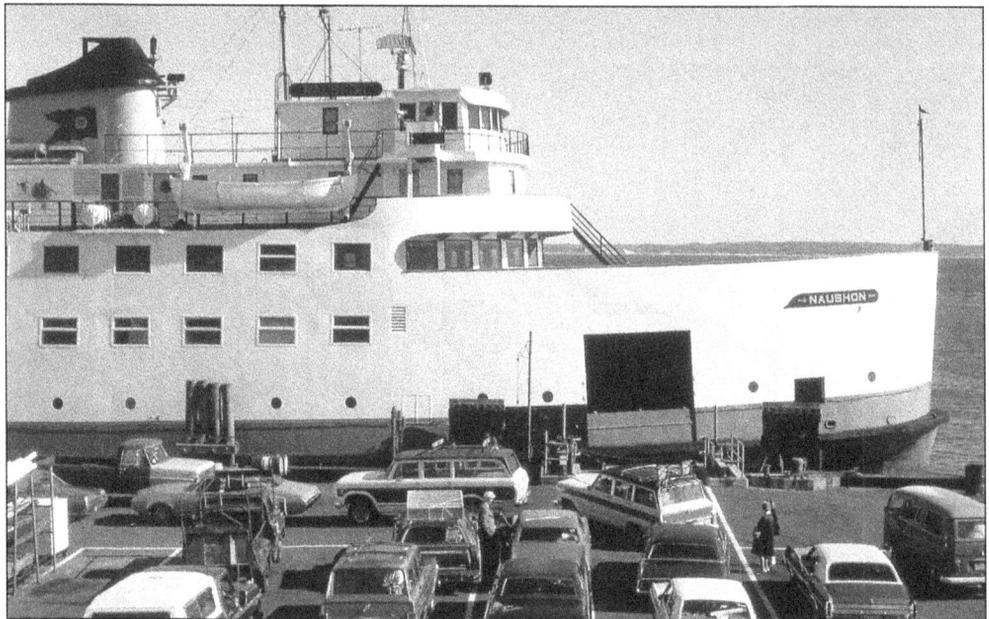

The *Naushon* continued in service, mostly between Woods Hole, where she is seen here, and Martha's Vineyard. As mentioned earlier, she was both a stern and side loader. She usually loaded automobiles at the side gangway in Woods Hole and unloaded them from the stern. For some reason, it appears here that the cars are going around to go aboard at the stern. (Photograph by the author.)

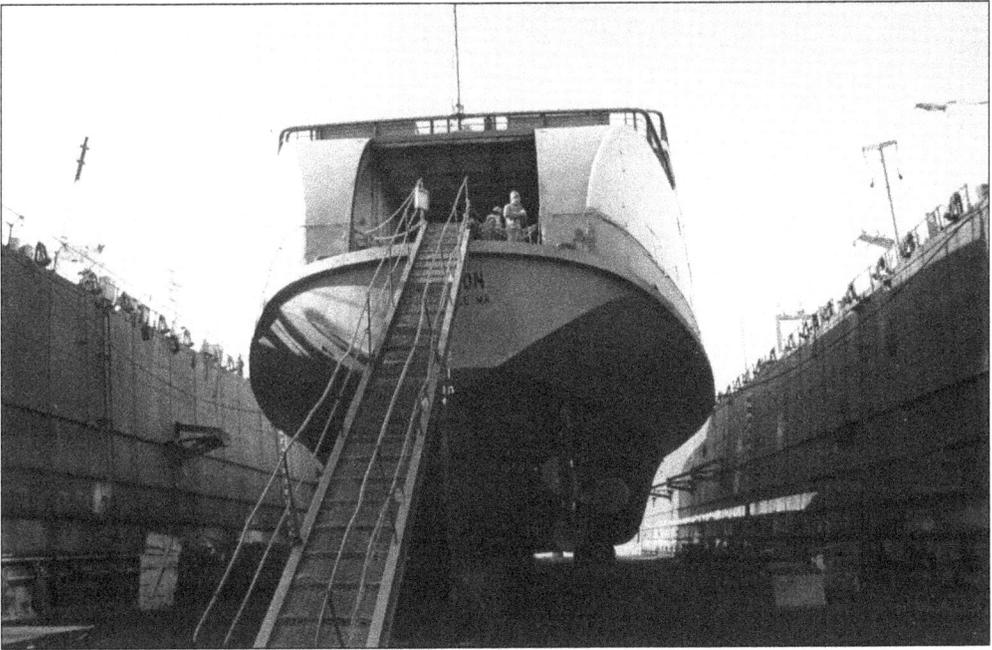

In April 1982, the *Naushon* was in dry dock, as seen here in East Boston, for her annual overhaul. She has steam up, and once the crew was aboard, the dock was flooded so she could be moved out. On this day, the author was aboard for the deadhead run back to Woods Hole. (Photograph by the author.)

The officers on this non-revenue run of the *Naushon* back to her homeport at Woods Hole were all longtime employees of the island line and experienced steamboat men. Capt. Edward Nemeth (pictured) began his career with the line working for the New England Steamship Company on board the 1929-built *Naushon*. He commented that the new ferries were boats, while the present *Naushon* was a ship. (Photograph by the author.)

Chief engineer Joseph Dawicki had worked for the line for over 30 years by this time, starting out on the steamer *Nantucket*. Although he was chief on most of the vessels of the line at one time or another, including the motor vessels, he much preferred the steamers. He was the last chief engineer of the *Nobska*. (Photograph by the author.)

The first mate for this trip was Carl Maseda. He also began his career on the line with the New England Steamship Company. His first ship was the *New Bedford*, but he had praise for the *Naushon* of 1929, saying that she was big, fast, and comfortable. When the present *Naushon* returned to Woods Hole, Maseda would be in charge of making her ready for the coming summer season. (Photograph by the author.)

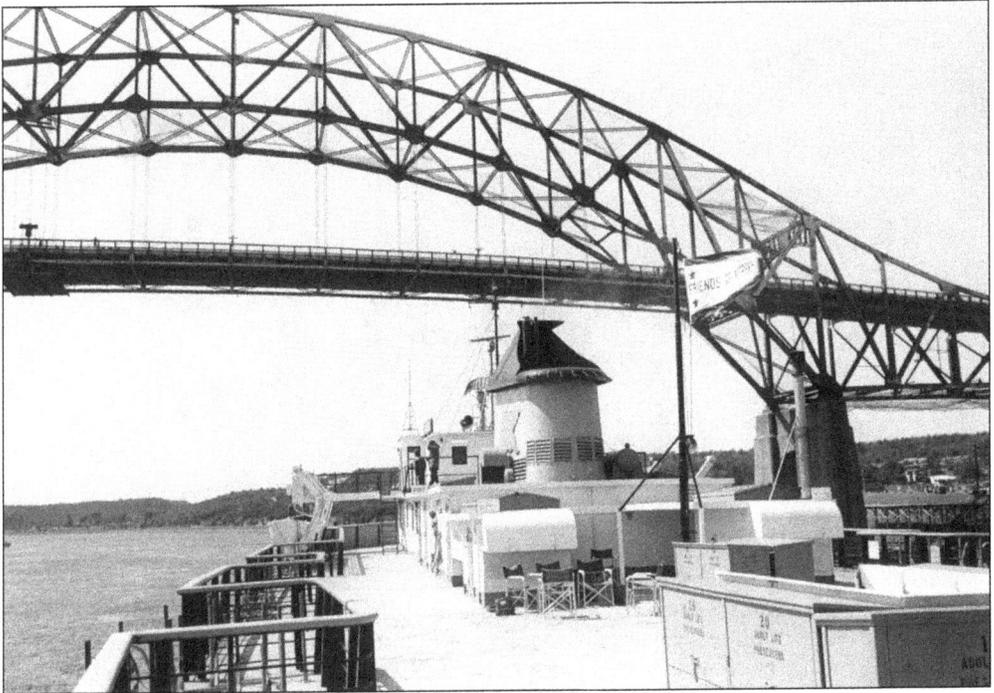

In this photograph taken from the hurricane deck, the *Naushon* is proceeding through the Cape Cod Canal on her way back to Woods Hole from the shipyard in East Boston. She is about to pass under the Sagamore Bridge, one of two highway bridges over the canal. The Friends of *Nobska* flag is flying from her mast. (Photograph by the author.)

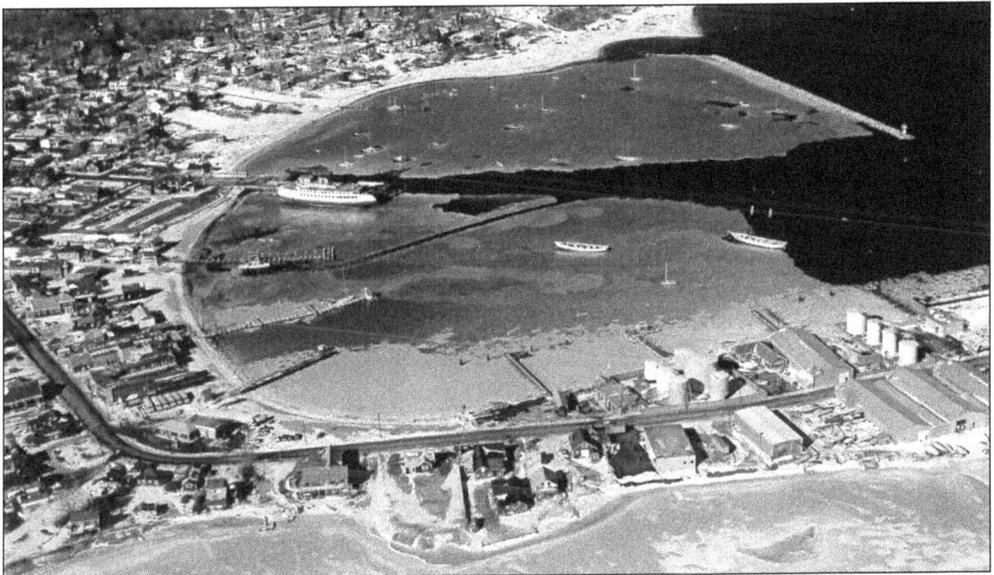

In this aerial view of Vineyard Haven, the *Naushon* can be seen laid up for the winter at the steamboat wharf. There were times when Nantucket was so completely blocked by heavy ice that the newer ferries and a Coast Guard ice-breaking tugboat could not get through. Several times, the *Naushon* was brought out of lay-up, and with her power and strong hull, was able to open the channel. (Courtesy of the Vineyard Gazette)

By spring 1988, the *Naushon* was out of service. Before being delivered to new owners, she was needed once more, to fill in for a ferry out for repairs. On the Friday of Memorial Day weekend, a Steamship Authority crew boarded her for one more day on the line, bringing along a Don't Give Up the Ship flag. That day, the sun set on American coastal steamships. (Photograph by Alison Shaw, courtesy of the *Vineyard Gazette*.)

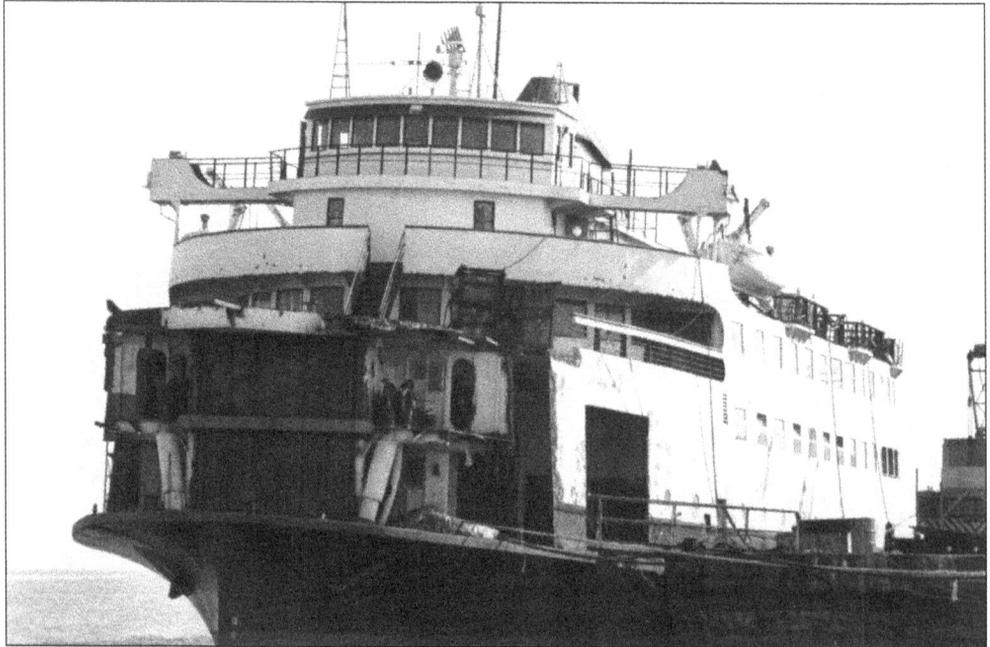

Here, the *Naushon* is seen at Mobile, Alabama, in a sad state. She was in the process of being converted into a stationary gambling ship. As is often the case with schemes like this, it did not last. She ended up in a landlocked pond in Mississippi, and after a record flood of the Mississippi River, she was left sitting on the bottom listing to starboard. She was scrapped in 2012. (Photograph by William Rau; author's collection.)

Six

Voices from the Past

The steam whistle has been called the voice of industrial America. They came in all sizes, shapes, and tones. The earliest steamboat whistles most likely had a single tone. Gradually, chime whistles, with three or more notes, became common. Although there were plenty of steamers with single-note whistles and others with as many as six notes, a deep-sounding, three-tone chime was considered a steamboat whistle.

Each steamboat had its own distinctive-sounding whistle and could be identified without being visible. Captains also developed their own way of blowing the whistle so that those familiar with various steamers knew who was in command.

Steamboat whistles are generally very pleasant sounding, more so than the sharp blast of a diesel horn. Also, being multidirectional, whistles will echo off of distant objects, and if the wind is right, they can often be heard from a greater distance than a one-directional horn.

The author and several other historians approached the Woods Hole, Martha's Vineyard, and Nantucket Steamship Authority about the possibility of installing historic steamboat whistles on some of the present diesel ferries. The Steamship Authority's response was very supportive. They embraced the nostalgic and historical appeal, as well as the public relations value. Although whistles blown by air do not have quite the same power as with steam, they do sound wonderful, and the response from passengers and residents has been very positive. One of these whistles has consistently been heard overland almost eight miles away.

As of this writing, three of the vessels have historic whistles, and one more whistle will be installed in less than a year. The search is on for another whistle to be used on a new boat that is due in 2016.

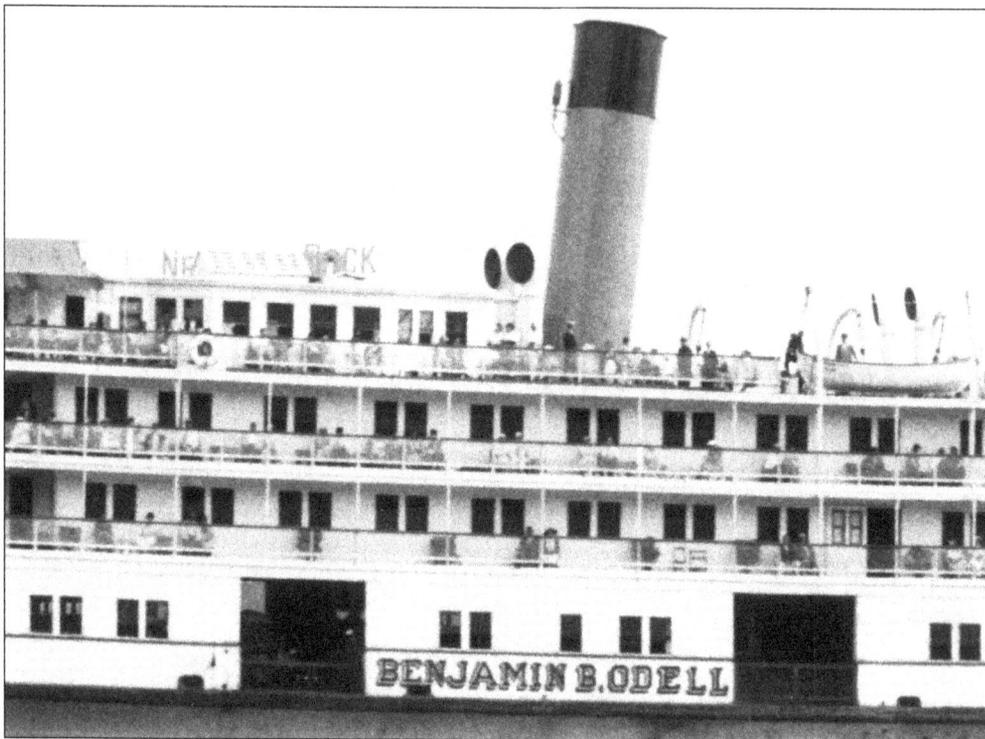

In this image of the Hudson River steamer *Benjamin B. Odell*, her crown-top whistle can be seen on the smokestack. It was this whistle that supposedly was installed on the *John A. Meseck*, the former *Naushon*, replacing her original whistle.

In the 1960s, the Steamship Authority acquired the whistle from the *John A. Meseck* and installed it on the steamer *Nantucket*, as seen here. The black cylinder to the right and below the whistle is the *Nantucket's* steam horn. (Photograph by the author.)

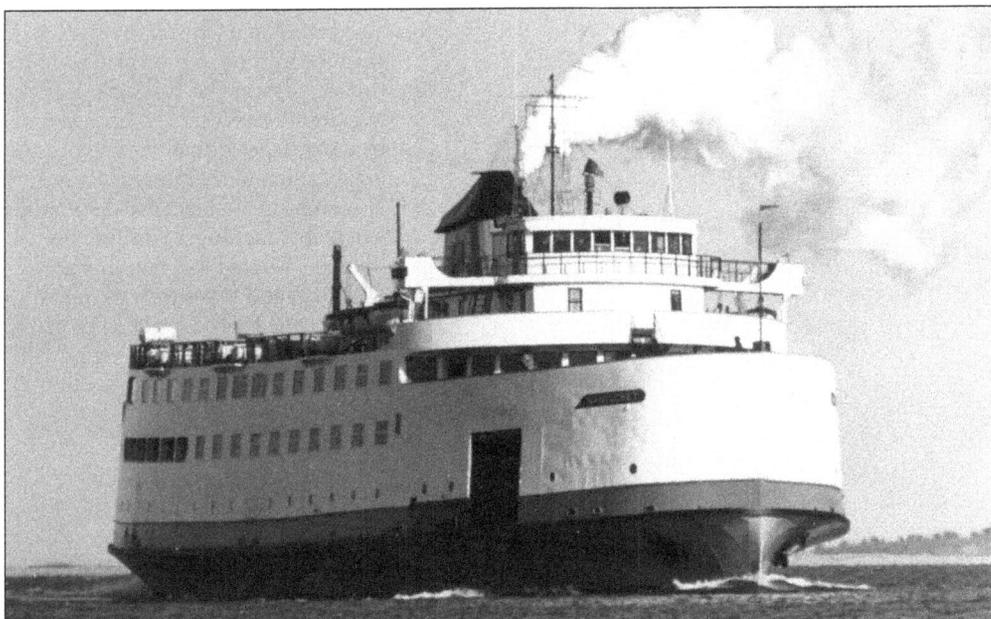

In this photograph taken on New Year's Day 1968, the *Nantucket* has just rounded Brant Point at Nantucket. The column of steam is from the whistle as it is blown to signal her approach to Steamboat Wharf. Due to problems with piping and pressure, the whistle was eventually removed. (Photograph by the author.)

As covered earlier, the island steamer *Sankaty* finished her career and was rebuilt as the *Charles A. Dunning*. At some point during her service in Canada, her original single-tone whistle was replaced with a three-tone chime whistle. Loaned by Conrad Milster of New York, this nice-sounding whistle is now in use on the ferry *Martha's Vineyard*. This view shows that whistle atop her pilothouse. (Photograph by the author.)

The last chime whistle on a steamboat in regular service to the islands was the *Nobska's*. It was always a pleasure to hear her blowing, especially miles away in the fog, heading for Nantucket in the late evening. To alert the dockhands when approaching a landing, the steamers would blow one short, one long, and two short, which is Morse code for the letter L, probably to mean landing. (Photograph by Steve Dininio; author's collection.)

The *Nobska's* voice can be heard once again over the waters of Nantucket Sound. Made available to the Steamship Authority by the New England Steamship Foundation, the whistle has been installed on the ferry *Eagle*, running between Hyannis and Nantucket. Today, it echoes off the same historic Nantucket buildings as it did when the *Nobska* was in service. (Photograph by and courtesy of Barry Eager.)

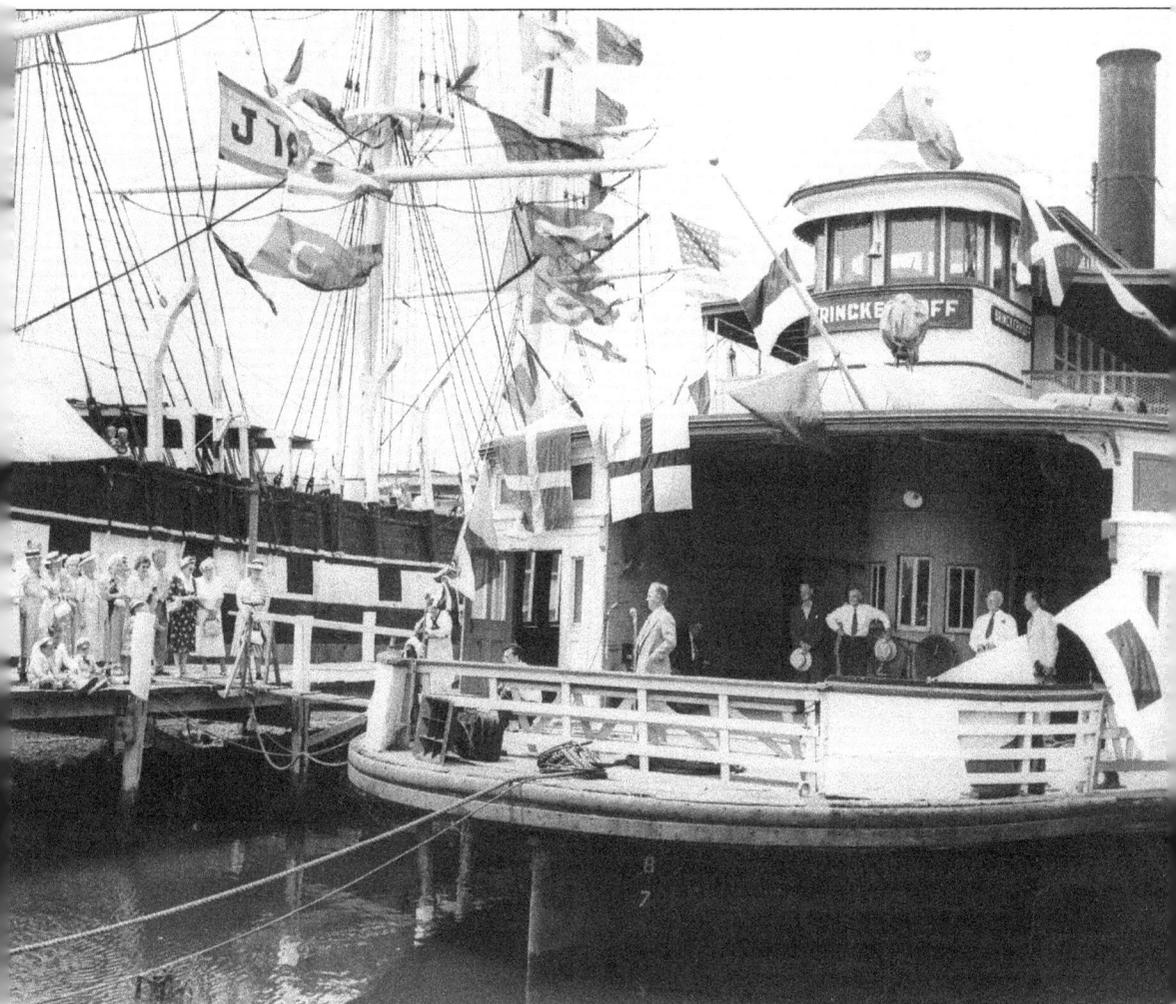

The whistle from the classic 1899 side-wheel ferry *Brinkerhoff*, loaned by the author, has been installed on the ferry *Nantucket*. The *Brinkerhoff* operated on the Hudson River at Poughkeepsie for 42 years. She then became an excursion boat at Bridgeport, Connecticut, and in 1950, was donated to the Mystic Seaport. She was a museum ship, as seen here, until 1961, when she was sold and ultimately burned for scrap. (Photograph by the Mystic Seaport; author's collection.)

Visit us at
arcadiapublishing.com

www.ingramcontent.com/pod-product-compliance
Lightning Source LLC
Chambersburg PA
CBHW050558110426
42813CB00008B/2394